THE PASSIONATE PHOTOGRAPHER
TEN STEPS TOWARD BECOMING GREAT

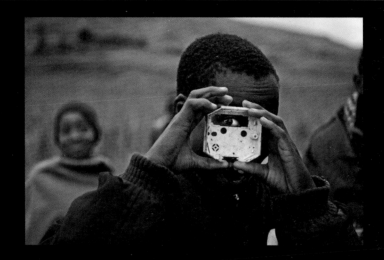

Steve Simon

THE PASSIONATE PHOTOGRAPHER
TEN STEPS TOWARD BECOMING GREAT

Steve Simon

New Riders
1249 Eighth Street
Berkeley, CA 94710
510/524-2178
510/524-2221 (fax)
Find us on the Web at www.newriders.com
To report errors, please send a note to errata@peachpit.com
New Riders is an imprint of Peachpit, a division of Pearson Education

Editor: Ted Waitt
Production Editor: Lisa Brazieal
Cover Design: Charlene Charles-Will
Interior Design and Composition: Kim Scott, Bumpy Design
Indexer: James Minkin
Front Cover Image: Steve Simon
Back Cover Author Image: George Barya

ISBN-13 978-0-321-71989-8
ISBN-10 0-321-71989-1

9 8 7 6 5 4 3 2
Printed and bound in the United States of America

For my wife, Tanja, my greatest inspiration

...and to passionate photographers everywhere.

CONTENTS

Introduction vii

Step one

PASSION: AN INCH WIDE, A MILE DEEP 2

My Inspiration 4
Your Inspiration 11
Finding Your Passion 11
The Sum 12
The Good Book 13
Lessons Learned: The Power
 of Photography 18
Personal 20
The Idea Is Everything 21
The Cause 22
Personal Challenges 23
Meetings 25
Your Story 26
The Written Component 27
A Framework 28

Step two

VOLUME, VOLUME, VOLUME: 10,000 HOURS: PRACTICE AND PERSISTENCE 31

Hurry Up and Wait 34
Close the Gap 35
Just Shoot It 36
Style and Technique 37
Master Your Gear and Creativity Soars 40
Simplify 43
Gear and Technical Proficiency 46
How I Work: Aperture Priority 46
Why I Choose Aperture Priority 48
ISO and Auto ISO 50
Shutter Speed: The Deal Breaker 52

The Argument for JPEG vs. RAW 55
The Argument for RAW vs. JPEG 55
Your Best Friend: The Histogram 57
Eye on the Prize 61

Step three

WORK IT: DON'T GIVE UP ON THE MAGIC 63

Some Basic Guides 66
The Moment 69
Work the Scene 70
Change Your Vantage Point 72
The Problem with Zooms 73
Choices and Limitations 74
More Deconstruction 76
The Enemy 78
Patience in Composition and Life 82
Design and Tradition in Composition 85
Lessons Learned: Don't Give Up
 on the Magic 92

Step four

THE LONELY ADVENTURER: CONCENTRATION AND NEVER LINGERING IN YOUR COMFORT ZONE 97

Learning to Concentrate 98
Instinct and Intuition 102
In the Moment 104
Lessons Learned: Instinct, Intuition,
 and Concentration 106
Fighting Photographer's Block 109
Finding Direction 109
Image Review 112
The Fixer 113
Paying for Pictures 114
The Warm-Up 114

Step five

THE EVOCATIVE PORTRAIT: PHOTOGRAPHING PEOPLE GETS EASIER 119

Portraits Beyond the Surface 120
Candid Portraiture 121
Access Is Everything 122
Talk to Strangers 126
No Cheese, Please 130
The Self-Conscious Smirk 130
Formality 132
Work with Me, Baby 135
Lessons Learned: The Chief 136
The Portrait Assignment 138
The Light 140

Step six

FOLLOW THE LIGHT...AND LEARN TO MASTER IT 147

Follow the Light 152
Lessons Learned: Find the Light and
 Stick with It 154
Color 156
Color Temperature and White Balance . . . 158
Black and White 163

Step seven

THE ART OF THE EDIT: CHOOSE WELL AND BE THE BEST YOU CAN BE 166

Your Own Best/Worst Editor 168
First Impressions 171
Lessons Learned: To Delete or
 Not to Delete 174
Please Back Up Immediately 176
Did I Say "Ruthless"? 176
Making Things Better 177
Editing with Purpose 180
Get a Second Opinion 182
Sequencing and Order 183
Post Inspiration 185

Step eight

ASSESSING STRENGTHS AND WEAKNESSES: NEVER STOP LEARNING AND GROWING 189

Lucky Accidents and Learning
 from Mistakes 192
Look Closely 196
Critical Think 196
Lessons Learned: Getting Naked 200
Just Shoot It 203

Step nine

ACTION PLAN: SETTING GOALS AND CREATING STRATEGIES 207

Goal Number One 209
Mark Them Down 210
Project Goals 211
Artistic Goals 213
Lessons Learned: If You Want to
 Know It Well, Teach It 214
Technical Goals and Shooting More 216
Business Goals 216
Equipment Goals 216

Step ten

FOLLOW THROUGH: SHARE YOUR VISION WITH THE WORLD 221

The Social Network 223
My Experience 226
The Business 227
The Website and Blog 228
The Good Book 229
The Personal Meet-Up 232
Lessons Learned: Keeping the Faith:
 Empty Sky Project 236

Index 248
Acknowledgments 254

AUTHOR LINKS

To see more of Steve Simon's work:
www.stevesimonphoto.com

The Passionate Photographer blog, workshops, and books:
www.thepassionatephotographer.com

Print sales and limited editions:
prints@stevesimonphoto.com

To book Steve to speak to your group or for personal instruction:
info@stevesimonphoto.com

Join the Passionate Photographer Flickr group:
www.flickr.com/groups/thepassionatephotographer

Twitter: stevesimon
LinkedIn: www.linkedin.com/in/stevesimonphoto
Facebook: www.facebook.com/stevesimon

INTRODUCTION

When I think back to the initial spark that ignited my passion for photography and all things photographic, it takes me to my childhood—and to a specific moment when I was 11 years old. Outside my suburban Montreal apartment building, my two best friends, Andre and Roger, were devouring a photo store catalog with geeky excitement. I quickly joined them in their enthusiasm.

There was page after page of cool-looking cameras decorated with buttons and knobs. I have to admit, it wasn't photography as an instrument for social change that I was thinking about. I was enamored with the camera as this cool object that I wanted to own.

The object of my desire? A Russian goddess called the "Zenit E." It was the beauty of this intricate tool with all its magic dials, plus the fact that, at $79, it was within the financial realm of a newspaper boy's salary. With an interest in journalism, I had spent my first summer's savings on a Smith Corona manual typewriter and was about to spend my life savings on a tool that would save me from typing a thousand words every time I clicked the shutter. It turned out to be my greatest investment.

My enthusiasm for the process could not be contained when I finally bought my first camera, a Yashica TL Electro X (which I ultimately chose over the Zenit). Every day, I climbed to the roof of my apartment building on Ward Street in Montreal to photograph the beautiful sunsets and planes making their approach into Pierre Elliott Trudeau International Airport (then called Dorval). I don't remember consciously thinking that I would someday like to be on the planes I photographed and see the world with my camera, but that's what happened. In retrospect, it was what I had dreamed of. I thought about the people on those jet airliners and speculated on who they

Sunset, from the roof of my apartment building on Ward Street in Montreal. Captured on GAF 500 ASA film. © Steve Simon

were and where they came from. The camera was my ticket to achieving my dreams of travel and experiencing the people and cultures of faraway lands, and it changed the way I saw the world around me. Of course my eyes were always open, but with a camera it felt like I was truly seeing for the first time. Photographic gifts were out there, everywhere, in unlimited supply and free for the taking. I also knew that I had stumbled upon something I would never grow tired of. Not only was photography fun and rewarding, but it was a way for a shy kid to communicate and share his vision and passions with the world.

That was a long time ago, and so much has changed. Yet my enthusiasm for photography has only grown more intense. This too is the gift of photography, a lifelong love. If you're reading this, I suspect you know from where I speak.

I have owned many cameras over the years and have experienced the paradigm shift from analog to digital. Even with this dramatic transformation, important concepts of photography have remained

the same. It's the content that counts the most. An image has the power to move people, to enlighten, inform, entertain and transform light and time into something tangible. Images can change the world. This is what *The Passionate Photographer: Ten Steps Toward Becoming Great* is all about. If you've ever been disappointed by the gap between the picture you envisioned and the one you actually got, this book will close it for you.

Looking back at 30 years of photography, I have culled from my experiences the best ways to help you become a better photographer. I have distilled the process into 10 steps. This book puts forward ideas and creative solutions to draw out the personal vision of every reader, encouraging a unique way of looking at the world we all possess but don't always have the confidence to develop.

There has never been a better time to pursue photography. We are in a new golden era. My passion is ignited, much like it was when my friends and I pored through that camera catalog, dreaming of following our cameras into the adventures that came with it. If you read this book and make serious attempts at the 10 steps, I promise you will become a better photographer and your passion fire for photography will ignite, and stay lit always.

The shadow of my plane en route to Nairobi; my Nikon and I, off on another adventure. © Steve Simon

PASSION: AN INCH WIDE, A MILE DEEP

*"Passion is in all great searches and is
necessary to all creative endeavors."*
—W. Eugene Smith

All I ever wanted to do was take pictures. I was 16, and it
was a dream summer. A Nikon FM camera with a 35mm
f/2.8 lens dangled from my neck as I rode around subur-
ban Montreal on my Honda 70cc motorcycle, documenting
community life for a local weekly newspaper that no longer
exists. And I got paid for it!

Years later, I graduated from university with a journalism
degree, and I couldn't contain my enthusiasm for embark-
ing on my photojournalistic career. I was young and idealis-
tic on that first day at *The Edmonton Journal*, and I couldn't
wait to aim my camera at issues and stories I thought were
important.

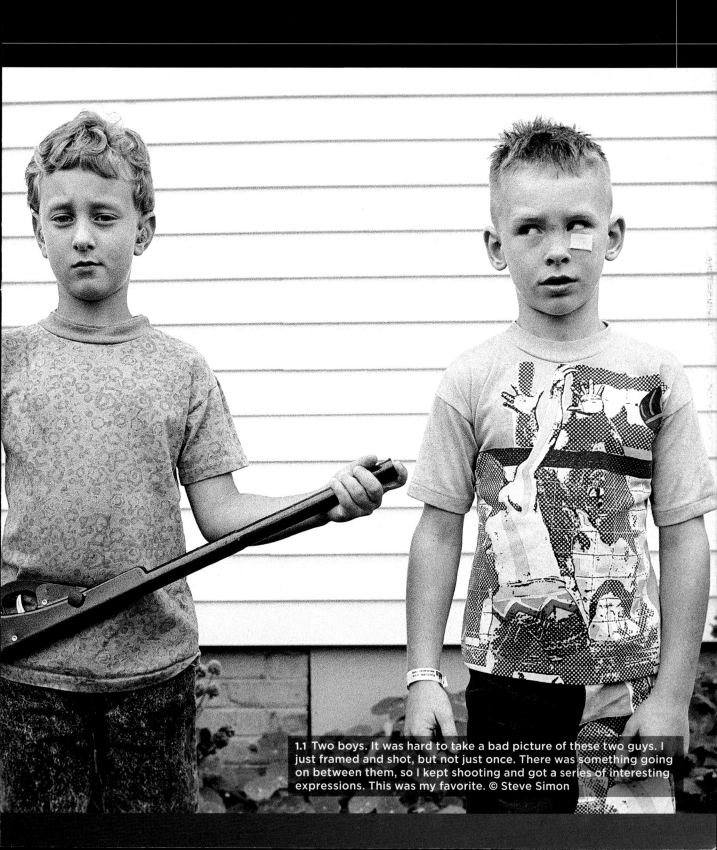

1.1 Two boys. It was hard to take a bad picture of these two guys. I just framed and shot, but not just once. There was something going on between them, so I kept shooting and got a series of interesting expressions. This was my favorite. © Steve Simon

Fast-forward a decade. After 10 wonderful, sometimes-frustrating-but-always-stimulating years as a news photographer, I often found it difficult to stay fresh and challenged. Daily assignments had made me a skilled and quick-working photographer able to deal with a variety of situations and work toward the strongest image out of any assignment.

1.2 My years as a newspaper photographer were a powerful photographic and life experience, but I was ready to slow down and take on a longer-term personal project. © Steve Simon

Yet I had become impatient, often retreating to my comfort zone, feeling forced to work in a formulaic way because of time constraints. I was ready for a photographic change, a way to slow down and find a way back to the innocence of vision I had as a young photographer, to find the joy that I had lost and rekindle my passion (**1.2**).

In the evolution of a photographer, to get to the next step, you should liberate yourself from photographic routine. Photography is a creative pursuit, and every photographer has a unique vision of the world. To get to the core of our photographic souls is to be honest with ourselves and ask, "What is it I am trying to say through my photography?"

Enter passion for the personal project (**1.3**).

If there's one concept I want you to take away from this book, it's that the most rewarding part of the photographic process often comes when you find a project or theme you feel passionate about. Don't get me wrong; I'm not advocating you go out and change the world with your camera (which I believe can happen). But by finding meaning and purpose in your picture-taking process, you will learn about yourself while elevating your personal photographic vision.

MY INSPIRATION

In the summer of 1996, with money I had saved and a leave of absence from my newspaper job, I set out on a fantastic journey in my 1990 Ford Topaz to travel the states that border Canada, from Maine to Alaska. It was my way of rekindling my love affair with photography; the journey was the destination, providing me with experiences that I would learn and grow from (**1.4**).

I'm going to talk more about finding inspiration later in the chapter, but for me, inspiration once came through a newspaper article in which Canadian writer Margaret Atwood talked about Canada becoming more and more like the United States, for

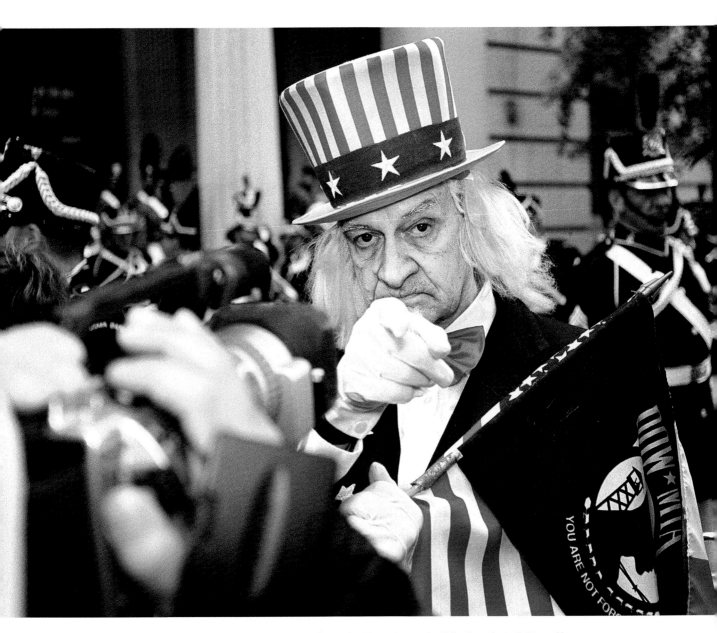

1.3 Uncle Sam being interviewed in New York City, from the "America at the Edge" project. © Steve Simon

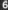

1.4 A drive-in theater in Twin Falls, Idaho. From the "America at the Edge" project. © Steve Simon

better or for worse (**1.5**). This was the spark that ignited my idea. I wondered: If Canada were to become more like the United States, might we start to actually *look* more like the U.S.? What would that look like?

I decided to take a photographic road trip to observe life and find the answer, and I would do it just across the border that separates the two countries. I thought that, through my photography, I could illuminate what life was like along the northern edge of the United States, and give Canadians a peek into our own futures. "America at the Edge" became the working title for my personal project.

This project was organic for me. As a kid growing up in Montreal, I would often venture across the border on vacation with my family, and I remembered how different and captivating life was in this strange new place. I also wanted a project that was not too specific, leaving me free to experiment throughout the huge geographic landscape I was about to cover.

I took a variety of cameras to push myself beyond the self-imposed and often unconscious barriers I had erected over the years. I wanted to feel different when I was shooting this work, a good reason to try a variety of cameras and formats. But I also wanted the picture-taking process to be second nature—organic and fast—feeling my way through and reacting on instinct. I mostly shot with wide lenses, for the look and feel of intimacy I was hoping to convey.

It was the predigital era, and I armed myself with Nikon SLRs, a Leica M6, and a Pentax 645 along with a tape recorder to interview people along the way. I think it's smart to get in the habit of keeping meticulous notes and information, which comes in handy down the road if you choose to do a book or exhibition. Collecting relevant artifacts is a good idea, as is thinking of the inevitable multimedia components of sound and video. You want to leave yourself and your project with as many options as you can, because it's impossible to predict just where your project will end up.

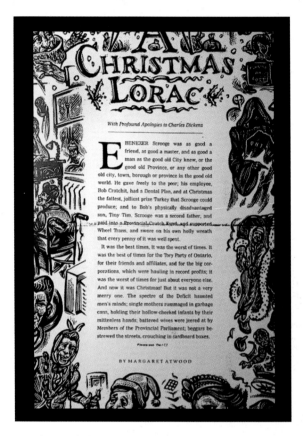

1.5 The article by Margaret Atwood.

It was not always easy to find the Zen photographic state I was looking for, especially when struggling with new and unfamiliar tools. In retrospect, simplifying the process would have made more sense—one camera and lens. But that was a conclusion I needed to work toward. It was an amazing journey, one that taught me the bones of the Ten Steps process that I'm passing on to you.

I realized that, for a photographer, a day never has to end. Life is 24/7 and so are photo opportunities. The look, feel, light, and rhythm of a place constantly change and can be interesting at different times of the day or night. I just needed to edit my situations, choosing where and when to photograph. I needed to use visual potential as my criteria, and learn to slow down and be patient (**1.6–1.9**).

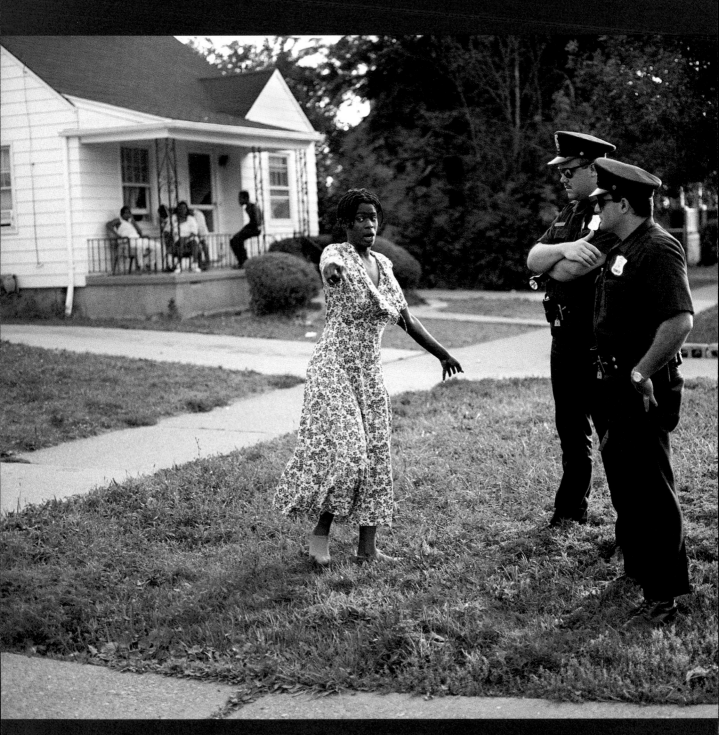

1.6–1.9 Four images from the "America at the Edge" project. © Steve Simon

1.10 An arrest in Spokane, Washington. From the "America at the Edge" project. © Steve Simon

The project taught me the rewards of leaving my comfort zone and getting past my own fears. A shy person working on a project that requires you make contact with strangers certainly did that; I outline my strategies for photographing people in Step 5. I learned to trust my instincts and intuition when I photographed the Aryan Nations, and I learned that patience and persistence would often be rewarded with great images.

I heard about a Canadian, Ronald Smith, on death row in Montana. Because I was looking at issues like capital punishment on both sides of the border between Canada and the United States, I wanted to get in to interview and photograph him. The red tape was long, but after a year of writing letters to the prison, Ronald Smith's lawyer, and Ronald Smith himself, I was finally given permission. Some stories seem impossible to access, but you'd be surprised how many times seemingly impossible permissions are granted to photographers; it's always worth a try.

I realized that each situation was a process, and by doing a compositional dance and moving around my subject—eye to the viewfinder—I would see my subject from all angles, which often took me to great images I would not have otherwise had (**1.10**). This way to move around your subject, as outlined in Step 3, increased my editing time by making my choices difficult because I had a lot of photography I was happy about.

I learned to edit thoroughly (Step 7) and seek out trusted second opinions that would offer me the insight I needed because I was too close to the material to see it myself. This part of the editing process helped me learn, grow, and improve. By looking at my contact sheets and seeing when I had not worked

the scene enough, I learned from my mistakes and, when possible, would go back and correct them—a great way to strengthen a photographic weakness (Step 8).

I found out that when I was distracted, I would not be doing my best work. I needed to discipline myself, to concentrate in order to find my way into the photographic zone, which I discuss in Step 4. I learned that the light was constantly changing, so I needed to follow the light to increase my chances of getting better images (Step 6), and be alert and work quickly when the light was good because it moved so fast.

I set actionable goals for my project and stuck to them (Step 9), leaving room for spontaneity and, when the feeling took me there, going outside the lines. When I was done I was not shy about seeking opportunities that helped me get my vision out to the world (Step 10). So much growth—and all from one personal project.

All my personal projects have been extremely rewarding. Good things happened that I never could have predicted—throughout the journey and through the finished work. I am more enthusiastic than I have ever been. I have rediscovered the sheer joy of photography I felt as a young man, riding my motorcycle through the suburban streets of Montreal, looking for my next photograph.

YOUR INSPIRATION

But how do you figure out what your personal vision is, and how do you nurture and grow it?

"Think big" is what *New York Times Magazine* photo editor Kathy Ryan recommends, and it's good advice. Of course, all big ideas start with a small step, and securing your idea is what you need to do first. You won't know for sure that your idea is executable until you start the process of shooting.

Years ago, when I hit my creative wall as a newspaper photographer, I was inspired by much of the great documentary work I was seeing in books and magazines and on the Web. I saw work from enlightened people showcasing innovative and in-depth work often created in their spare time.

I took a workshop with the documentary photographer Eugene Richards, whose work stopped me in my tracks and motivated me to travel thousands of miles for the weeklong workshop to see just how he did it. How did he get so emotionally and physically close to his subjects?

Richards needed to be close enough to his subjects to touch them, and an Olympus and 21mm lens were the tools he used at the time. But the technical stuff is easiest; I wanted to know how he could get so close to his subjects and capture such emotional intimacy. I learned that concentration, patience, passion, and empathy for his subjects were some of the answers.

It was his workshop that made me realize that I was not doing the work I wanted to do. I realized that I needed to find a way to peel the onion and go deeper with my camera. Finding a personal project was my way to break free from the shackles of daily assignment work. I needed to pursue a story I felt passionate about; I needed to follow the story in depth and with the only limits being ones I set for myself. I would learn to slow down and make time to get what I was after.

I would also unlearn some processes that had become formulaic and that were preventing me from moving beyond my comfort zone and into a new and exciting creative place. I wanted to be original, authentic, and true to who I was as a person and photographer.

FINDING YOUR PASSION

Directing your photographic energy and passion to a story or theme is something I feel confident will lead you through these Ten Steps toward becoming a great photographer. It is passion that will take you there...if you let it.

But you have to find that story or theme that inspires you to commit and drives you to work hard, moves you past frustrations and through obstacles, pushes you toward a photographic place of competence and excitement you cannot even imagine as you read this. In the Action Step at the end of this chapter, you will find a series of questions to help you find your passion, your story. Let's first take a look at the process and projects that can help inspire your story.

THE SUM

Chuck Close is an artist whose unique and consistent artistic vision has made him one of the most important contemporary artists working today. His technique has a lot in common with digital photography, though he has been making his art since long before the first digital cameras existed.

Close often works from photographs he takes himself, and his images consist of small, individual pixel-like paintings, which when viewed from a far enough distance, take on a whole new meaning. The sum of the rectangular "pixels" tells a much different story than that of each unique one (**1.11–1.13**).

It is his process that makes Close's work analogous to my point for taking on a project or theme. When you take on a project, you strive to make each image as strong as it can be. The challenge of creating a set of pictures is to make each piece strong on its own, yet when put together in a very deliberate way, the message communicated is often bigger and more complex than any individual piece could convey on its own. The sum is greater than the parts.

Story ideas can come from anywhere. I tend to read as much as I can, looking at blogs, magazines and newspapers, and the work of other photographers. But many of the best ideas come from your own life. Personal experience and exploring your own connections often yield some of the best and most rewarding stories.

My encouragement for you to pursue a project or theme comes from my own experience.

As you'll find out in Step 2, it's no mystery that when you go through a volume of work, you learn from your experience and you get better. More

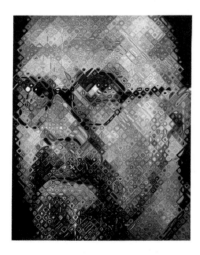 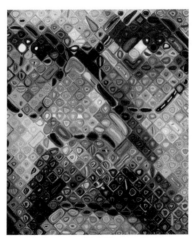

detail *detail*

1.11–1.13 When you study a Chuck Close painting up close, you see individual "pixels" that, when viewed from a distance, look completely different. The sum is greater than the parts. © Chuck Close, courtesy The Pace Gallery

comprehensive coverage yields stronger, deeper, and more interesting work. If your story involves people, for example, they often get more comfortable with you as time goes by, relaxing and letting their guard down to reveal more of themselves for you to capture. Shooting more helps improve your skills and makes you a better photographer. It lets you communicate your vision of the world.

THE GOOD BOOK

Whenever I'm looking for ideas and inspiration, I love going to my library, grabbing a book, and finding inspiration between the covers. Nothing to plug in or charge, the sweet aroma of ink on paper, it's an intimate experience that lets me get inside the head of the photographer who created it.

When you look at a photo book, in most cases you're looking at the culmination of a personal project the way the photographer has intended you to see it. It represents a long and arduous process, and there's a lot to be learned from the work, the edit, the sequencing, the format, and the words. It's a rare entrée into the psyche of the masters of the medium. We see immediately where the bar has been set.

I spend time analyzing the best work and then taking a critical look at my own, asking myself if the qualities I'm inspired by or are responding to can be infused into my own photography. And then there's the inspiration of ideas that can be triggered by looking.

To give you a lay of the land on which photo books to explore, three of the best references are books about books: *The Photobook: A History*, volumes 1 and 2, by Martin Parr and Gerry Badger (Phaidon Press) and Andrew Roth's *The Book of 101 Books: Seminal Photographic Books of the Twentieth Century* (PPP Editions). These reference volumes will not only show you the insides of great, hard-to-find books, but you'll also see the photography and photographers who have made those books great.

Skeptics say, "It's all been done before." But that doesn't really matter. Each of us brings our own unique vision to an assignment or project, and I've seen it many times over the years as a teacher: two photographers in the same place at the same time with completely different—and equally brilliant—results. When I go out shooting with my wife, Tanja, who uses a little point-and-shoot camera, I'm reminded that the colorful details and graphic textures she sees, I overlook, and it inspires me to see in new ways.

When I first moved to New York, I spent an afternoon at Coney Island, where I made what I thought were some nice images. When I later approached a magazine about publishing them, they told me they had a ban on looking at images from Coney Island since so many photographers were shooting there and they had already published some work.

But photographers go there for a reason; it's a great place to shoot pictures! Just because someone else has done a project does not exclude you from doing your own. Yours will be different. Of course it's always good to have a great and original idea, but don't write something off just because it has been done before; do it better and do it your way. I'm sure Brassai was not the first photographer to photograph the city at night. Just look at the beautiful imagery and lush printing in Brassai's *Paris by Night* (Bulfinch).

Brassai would wander the streets of Paris at night with his Voigtlander 6x9 plate camera and 105mm f/4.5 lens on a wooden tripod, capturing the beauty, mood, and mystery of the city on glass-based negative plates. It was the 1930s, when the process was more cumbersome and difficult. He often needed long exposures, which he measured with lit cigarettes, using a cheap, fast-burning Gauloise for short exposures, and a thicker, slower-burning Boyard for longer exposures. He would often use a flash bulb, which was new technology at the time and less dangerous than flash powder (especially when you use

HOWARD CHAPNICK ON THE PHOTO ESSAY

In perhaps the best description I've seen of what the photo essay should be, the late Howard Chapnick, founder of Black Star Agency and a legendary figure in photojournalism, described in the early 1990s what he thought was important for a strong photo essay in his book *Truth Needs No Ally*. We've seen a paradigm shift to digital since his book published, but Chapnick reminds us that in the end, it's the photograph that matters most, regardless of how it was captured. Content is paramount, and though written for the documentary community, his words ring true regardless of the personal project you pursue. The following are quotes from his book:

1. The photographer must start with an idea that is cogent, concise, journalistically realizable, and visually translatable.

2. The subject must have depth and diversity of situations, and visual redundancies must be avoided. Each photograph should add new dimensions of understanding to the subject being photographed.

3. Photographic essays need time—time to permit exploration of every nuance of the subject, time to allow the elements of conflict within the story to reveal themselves, time for the photographer to be immersed in the subject and grow in understanding of it.

4. Photographic essays require cooperation. Subjects of such stories should be apprised early on in the project demands on them will be great, that the photographer might intrude on the individual's privacy in getting beyond superficial coverage.

5. If the story is based on an individual personality, it must reveal the essence of that individual, warts and all, and not be press-puffery in lieu of honesty and reality.

6. Great photographic essays are dependent on words to amplify the photographs, to interpret photographic ambiguities, to form a journalistic whole, where words and pictures are perfectly matched.

7. On a photographic essay, preconceptions and illusions are dashed. Photographic essays can turn out to be voyages of discovery in which the subject's evolution is antithetical to the original conception. Such was Gene Smith's journey into the life of Dr. Albert Schweitzer in *Lambaréné*. At the beginning, Smith had expected to find the saint that he had conjured up in his mind, but after months of photographing Schweitzer, Smith found him to be an autocratic man complete with human foibles.

8. The success of a photographic essay depends on attention to detail. The photographer should have a structure in mind, written or unwritten, as the essay unfolds. All along the way, the photographer should have a mental or written checklist against which the photographs are made, so that when the work is finished there are no unfilled gaps in the story.

9. Putting together a photographic essay is personal. It cannot be done by committee. It is an individual statement, so conceived that usually only the photographer is capable of putting it together in a comprehensible way. That doesn't mean that the art directors cannot contribute meaningful ways of putting the pictures on a page or that editors cannot add valuable insights into the structuring of the essay. But ultimately, the photographer has to decide what story is to be told and how. ■

Quotes reprinted from *Truth Needs No Ally*, by Howard Chapnick, by permission of the University of Missouri Press. Copyright © 1994 by Curators of the University of Missouri.

cigarettes as timers). Brassai's work is inspiring for its beauty and composition, and it holds up today.

What does your block, neighborhood, or city look like when the sun goes down? Night photography is a demanding, challenging, unpredictable, and rewarding genre, and it's the kind of project available for all to explore and bring their vision to.

The highly influential documentary photographer Diane Arbus once said something to this effect: "The more personal you make it, the more universal it becomes." Personally, I have always been less interested in celebrity and more drawn to capturing the human condition, real people living real lives—the heart of documentary photography. Like music, photography is a universal language we can all understand.

There's a long history in photography of photographers getting personal by documenting their own family, using their talents to create a family album they share with the world. Iconic family photographs like W. Eugene Smith's "A Walk to Paradise Garden," which was the final piece in Edward Steichen's famous Family of Man exhibit, was an image of his own children. Of course love, passion, and talent can shine through when you're capturing your own life and family.

Making a statement with his beautiful book *The World from My Front Porch*, the poetic and passionate Larry Towell combines his photography with poetry and prose, artifacts, and archive images and prints from his own family album made over 20 years. He goes on to include tear sheets and observations of the dispossessed, people he has photographed far from his front porch but who are close to his heart.

Much of Sally Mann's work focuses on her home environment and her children growing up. Back in 1992, the Houk Friedman Gallery in New York took orders for more than 300 prints, well over a half million dollars generated by the haunting and evocative images of her own children and home environment.

The mantra "photograph what you know" is illustrated in Bill Owens' examination of *Suburbia*, the title of his project documenting both his and a wave of Americans' migration away from the city that began in earnest in the 1960s (**1.14–1.17**). When choosing a story or theme, you should have a solid point of view and know that the subject matter has visual potential. Some stories don't seem visual on the surface, but once inside, great pictures can be made.

Owens aimed his medium format camera and Tri-X 220 film at friends and neighbors in the community where he lived and worked as a news photographer in Livermore, California. What resulted is a seminal work where individual images tie together and create a snapshot of life in the new suburban North America.

Owens' project was a very deliberate one. He would shoot for it every Saturday for a year—creating shot lists and scripts for events and holidays he wanted to include like Christmas, Thanksgiving, Tupperware parties, and birthdays—using his many community contacts made from his news photographer job. He would also advertise to find willing and relevant subjects through classified ads, an idea updated by many photographers who use free online ad services like Craigslist to do the same.

Bill Owens met the challenge of finding the extraordinary in the ordinary. It's all in your perspective. It's tough to come up with creative, evocative, interesting images from subject matter that isn't exciting, but if you can meet this challenge, then when you get inherently strong content you'll do even better work.

In determining what or who to photograph, I'm constantly looking for good visuals as well as subjects who are more outgoing; expressive people often make better subjects than those who keep it all inside.

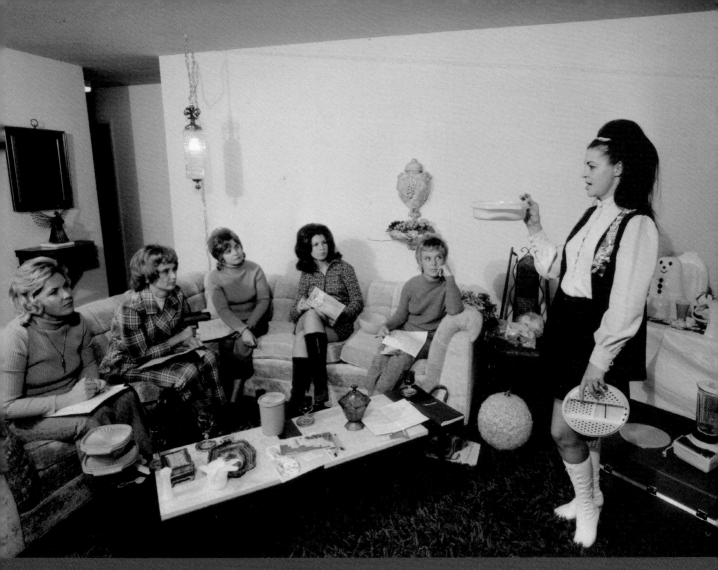

1.14–1.17 Bill Owens spent a year of Saturdays documenting the phenomena of suburbia. © Bill Owens

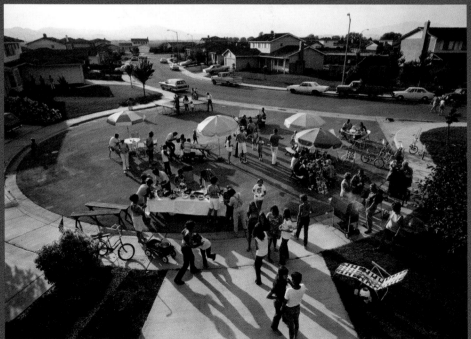

Lessons Learned

THE POWER OF PHOTOGRAPHY...

I'm optimistic about the future of photography in this visually oversaturated world. That's because I believe in its transformational power. It can transform light and time into something physical. It's a universal language we all speak, and great photos communicate so much, in an instant, without words or sound. We think in still images; our memory is formed by them.

Migrant Mother
Dorothea Lange, 1936

1.18 Can you see the image "Migrant Mother" by Dorothea Lange?

The image of the blank piece of paper with the caption "Migrant Mother, Dorothea Lange, 1936" makes my point (1.18). There is no image there, but chances are if you've seen this iconic picture by Dorothea Lange, of a mother and her two children, you can "see" the picture now.

You can spend time with a strong image, lingering and discovering something new each time you view it. My belief in the power of photography to move people was solidified when I recently came across a small memorial in Kigali, Rwanda. I was moved by the simple wire-and-clip display of snapshots of victims from the 1994 genocide (1.19 and 1.20).

Photography is a way to record our milestones, often brought out when happy times are upon us or at big events. These were the images on display—images of people we can all relate to during important moments in their lives. For some, the images were the only proof of their existence. It was a moving, powerful display, and as a photographer, I made pictures of the pictures as a way to share my experience with others. I learned that it's not always the grand vista that tells the bigger story. ■

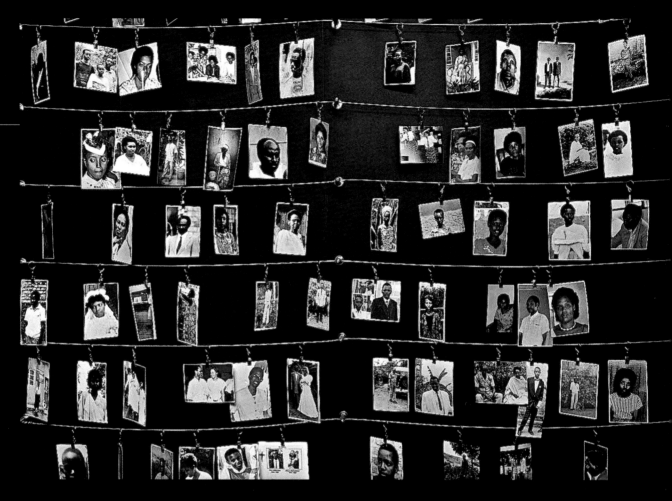

1.19 and 1.20 Images of victims of the genocide, Kigali Memorial Center, Rwanda. © Steve Simon

PERSONAL

While rummaging through the photo section of a small bookstore in a small town, I came across a beautiful little personal project that made a big impact on me. The inspiring book was *The Day-to-Day Life of Albert Hastings* (Princeton Architectural Press), by American photographer KayLynn Deveney. She was living in Wales when she met Mr. Hastings, the subject of her story, who was 85 when they met (and since passed away at the age of 91).

Deveney's work is a reminder that there are great stories and subjects close by, and that it's not necessary to travel across the world to find inspiring subject matter. She had to move from her comfort zone to initiate the meeting that would lead to her project and their book. She writes in her book, "At first I felt shy about introducing myself to Bert, but eventually I did walk over to meet him and he greeted me warmly."

What results is a beautifully documented look at one man's life through the simple, tender, and evocative photographs combined with Mr. Hastings' artwork and captions (**1.21-1.25**). Through their collaborative efforts, we enter a private world of an elderly gentleman whose life makes us think about our own and those of our loved ones.

For 15 months in 2001–2002, Deveney would visit her neighbor three or four times a week, sometimes making pictures, sometimes not. Many of her photographs are of details: Mr. Hastings' socks hung over his door on a hanger to dry; a broken daffodil rescued by a rubber band that lets it stand up in a coffee mug.

"It's tough to shoot in one room over a long period of time. You have to constantly be challenging yourself to see new details, notice nuances in the light and small mannerisms of his. It's important to not stop looking," Deveney said.

As you turn each page, you learn more about Hastings' home, personality, and life. By the end of the book, you really feel like you know him.

1.21–1.25 From *The Day-to-Day Life of Albert Hastings*, by KayLynn Deveney. "It's important to not stop looking," she says. © KayLynn Deveney

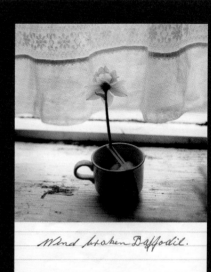

Deveney uses her camera with compassion and understanding to shine the spotlight on an ordinary man, and perhaps she inspires the reader to make contact with people like Mr. Hastings who we know in our own lives.

If you want to see the power of words and photographs working together, take a look at Joel Sternfeld's *On This Site* (Chronicle Books). Sternfeld melds photojournalism with landscape and crime-scene photography as he goes to famous places where tragic events took place in America and re-photographs a rather ordinary scene. It's only when you read the words and realize what happened on that site that the power of the project takes hold. These innocuous-looking images take on a strong resonance, triggering your own remembrance of an iconic image or news story that emanated from that spot. A great project idea, well executed.

THE IDEA IS EVERYTHING

When I came across the following quote from Albert Einstein, I knew it belonged in this part of the book.

"If at first an idea does not sound absurd, then there is no hope for it."
 —Albert Einstein

My take on Einstein's quote is that, if you can execute them successfully, there really are no bad ideas. With some projects or themes, you need to exercise a single-mindedness of vision, a laser adherence to the idea that every photo must contribute to the story or theme or it's excluded, no matter how strong it may be.

Tucker Shaw had the idea that he would take a picture of everything he ate for an entire year. The result? A book entitled *Everything I Ate: A Year in the Life of My Mouth* (Chronicle Books). He used a point–and–shoot camera to photograph every morsel

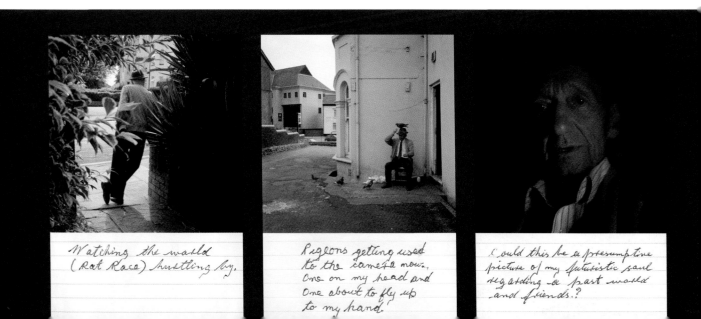

Watching the world (Rat Race) hustling by.

Pigeons getting used to the camera now. One on my head and One about to fly up to my hand.

Could this be a presumptive picture of my futuristic soul regarding a past world and friends?

of food before he ate it. The idea sounds unusual, and it is, but the result is a thought-provoking work.

When you make your way through Shaw's catalog of food pictures, at first you look, then you process, then you personalize and imagine looking through a similar catalog of images of what you've consumed in a year. Then the thought horrifies you, and you put the book down.

"Sure, it's just a bunch of pictures of food, none of them all that great. But it's the most honest thing I've ever done. There are no secrets in these pictures. Nothing is missing," said Shaw. He used photography in a clever and simple way as an archiving tool, and the sum is definitely greater than the parts.

I have a few other seemingly absurd ideas that grace my bookshelf.

John Glassie did a book called *Bicycles Locked to Poles* (McSweeney's). In it, you'll find images of—you guessed it—pole-locked bicycles. Similar to Shaw's work, the catalog of straightforward, literal depictions starts to gain momentum as you view bicycle after bicycle, abandoned and sad, with missing parts, showing you what the photographer wants to show you.

That's what we do as photographers. We say to our viewers, "Look at this. It's funny, sad, shameful, beautiful." It's a bicycle locked to a pole.

Andrew Danson is a Canadian photographer who decided he would photograph Canadian politicians alone in their offices, with a twist. In his book *Unofficial Portraits* (Doubleday of Canada), Danson himself didn't take a single picture. Instead, he would frame the image with his subject in place, set up the lights, adjust the exposure, and then leave. The subject was left behind, in a quiet room with a cable release (which you could see in the picture), and would take a series of 12 self-portraits. When done, the subjects would come and get him.

"Some politicians saw humor in such an undertaking while others took themselves very seriously. This work is about power, self-image, imagination, and about the dialectics of photography," said Danson. The results were fascinating. Some of his subjects would puff themselves up, trying to project a look of confidence or bravado. But the camera could not be faked out, and those images often ended up looking silly. His inspiration for the project came while working far removed from the world of Canadian politics, when he was documenting poverty in Jamaica. He says sometimes inspiration comes when you're distanced from your regular routine and surroundings.

THE CAUSE

Then there's the passion for a cause. There was arguably no one more passionate about the stories he worked on than the great W. Eugene Smith. Smith did some of the best-known photo essays for *Life* magazine: Country Doctor, Nurse Midwife, and Spanish Village.

Later in his career, along with his wife Aileen, Smith moved to southern Japan to the village of Minamata to document the carnage caused by mercury poisoning of the water supply by the Chisso Corporation's dumping of industrial waste into the bay. For three years, they documented Minamata for their book of the same name. The Smiths' photographs and words personalize the story and give a detailed account of the toll the tainted food chain had on the people there, including severe health problems and birth defects. The book includes one of Eugene Smith's greatest photos, "Tomoko Uemura in Her Bath."

Documentarians like Donna Ferrato, who produced comprehensive photographic coverage on domestic violence in her book *Living with the Enemy* (Aperture), which was eight years in the making, or Eugene Richards, whose raw reporting of a Denver hospital in *The Knife and Gun Club: Scenes from an Emergency Room* (Atlantic Monthly Press), are two examples of photographers identifying a cause or subject close to their hearts and putting in the effort until they were ready to share their final, brilliant result with the world.

Nature photographer James Balog is a great example of someone who thinks big and outside the frame, who is not content to take an easy, traditional approach to his work. For his book *Tree: A New Vision of the American Forest* (Sterling), he took hundreds of photos—many while rappelling from surrounding trees—and digitally merged them into composite images to capture the grandeur of his subjects. In his "Extreme Ice Survey" project, he uses time-lapse, stills, and video to record the melting of the earth's glacial ice caused by global warming.

In his remarkable book *Survivors: A New Vision of Endangered Wildlife* (Abrams), Balog wasn't interested in the romantic imagery of wildlife in idyllic environments and golden light that say that all is good in the animal world. Instead, Balog's vision of the project was new and original. He proposed to bring these animals into the studio, away from their usual habitat, and photograph them with sophisticated studio lighting usually reserved for fashion and advertising images. He had difficulty garnering support for his project until he made some images for people to understand his idea.

PERSONAL CHALLENGES

Some projects are about photographers challenging themselves. A wealth of photo-a-day blogs have sprouted up all over the Web and, as you'll see in Step 2, getting through a volume of work is necessary to get you to the next step in your work.

Nature photographer Jim Brandenburg took the photo-a-day idea to an extreme. As a renowned *National Geographic* photographer, he was used to taking thousands of photos on an assignment that would be culled down to a handful of the very best from his take.

But feeling frustrated with his work and wanting to rekindle his passion for photography, he gave himself an extraordinary assignment: to photograph a picture a day for 90 days, from the first day of fall to the first day of winter (**1.26**). Brandenburg meant

that literally: he would take just one frame a day, no second chances. He described the journey for the project as a very personal one, but the work ended up as a cover story in the November 1997 issue of *National Geographic*—with the most photographs ever published by the magazine in one feature (using the least amount of film, by the way)—a book, and Emmy-award-winning video called "Chased by the Light."

For Brandenburg, the challenge of which one frame to shoot each day was met equally with what not to shoot. Imagine the discipline it takes with this kind of a project, to pass up good photo opportunities holding out for something better that may or may not materialize.

*"The day was dark and gloomy; my mood reflected the weather. I wandered through the dripping forest all day long. Tired, hungry, and wet, I was near tears. I was mentally beating myself for having passed up several deer portraits and the chance to photograph a playful otter. None of those scenes spoke to me at the time. But perhaps because I was patient, and perhaps because, as natives do on a vision quest, I had reached my physical limits, I became open to the possibility revealed by a single red maple leaf floating on a dark-water pond (**1.27**).*

My spirits rose the instant I saw it, and although the day was very late and what little light there had been was fleeing rapidly, I studied the scene from every angle. Finally, unsure of my choice, I made the shot anyway, thankful at least that the long day had ended. Once more I was surprised by the result. The image seems to have a lyrical quality, with rhythm in the long grass. A brooding sky reflects back on the water. Although when I had first framed it in the viewfinder it was quite disappointing, on film it gave me happy surprise. I know that what I see isn't what you will see—for me, this photograph is a lesson in diligence and patience. It speaks to me of intimacy as well, reminds me to look closely at the world. As in life, you never really know what it is you have until later."

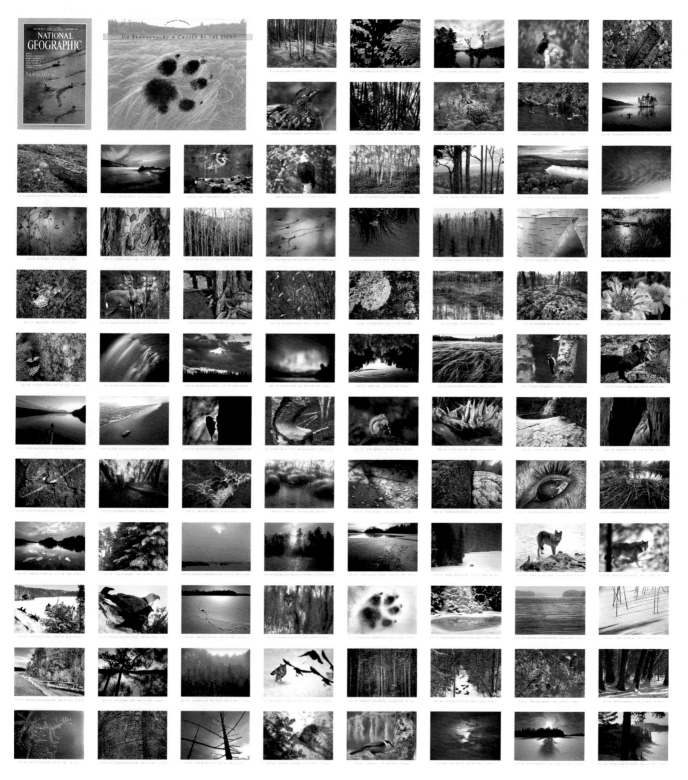

1.26 The remarkable 90 frames from Jim Brandenburg's frame-a-day project "Chased by the Light."
© Jim Brandenburg (www.jimbrandenburg.com)

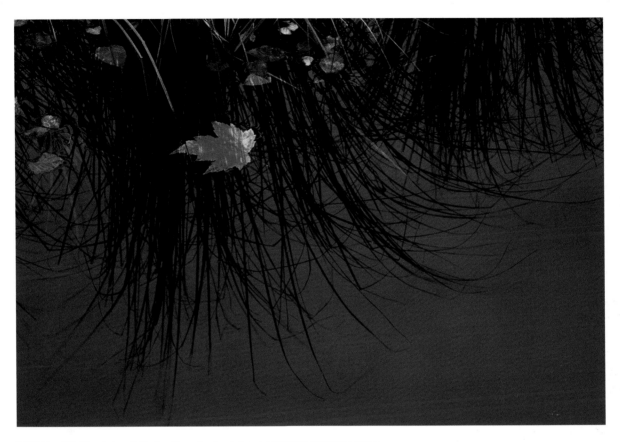

1.27 Day 23, Maple Leaf. © Jim Brandenburg (www.jimbrandenburg.com)

MEETINGS

When I first encountered Paul Shambroom's photographs, it was quite by accident. It was the autumn of 2002, and I was making the rounds of some of the galleries near where I live in New York City. As a longtime newspaper photographer, I would often be sent out to cover a meeting. These were perhaps the least inspiring group of photo assignments I can think of.

Then I encountered Paul Shambroom's "Meetings" at the Julie Saul Gallery.

I have to admit, I was blown away. Shambroom had transformed my most boring photographic

nightmare into an amazing body of work that upended the idea that meetings are not visual. Like most important projects, a volume of work has gone into making these extraordinary photographs possible. Between 1999 and 2003, Shambroom attended hundreds of small-town meetings across the United States, where he photographed in a very big way, using a 6x12 roll back on a 4x5 field camera to capture epic portraits of democracy in action (**1.28**).

Each one was captured in existing ambient light and scanned, and then extensive digital correction was applied. The image was then blown up larger

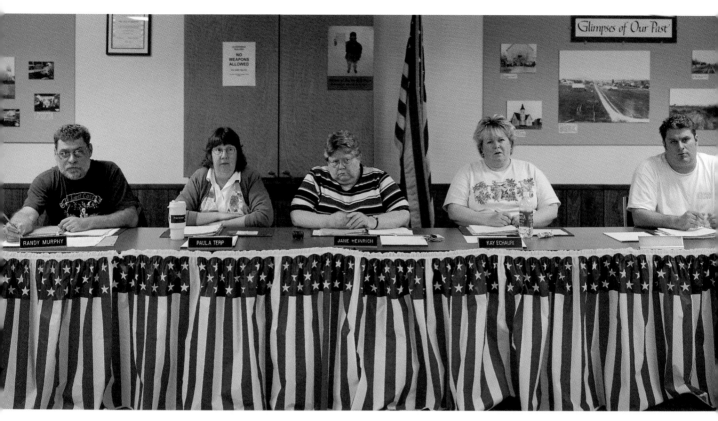

1.28 "Yamhill, Oregon (population 790) City Council, April 9, 2003." © Paul Shambroom

than life onto canvas, where these painterly pictures made a huge impact on me. These meeting photographs were inspired and inspiring. When I came away from the exhibition I reconfirmed that, in the photographic arts, anything is possible.

YOUR STORY

If you're having trouble deciding on a personal project, think about taking on a smaller one for a start. A short-term photo essay can be a visual profile of an idea, a person, an event, or a business; a "day in the life" of an artisan, musician, community leader, or heroine; or a portrait series of a certain group of people. It can be still lives, landscapes, or other groups of images with a common thread that ties them together.

You can come in with a clear point of view or idea for documenting the subject by focusing on one aspect or one person, which usually leads to clearer coverage of that issue. Keep it simple; less is more. It can be presented chronologically or thematically, but the images need to work together. Look for subjects and environments that you're going to enjoy and have fun with.

Access really is everything, and it helps maximize your shooting possibilities and strengthen the work. It's best to choose a subject that allows unfettered access. Maybe it's a 24-hour Laundromat or diner, a street corner, a nature conservatory, a bus or train line.

If there's an event that's coming up, you can target that for your photo essay. When it was election night in the United States, I went to Harlem to do

a short essay on the faces in the crowd on that historic night (pages 124–125).

Stories that have a resolution that you can document—a pregnancy, sports stories, an election night, events that begin and end—let you concentrate your time and energy. There are no rules. I've seen great essays where images were all taken from the same window, with a photographer riding on one bus line all day. It's really up to you.

Also, consider taking on small projects alongside more comprehensive ones.

When I start a project, I often find that many of the images—though they're all quite different—end up communicating the same or a similar idea and are not moving the body of work forward. This is not to say that every image needs to be uniquely different from the other; in fact, some projects use repetition as a way to build momentum. Finding ways to illustrate or document your idea in a storytelling way is one of many challenges you'll face that will help you break through to the next level of your work.

THE WRITTEN COMPONENT

"If I could tell the story in words, I wouldn't need to lug around a camera."
—Lewis Wickes Hine

I'm of two minds when it comes to artist statements. There's a reason why people say a picture is worth a thousand words; it's because the good ones are. Strong images communicate so much, in an instant. If photographers were better able to communicate with words, I'm sure many of us might be writers instead.

But articulating a project in an organized and coherent way can help clarify and focus your vision for a consistent point of view in your work, as well as help form a framework for future shooting. A written project description is also a prerequisite to apply for grants, enter some contests, or look for support for your project.

The images will speak the loudest, but knowing how to describe your project will also help when editing. Nailing down a paragraph or headline can help you keep a tight thread through the story or theme, making sure all photos reflect that headline and let you stay on point.

Having a mission or artist statement for your work helps you keep your point of view consistent, something well worth striving for. Many of the best documentary photographers practicing today belong to the cooperative Magnum, whose original members—Robert Capa, Henri Cartier-Bresson, George Rodger, and David "Chim" Seymour—started the cooperative to chronicle the world: important issues, events, and people. Many of today's Magnum shooters have boiled down their vision into a few words. Here are a few:

"If there's one theme that connects all my work, I think it's that of land-lessness; how land makes people into who they are and what happens to them when they lose it and thus lose their identities."
—Larry Towell

"The maximum from me and the maximum from others."
—Josef Koudelka

"I'm more interested in a photography that is 'unfinished'—a photography that is suggestive and can trigger a conversation or dialogue. There are pictures that are closed, finished, to which there is no way in."
—Paolo Pellegrin

"I am forever chasing light. Light turns the ordinary into the magical."
—Trent Park

"For me, photography has become a way of attempting to make sense of the very strange world that I see around me. I don't ever expect to achieve that understanding, but the fact that I am trying comforts me."
—Mikhael Subotzky

If you haven't come up with your own artist statement yet, take some time and find a quiet place for a brainstorming session with yourself. Jot down the common adjectives that describe what you like to shoot with your camera and why. These words will give you the skeleton of an artist statement, which will evolve over time.

A FRAMEWORK

Like Chapnick's wise and salient words, we can learn from the classic photo essayists from the past. Many of the early photo stories in *Life* took a formulary approach. In the early days of the magazine, stories were often told chronologically, scripted, and storyboarded. Photographers were given the formula and a laundry list of shots to take.

The blueprint for a typical *Life* magazine story required eight types of pictures to ensure photographers came back with a variety of imagery—from an overall shot, to a medium view, close-up, portrait, a sequence, an action shot, a closer or end shot, and of course, the all-important signature image. Even today, if your photo story contained strong images from these categories, chances are it would be successful.

By applying their simple framework to a story or essay, you can give your theme some necessary direction and structure. Moving through the next few steps in *The Passionate Photographer*, you'll learn to work your scenes and give yourself options from all the elements that follow, a shortened structure of the classic *Life* magazine photo essays.

- **Signature image:** This is often the strongest image, with visual impact that both tells a story itself and invites the viewer into the story for further investigation. It's the book cover, the storefront window display, the icon, and web page attention getter. We strive to make every image a signature image, but in the end, it rises to the top from the following visual possible components that make up your essay.

- **Portrait:** A picture of a key player in the story you are photographing. Make sure to use background and/or foreground elements to help bolster the narrative. Environmental portraits, where the subject is caught in a real moment, can be very compelling, but so too can a series of posed portraits.

- **The overall or wide view:** This photograph gives us a sense of the place or a part of the place where your story happens. Note that sometimes a sense of place can be communicated in a series of detail images.

- **The detail:** Look for a photograph that examines details rather than the larger picture. This photograph can often be abstract and particularly eye-catching, a nuance. This detail also can reveal to the viewer something that would otherwise be missed in a wider shot. A series of small details can be used as a mosaic in one image.

- **The action:** Show us what is going on in your story. Look for dramatic and poignant images capturing people interacting with each other, moments and gestures that elevate and amplify the visual communication in some way.

The above is meant as a guide or starting point should you need it. There are always new, innovative, and creative ways to present your story.

Short-term projects become a powerful starting point for more comprehensive work, allowing you to delve deeper, showing new and different sides of an issue or theme. The more you shoot, the better you will get, but the catch-22 is this: if you are not inspired, you probably won't shoot much. You need to find the inspiration, then let your passion for the project motivate you to work and improve.

Step one

ACTION: Passion: A Brainstorming Exercise for Story/Project Ideas

"Pick a theme and work it to exhaustion...the subject must be something you truly love or truly hate."
—Dorothea Lange

1. What can't you help but photograph? What are some of the common threads in the images you've made up until now? Think about these questions and mark down any ideas that come to mind.

2. Make a list of some of the best photo experiences you've had. Then look for links between them that might lead you to similar great photographic experiences to pursue in the future.

3. Do you have special access to an interesting place, person, or story through a personal connection or through work, relatives, or friends? Are there story ideas there?

4. Make a list of places near where you live that you like to spend time. Do any of these places have opportunities for photo projects? How do they change when viewed at different times of the day? Do you regularly pass by places that make you intrigued to see what's there?

5. Make a list of photographers whose work you admire and see if any of the stories they pursue might be a direction you want to take. Look for small stories in newspapers and magazines to develop into projects.

6. Come up with some photo shoots you think would be fun. It could be anything, anywhere; money is no object—let yourself go. Don't think too much, just mark stuff down. Come up with a list of subject matter that you think will inspire you. It could be anything, anywhere, no limits.

7. Is there a group of people or a person you admire who might make a good day-in-the-life or portrait series? Are there issues you are passionate about where you can aim your camera to communicate and promote awareness of that issue?

8. Make a list of dream jobs for the future. They don't even have to be photographic. Talk-show host, chocolate factory taster, anything. Any story ideas there?

9. Go to a place that has newspapers and magazines from around the world and look for ideas to pursue from stories you find. If it's not the specific story, maybe you can find a way to localize and work on a similar story.

10. Go to a big bookstore with a great photo book section and get lost in those shelves for a couple of hours and make notes in your You Book or iPad (see Step 9).

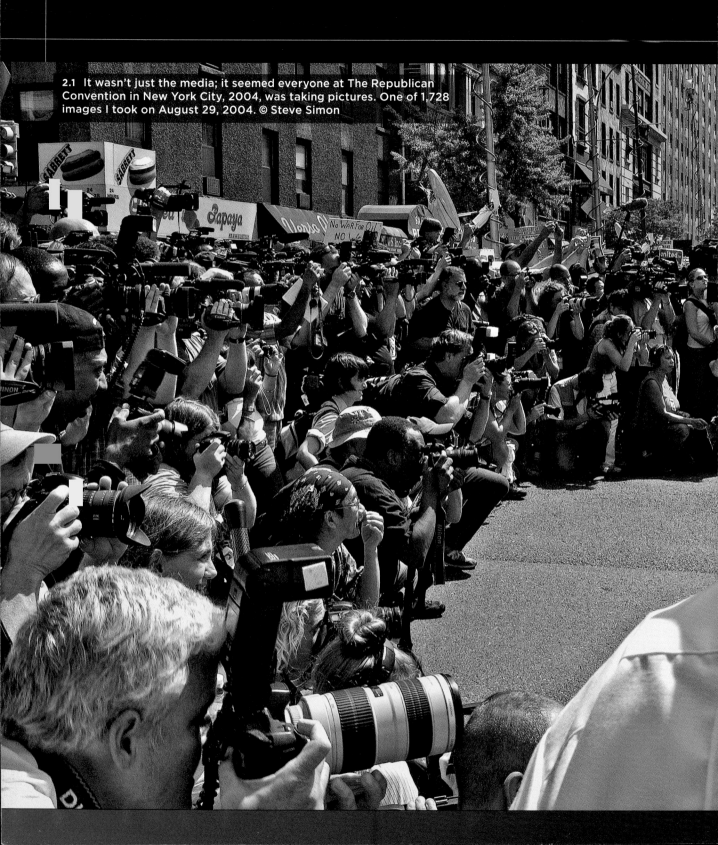

2.1 It wasn't just the media; it seemed everyone at The Republican Convention in New York City, 2004, was taking pictures. One of 1,728 images I took on August 29, 2004. © Steve Simon

VOLUME, VOLUME, VOLUME: 10,000 HOURS: PRACTICE AND PERSISTENCE

"Your first 10,000 photographs are your worst."
—Henri Cartier-Bresson

It's not a great mystery: perhaps the best way to learn something is to do it. The more you shoot, the better you get, period. The more you shoot, the faster you react, the more experience will teach you what works and what doesn't. The more you shoot, the more your eye is on the viewfinder and you find yourself in the right place at the right moment in the right light without having to consciously think about it. But to do this step properly means you have to put in the time and practice. Repetition becomes your teacher. Experience stays with you and waits, letting you access when needed. When you reach that inevitable wall of doubt, you have faith because you've crossed through it before and you will again. Confidence is accumulated. When you go through a volume of work, you get to the other side of great images (2.1).

2.3 Yousuf Karsh spent a lifetime perfecting his portrait lighting techniques. Here are Yousuf and me, Graduation Day, Dawson Institute of Photography, Montreal, 1979, at the beginning of the many hundreds of thousands of frames I have taken since this picture was captured by my dad.

passionate photographers shoot because we have to, and it rarely feels like work.

The fact is, when we look at masters in the arts, often these are people who have the luxury of working and thinking about their craft 24/7. So when inspiration comes, it's often the result of a percolation of sorts, triggered by whatever it is that fires those particular neurons in the brain.

If you're like most passionate amateurs, you need to get to work making pictures and good photographic things will happen. Chuck Close talks about the process.

"The advice I like to give to young artists, or really anybody, is not to wait around for inspiration. Inspiration is for amateurs; the rest of us just show up and get to work. If you wait around for the clouds to part and a bolt of lightning to strike you in the brain, you are not going to make an awful lot of work. All the best ideas come out of the process; they come out of the work itself.

Things occur to you. If you're sitting around trying to dream up a great art idea, you can sit there a long time before anything happens."
—Chuck Close, from *Wisdom: The Greatest Gift One Generation Can Give to Another* by Andrew Zuckerman

One of my mentors, documentarian Eugene Richards, told me as a young photographer, "It takes ten years to become a good photographer," and after some time had passed, I agreed with him. Not only do you need to practice and learn from your mistakes but you also need to accumulate life experience, which can be incorporated into your vision, communicated through what you point your camera at and how you choose to capture it.

HURRY UP AND WAIT

So what exactly is a volume of work and how do you define it? For a large-format landscape photographer, the idea of volume may be very different from that of a professional sports shooter. What I'm talking about here is less about the number of frames shot and more about spending time in the field shooting.

Malcolm Gladwell's book *Outliers* cites the 10,000-Hour Rule based on a study by Anders Ericsson, which basically says if you do anything for 10,000 hours you will become an expert at that thing. He gives examples of mastery that come with putting in the time, like The Beatles, who played live an estimated 1,200 times from 1960 to their arrival in New York in February 1964. They arrived as expert musicians/entertainers with well beyond 10,000 hours under their belt.

You've no doubt heard it countless times: the best way to improve your work or get better at anything is to practice (**2.3**). I have always maintained that, in photography, the more you shoot, the better you will get. Even if you didn't try to improve, you will. Taking it further still, by having your eye to the viewfinder and finger on the shutter release, you increase your odds of shooting more and getting

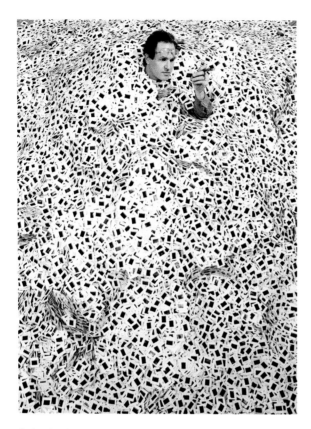

2.4 Whether it's 10,000 hours or 10,000 frames, there is no doubt Jay Maisel has put in his time to master the medium. Photographer Chris Callis photographed Jay swimming in his rejected slides for the cover of *American Photographer* magazine in 1982. © Chris Callis

better images (**2.4**). The more you shoot, the luckier you get. As Jimmy Dean said, "You gotta try your luck at least once a day, because you could be going around lucky all day and not even know it."

CLOSE THE GAP

From my own experience as a photography teacher, I have seen and heard this same scenario often—where photographers describe their excitement for the photo shoot and then the disappointing reality of what they got. The disparity between the image

you thought you got and the one you see on your computer screen is a gap that closes when you go through this volume in a targeted way, working every scene.

I'm going to explain in detail strategies for going through this volume in the next step. But first I'm going to describe a nonvisual analogy that illustrates my point for shooting lots.

Ira Glass has had a long and distinguished career in public radio. The current host of *This American Life*, which reaches 1.7 million listeners each week, has been honing his skill for more than 30 years. In a series of YouTube videos, he articulated just how long it took him to make the work that lived up to his ambitions for it. He points to a piece he made after eight years working full-time in radio that he describes as "horrible," and says it is perfectly normal to make work that is not as good as you know it can be. It takes a while to get better; you just have to fight your way through it.

"You've got to get rid of a lot of crap before you're going to get anything that's special. You don't want to be making mediocre stuff. There's a gap for the first couple years that you're making stuff. What you're making isn't so good. But your taste, the thing that got you into the game, is good enough that you can tell what you're making is kind of a disappointment to you. A lot of people at that point, they quit. The thing I would say to you with all my heart is that most everybody I know who does interesting, creative work, went through a phase of years where they had really good taste, they could tell what they were making wasn't as good as they wanted it to be. They knew it fell short. Everybody goes through that. If you're going through it right now, or if you're just starting off and you're entering into that phase, you've got to know it's totally normal and the most important thing you could do is do a lot of work. Do a huge volume of work because it's only by actually going through a volume of work that you're actually going to catch up and close that gap."
—Ira Glass

There are many examples of inspiration that speak to the theory of getting through a volume of work to produce something worthwhile and satisfying. The whole idea of finding a theme was outlined in Step 1, and photographer Robert Frank, arguably one of the most influential photographers or our time, devoted two years of road trips in 1955 and 1956 across the United States to come up with the content that became his seminal volume, *The Americans*. He took more than 27,000 frames with a Leica rangefinder camera, and eventually distilled that into the 83 photographs that make up the book.

JUST SHOOT IT

Perhaps the poster boy for shooting volumes is street photographer Garry Winogrand (**2.5**). When he died of cancer at the age of just 56 in 1984, he left behind 2,500 undeveloped rolls of 36-exposure 35mm film (mostly Tri-X), 6,500 rolls of developed but not contact-printed film, and another 3,000 apparently untouched, unedited contact sheets. That's a staggering number of images. Colleagues, students, and friends talked about him as an obsessive picture-taking machine.

2.5 Garry Winogrand. © Mason Resnick

As with sports photography where there are 8,000 moments in a single second, volume is essential in the haphazard, constantly moving, and out-of-control world of the street photographer. To photograph chaos in a coherent way, Winogrand melded intuition and chance with experience to capture serendipity in some order. His images juxtapose disparate visual elements in an organized, connected way that could not be orchestrated. His pictures often communicate complex scenes in a simple, easy-to-read way. To do this kind of work, shooting a volume is necessary because most times you click the shutter, it doesn't quite work out.

"The nature of the photographic process—it is about failure. Most everything I do doesn't quite make it. The failures can be intelligent; nothing ventured, nothing gained. Hopefully you're risking failing every time you make a frame. I learned a long time ago to trust my instincts. If I'm at the viewfinder and I know that picture, why take it? I'll do something to change it, which is often the reason why I may tilt the camera or fool around in various ways. You don't learn anything from repeating what you know, in effect, so I keep trying to make [the process] uncertain."

—Garry Winogrand, from an interview with Bill Moyers

Photographer Mason Resnick was a young student of Winogrand's in 1976. He described the photographer's high-volume techniques: "He walked slowly or stood in the middle of pedestrian traffic as people went by. He shot prolifically. I watched him walk a short block and shoot an entire roll without breaking stride. He was constantly looking around, and often would see a situation on the other side of a busy intersection. Ignoring traffic, he would run across the street to get the picture. Incredibly, people didn't react when he photographed them."

With 10,000 hours comes technical mastery. Winogrand photographed most every day and didn't have to think about settings for his meter-less Leica;

2.6 My camera was on a tripod when I took this exposure of a candlelight procession at Lac Ste. Anne, where the water is said to have healing properties. The surprise was the recording of someone outside the line on the right, which looked like rosary beads and a cross. I showed this to the Father who posted it on the bulletin board there and later found out that someone claimed to have been healed by the photograph. The power of photography. © Steve Simon

he knew them instinctively and was constantly tweaking the exposure as the light changed. He stood in front of his subjects, sometimes blocking their way, and shot, nodding and communicating with people all the while, and few noticed him. No one seemed annoyed.

Resnick continued: "I tried to mimic Winogrand's shooting technique. I went up to people, took their pictures, smiled, nodded, just like the master. Nobody complained; a few smiled back! I tried shooting without looking through the viewfinder, but when Winogrand saw this, he sternly told me never to shoot without looking. 'You'll lose control over your framing,' he warned. I couldn't believe he had time to look in his viewfinder, and watched him closely. Indeed, Winogrand always looked in the viewfinder at the moment he shot. It was only for a split second, but I could see him adjust his camera's position slightly and focus before he pressed the shutter release. He was precise, fast, in control."

STYLE AND TECHNIQUE

Regardless of the subject matter you're passionate about, another common thread linking great master photographers together is their ability to communicate their own unique personal vision to viewers of their photographs (**2.6**).

In my role as a photography teacher, I'm often treated to visual surprises when students apply unique personal visions to the same subject matter. It often amazes me just how different they see and photograph things from each other and from myself. The obsession with developing a style is something that need not be a source of concern, because style will often reveal itself in retrospect, after a volume of work is taken (**2.7**).

And don't confuse style with technique, even though the two are sometimes inexorably tied. Richard Avedon's technique was to photograph his subject with a large-format camera on a white background. He was not the first to do so, but Avedon knew what he wanted when his subject stepped in front of his camera, and he would never end the session before he got it. The technique may have been similar to what others had done before, but his style— reflected in the images he captured—was unique.

Everyone has a different timeline, and all your life's experience can be infused in your personal vision if you let it. But you must be patient and persevere. After getting through the volume, you will find yourself at a place where you're happier and more satisfied with the work you produce. It's a bit magical, so the trick is to learn what you can, seek out constructive criticism, and shoot, shoot, shoot— and you will find yourself in this good photographic place.

The mystery of and obsession for harnessing your personal photographic style is not so mysterious, as longtime wildlife and bird photographer Scott Bourne describes.

"What is a photographic style? For me, it's simply a consistent way of seeing that ties directly to who I am, what I like, and what I want to express about myself and my feelings. It is not simply shooting the same subject over and over. It's how you shoot that subject that defines your style. Your style should fit your personality. I have a big personality. Consequently, I tend to go for the big, bold photos with lots of pop and enthusiasm."
—Scott Bourne

2.7 Your personal style, your unique way of seeing things cannot be forced but will instead reveal itself after thousands of frames have been taken. From the book *Empty Sky: The Pilgrimage to Ground Zero.* © Steve Simon

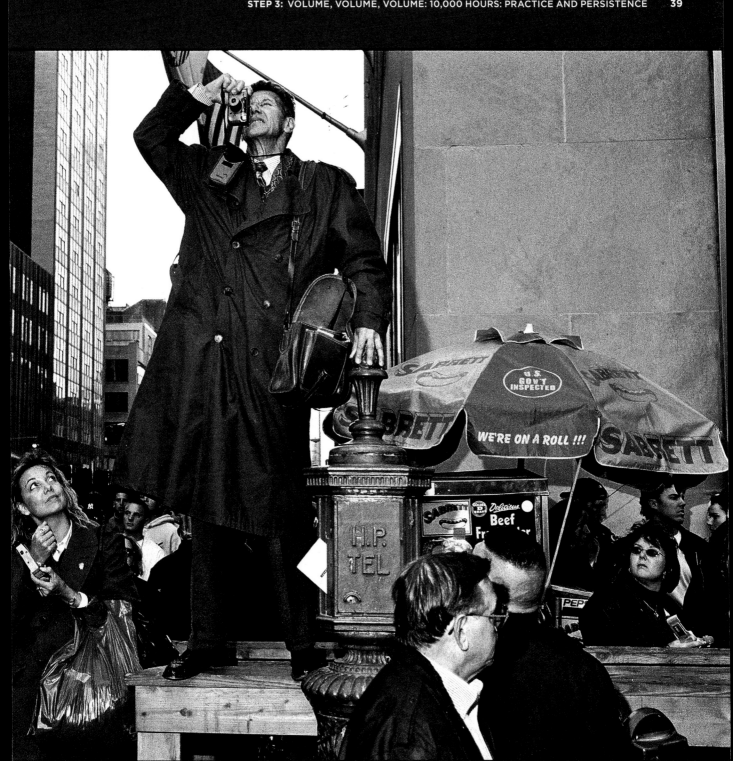

Personal style means defining your own way of shooting. It's a combination of what you focus your camera on and the techniques you use—from equipment to lens to subject distances. We all borrow from the photographers we admire, but after a volume of work, we leave their path and carve out a new one of our own. When you see a group of photographers all shooting from the same vantage point, shoot quick and then run the other way and find your own camera position.

In Step 1 you asked yourself what you must photograph, and you've hopefully found a project or a theme you can work on, which will go a long way to developing and showcasing a style all your own. Let others talk about your style; you just keep shooting.

Gregory Heisler is one of the most articulate photographers I have ever met, not to mention a master of portraits and lighting.

"I can have aspirations or ambitions or ideas or goals for my work, but in a sense, the only purpose those goals serve is to get me to take the pictures and only through the taking of the pictures will I find out who I am or what my pictures look like. In the end, oftentimes the pictures that I think I'm going to take aren't the pictures I take and the direction I'm headed isn't the direction I think I'm headed."
　—Gregory Heisler

MASTER YOUR GEAR AND CREATIVITY SOARS

For great photographers, technical excellence is a given. What photographers like Winogrand and other acknowledged masters have in common is technical mastery. They may not know everything there is to know about photography, but they know what they need to know to get the images they envision.

Getting through a volume of work will allow you to know your gear so well that your process becomes

second nature and your creativity soars, closing the gap between expectations and reality.

A nugget Gregory Heisler told me is one I often repeat. He was articulating the frustrations many photographers experience, particularly at the beginning of their obsession with photography. He said the left side of our brain, the logical side, is busy worrying about camera settings—white balance, f-stops, shutter speeds, histograms, focus points—while your right brain is demanding, "Shut up! I'm trying to take a picture!" (**2.8**).

Photography is all about making decisions, from where and when you trigger your shutter to what to include or exclude from the frame. Then there are the choices of which lens or zoom focal length to use, and all the exposure and technical controls your left brain is obsessing over.

2.8 The left-brain/right-brain dilemma. Left brain thinking is associated with logic, details, and planning. The right brain is more about images, emotions, and creativity. Does this left-brain/right-brain battle sound familiar?

2.9 Dealing with low light requires you be on your game technically to make the most of difficult low-light situations. Young men at a hotel bar in Mabote, Mozambique, near the South African border. © Steve Simon

It's no wonder I often see photographers struggling with the technical details before they can even begin to figure out all the other variables that make pictures great (**2.9**). Before your left brain can be freed from the chains of technical constraint, before technique fades to the unconscious and becomes intuitive as you explore your subjects with abandon in a dance of color, tones, and light—you have to pay your dues by shooting the volume and learning from experience.

Your ability to master the digital processes and photographic fundamentals is necessary, and it will happen as you work through the volume. It takes time for your technical savvy to catch up with your desire to capture the great images you know you are capable of, so don't despair, and never give up; better work is on the horizon, and I've got ways to simplify your technical process to speed things up.

Though this is not a technical book, I've included some important general technical concepts sprinkled throughout the ten steps. What follows are some of the ways I shoot that have helped me work faster and smarter. I know there are ideas here that can help you, too. I have been doing this a very long

2.10 The opening ceremonies were often dark and dim, which meant raising my ISO to 3200 and shooting wide open. This was shot in Aperture Priority with exposure compensation at –2 stops. © Steve Simon

2.11 The Gold Medal Ice Dancing Champions had enough light to allow me to shoot at ISO 2000 and still get a relatively fast shutter speed of 1/1250th of a second. With the white of the ice and the even arena lighting, I opted to take the camera off Aperture Priority and switch to manual for consistent exposures as I followed the skaters. © Steve Simon

time and over the years I've made a lot of technical mistakes. Getting through a volume of work means making mistakes, which can be the greatest teacher, as you'll find out in Step 8.

Mastering your technique and process is essential, but it's just the beginning. It's the starting line in becoming a great photographer.

"I took a lot of 'the operation's a success but the patient died' pictures.... I had a perfectly executed boring-ass picture that I had done. I even saw it happening like a train wreck and there was nothing I could do about it."
—Gregory Heisler

SIMPLIFY

For years, I was successfully avoiding the myriad of options available to me through my camera's menu system. I had my way of shooting and it worked fine. But when I started to tweak my camera by changing a few key settings, I learned just how fast and intuitive my camera could become and it helped free me creatively.

No recent assignment challenged my technical abilities more than the Winter Olympics and Paralympics in Vancouver. I'm not primarily a sports photographer, and shooting the Olympics was a test in stamina and problem solving, shooting in a wide variety of fast-moving situations where the light was often low and constantly changing. Because I had gone through a volume of work before taking this assignment, I was prepared (**2.10** and **2.11**).

As photographers, we are problem solvers. When we get to the scene of a photo, there are so many decisions to be made. The easier and more second nature your ability to make these decisions, the better your work gets—and it's the volume that will get you there. For me, the mantra of less is more holds true in so many areas of photography, but particularly when it comes to the technical things. I want to be able to react quickly so I don't miss important

moments. As a professional photographer, it's crucial.

By keeping things simple, I can devote less of my energy to the technical and more to the creative side. The simplicity rule starts with what I take with me. To stay nimble and quick to react, I don't want to be weighed down with too much stuff.

"The only thing that gets in the way of a really good photograph, is the camera."
—Norman Parkinson

But, as a rookie photographer, weighed down I was. I would pack too much equipment for each shooting session, wanting to be ready for anything—a good idea in theory, but not in practice. Carrying too much gear took a physical toll and actually hindered my image-making process. As I gained experience, I realized that I didn't have to take everything but instead make the most of what I did choose to take. The trick is to know what to expect from each assignment and make your best guess for what you might need.

The best camera is the one you have with you, and talented photographers can make great images from the most basic equipment (**2.12** and **2.13**). If you guess wrong and the picture you want is out of reach for the lens you have, then move up or move on, and get great images that are accessible to you.

Great images are great images. It doesn't matter if they were taken with an iPhone, a medium-format digital camera, a DSLR, or a pinhole camera. As Gregory Heisler laments, it's not about how or with what the picture was taken, it's about what it communicates to and evokes in the viewer. There's a whole rebirth of minimalist film cameras, as with the Lomography movement, which has a large following of photographers who prefer the unpredictable and raw look these inexpensive plastic film cameras provide.

I always have a camera with me, even if it's my iPhone, and I like to challenge myself and work

2.12 and 2.13 No two photographers will respond in the exact same way to a subject, and different viewers will often respond differently to the same photograph. Everyone brings their own biases to their viewing of an image—likes, dislikes, life experience. Some people may see the obvious, others understand the subtle details and symbolism included in the image. My friends Ben Long and Janine Lessing each brought their own perspective to the same scene here: Ben with a straightforward view of the forest with his Canon 5D (left); Janine with a picture taken with a homemade pinhole camera. Ben told me that he was disappointed because, despite having the fancy camera, he liked Janine's picture better. © Ben Long and Janine Lessing

within the constraints of the camera—yet I can get beautiful results and, surprisingly, can make big enlargements that look like they came from a much larger-resolution sensor (**2.14–2.17**). I often take advantage of a camera's shortcomings by exploiting them to capture mood and atmosphere.

There may come a point, however, where the equipment does matter, when technical limitations surface and the demands of the job exceed what you can do with the gear. You will know when the gear starts to matter to you. For example, if you are continually drawn to high-ISO, low-available-light situations, yet are unhappy with the noisy results you are getting with your camera, it might be time to consider a new camera body with better high-ISO capability. Or perhaps you like sports or wildlife and notice that your images are not close enough, yet you can't physically move in. Might be time to invest in a longer lens.

2.14–2.17 These photos were all taken with an iPhone 3GS and its 2.7 megapixel small sensor. My Nikon cameras have much bigger sensors and many more megapixels. It's not always about the camera but more about maximizing your camera's features for the best possible images. © Steve Simon

GEAR AND TECHNICAL PROFICIENCY

I'm a Nikon guy from way back, but the following concepts and controls are common to most camera makers. Just dig up your camera manual to confirm all the details.

First things first: just because your camera has a thousand different menu items and ways to automate exposure, it doesn't mean you have to use them all. Being the minimalist that I am, I want to have full control in the fastest and most convenient way—that is my philosophy when it comes to setting and using my camera controls. Before I get into specifics on my technical approach, here are a couple of quick points.

Even the simple task of holding your camera properly is crucial for image sharpness and should be reviewed. Poor shooting practices can cancel out the amazing quality of your expensive lens, so you need to be able to hold your camera comfortably and with stability so you don't introduce camera movement that detracts from image quality.

It might help to see yourself in action, so take a look at your shooting posture in the mirror or have someone videotape you shooting. I have to admit, I don't always follow my own advice here, but I do try to remind myself because I know it's important.

I want to keep my camera steady at all shutter speeds, but especially at slower ones. Standing straight, knees bent slightly, elbows in and touching my chest with the left hand cradling my camera from underneath—this is my basic shooting posture. Make sure you bring your camera to your eye rather than bringing your head forward. By not slouching you save yourself neck pain and increase your shooting stamina. When shooting verticals, rotate the camera and not your body. And always squeeeeeeze the shutter, rather than jab at it.

The other recommendation is to immediately check your diopter setting, making sure it's properly adjusted to ensure as crisp an image as your camera will allow. This can make a big difference on those occasions when you focus manually, though it won't affect autofocus. If the diopter is not adjusted for your eye, you might have a hard time finding focus.

Many cameras have built-in adjustable diopters. Simply hold the camera up to a bright light-colored wall, and turn the diopter dial until the frame lines in the viewfinder are as sharp as they can be to your eye, then lock it in place. You can even do this without a lens on your camera, aiming the viewfinder at a window or bright light.

HOW I WORK: APERTURE PRIORITY

Students are sometimes surprised to hear that I shoot in Aperture Priority mode. Back in my film days, I would use the camera manually, not willing to give up control to my camera's automatic exposure choices. As metering systems improved, I soon realized there was no practical advantage to staying in manual exposure mode; in fact, it was slowing me down and I was missing shots because of it.

It doesn't matter which exposure mode you choose. There is no hierarchy or holy grail of exposure mode to aspire to. They all use the camera's built-in metering system to lead you to the correct exposure. Shooting on manual doesn't offer any new creative possibilities different from Aperture Priority (or Shutter Priority or Program mode, for that matter). It's just another way to arrive at the correct exposure, and there's only one correct exposure for any one scene.

But knowing which correct exposure combination of shutter speed/aperture/ISO (of which there are many) will render your vision of the scene the way you want it, and tweaking that exposure combination to get you what you want, is all important.

Today's modern matrix/evaluative metering systems have been constantly improving and are way smarter than I am. The Nikon Matrix Metering, for example, divides the frame into grids and is able to assess and compare the color, brightness,

2.18 In the vast majority of my shooting, I'm in Aperture Priority mode and use the exposure compensation dial to correct when my meter is off. The Opening Ceremonies from the Vancouver Winter Olympic Games. © Steve Simon

and contrast in a scene with 30,000 actual sample images shot by engineers and uploaded to its memory chip. It knows what I'm focusing on from my focus point and will, in a fraction of a second, determine the best exposure—even in many difficult backlit, dark, or light-tone situations. I don't even try to compete with that.

In the end, my camera in Aperture Priority with Matrix Metering gives me perfect exposures in 85 percent of my shooting situations, and I know how to correct for the other 15 percent (**2.18**).

That said, I don't use automatic modes blindly. In every shooting situation I figure out my exposure strategy and determine if I'm going to need to

deviate from the camera's recommended meter reading. I have learned from experience when to override the meter with the exposure compensation control, to lighten or darken the image, or occasionally move to manual exposure mode. Because I've done this so often, it has become second nature, and I sometimes make changes before confirming with my camera's meter. Experience helps you work quickly and accurately.

"Sometimes we work so fast that we don't really understand what's going on in front of the camera. We just kind of sense that 'Oh my God, it's significant!' and photograph impulsively while trying to get the exposure right. Exposure occupies my mind while intuition frames the images."
—Minor White

Camera meters are programmed to see the world as a middle gray, which is accurate for most general shooting. But sometimes that means they're inaccurate. For scenes with large areas of light tones—say, a lot of sky or sand or snow—the camera meter sees these light tones as gray, and ends up underexposing. The opposite is true with large areas of dark tones. The camera will overexpose to render those dark tones a middle gray.

I tweak my exposure using the exposure compensation (EC) dial, which I affectionately call the make-your-picture-lighter-or-darker dial. I can lighten the exposure by moving the EC into the plus (+) range, usually from one-third to two full stops, depending on the scene; or I can darken the exposure to the same degree in the minus (–) range.

Exposure is so important—the closer you get to the "best" exposure for a particular scene, the more flexibility you will have in post-processing. So maintaining a best practices philosophy with in-camera exposure techniques will pay dividends later in post, and ultimately on your wall or website.

Because my image review screen (as resolute and beautiful as it is) can fool me into thinking I've got a perfect exposure depending on the light I view it in, I instead trust the histogram to give me accurate exposure information, while using the screen image to check composition and focus. (You'll learn more about histograms later in this chapter.)

WHY I CHOOSE APERTURE PRIORITY

It's a bit of misnomer to think that Aperture Priority is just about the aperture. In this mode—as in all automatic modes—when you change one of the settings, the camera automatically changes another to give you what it thinks is the perfect exposure.

So you can choose your aperture to control depth of field and the camera chooses the correct shutter speed for that lens opening. But even in Aperture Priority, you can select your shutter speed by simply turning the aperture wheel until the shutter speed you need is chosen (**2.19** and **2.20**).

It's about having an exposure strategy, which is crucial and one of the first things I think about when confronting a new shooting situation. Do I need depth of field or fast shutter speeds? If it's depth of field I need, what shutter speed has the camera selected? Not fast enough? Maybe I need to use my tripod. No tripod? Then I need to raise my ISO to get a fast enough shutter speed for sharp results. I can strategize and come up with a solution to most photographic situations while staying in Aperture Priority mode.

This is how I work. I find it faster and more intuitive to work in just one mode. I can have full control of both aperture or shutter speed, depending on what is important to the shot in front of me. In Shutter Priority, a similar relationship exists: you can choose your lens opening by simply changing the shutter speed and watching in the viewfinder for the aperture you want to work with. But I often work in low light, so I prefer Aperture Priority, where I can quickly wheel the aperture setting to wide open, check the camera's choice of shutter speed, and either shoot or raise the ISO if the light is too dim for a reasonably fast shutter speed to freeze the action.

2.19 and 2.20 We have so many technical choices to make; with experience these choices become almost second nature and instantaneous. In Aperture Priority, I choose my f-stop for selective focus at wide apertures or a lot of depth of field with small apertures. But I can also shift my thinking and adjust the aperture until I see a shutter speed I want—like a fast shutter speed (top) or a slow one (bottom). Both were shot in Aperture Priority.
© Steve Simon

ISO AND AUTO ISO

Speaking of ISO, it's the other main variable in the exposure triangle. A huge digital advantage over film is the ability to change your ISO, amplifying the sensor's light sensitivity from shot to shot.

Much like you turn up the volume on your stereo to amplify sound, you can turn up the sensitivity of the sensor in low light situations. But with amplification comes issues of "noise," which can compromise quality. It used to be that you wouldn't want to go much above 400 ISO on most digital cameras for fear of unflattering color/noise issues. But many of today's cameras let you ramp up the ISO to 1600, 3200, and even higher with stunning results (**2.21** and **2.22**). These advances have ushered in a new era in photography that allows us more freedom and control to be able to capture anything we see (and even things we can't see), from bright light to next-to-no-light.

It is my best practices philosophy to shoot at the lowest ISO I can get away with, but more and more I'm realizing that shooting at higher ISOs gives me flexibility without compromising quality. Even with flash I sometimes shoot at ISO 800 in low light when I want to balance the low ambient light with the light from the flash, all while maintaining fast enough shutter speeds to keep subjects sharp.

2.21 This picture was taken in extremely low light at ISO 12,800 with a Nikon D3s. © Steve Simon

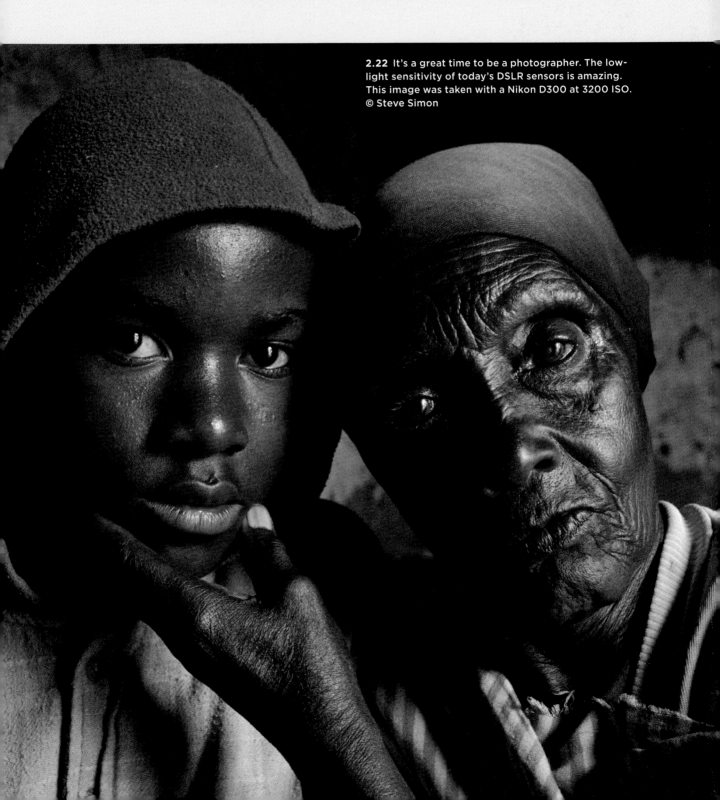

2.22 It's a great time to be a photographer. The low-light sensitivity of today's DSLR sensors is amazing. This image was taken with a Nikon D300 at 3200 ISO. © Steve Simon

In a perfect world, I take time to assess the scene and determine what angle and lens to use, which shutter speed/aperture combination would work best, and then select the lowest ISO I can confidently get away with for maximum quality. In the real world, though, I don't always have the time. With experience, many of my decisions are now made quickly and almost unconsciously. But even experienced professionals often can't match the decision-making speed of computerized camera bodies.

Case in point: Have you ever picked up your camera on a bright sunny day and started shooting only to realize those first few frames were shot at ISO 3200 set from the concert shoot the night before? Many of us have done this, yet there's a common feature available on most cameras that can think like a photographer and prevent this mistake.

It's called Auto ISO, an option that will boost your sensor's sensitivity in low light so you can maintain a fast enough shutter speed for sharp images. You usually have some say regarding what the parameters are, and this feature can end up saving your shot when light levels drop quickly and unexpectedly in fluid situations. I use Auto ISO a lot in unpredictable, fast-moving circumstances where light is constantly changing and often dim, as when I covered the Winter Olympics in Vancouver.

Because the light was fluctuating and I needed to maintain a fast shutter speed, I would set my Auto ISO minimum shutter speed at 1/500 of a second, and the camera would automatically ramp up the ISO to give me that minimum shutter speed for accurate exposure, as the light changed. With Auto ISO you can set a maximum ISO so you can maintain control over noise levels.

Wedding photographers choose it to maintain whatever minimum shutter speed they are comfortable with—say, 1/250 of a second inside a church under ambient light. When the photographer runs outside to catch the couple bursting through the church doors into bright sunlight, the ISO drops

2.23 A slow shutter speed of 1/20 of a second blurred this skier. © Steve Simon

automatically to the lowest setting (such as 200) and the chosen minimum fast shutter speed of 1/250 (likely faster) is maintained.

When you have the time to make all the exposure decisions, then you can take the time to do so, as with landscape or portrait work. But when you don't, Auto ISO is one more way to give your left brain a break and free you up to concentrate on creating—and less on the technical aspects.

SHUTTER SPEED: THE DEAL BREAKER

It has been my experience that the number one photographic spoiler—the leading cause of photographic unhappiness—is a blurry photo. Not to say that great photos need to be sharp; they don't. But if blurriness isn't helping an image by creating the illusion of movement or a soft dreamy atmosphere, it likely is hurting it.

When photographers complain about a lack of sharpness in their work, they often don't realize that it's likely not the lens or the camera, but their own doing. The three main causes of soft images—subject movement, camera movement, missed focus, or some combination of the three—can all be corrected.

2.24 A fast shutter speed of 1/320th of a second froze the balloons falling on John McCain and Sarah Palin. © Steve Simon

The best way to freeze fast moving subjects is with fast shutter speeds. The faster the subject is moving, the faster the shutter speed needed to stop it. Determining which shutter speed is considered fast is subjective. But I would say 1/250 of a second is fast enough for most general shooting, but if you want to make sure you stop motion, 1/1000 of a second and higher will almost always do the job (**2.23** and **2.24**).

Camera movement or camera shake is amplified by a poor hand-holding technique and/or longer lenses, which magnify movement. As a general guide, try this: multiply the focal length of the lens you use by two, and that should be a sufficiently fast shutter speed to prevent camera shake from causing blur. (For example, a 200mm lens would mean 1/400 of a second for a shutter speed.)

As you saw earlier, one of the best ways to prevent slower shutter speeds from becoming a photographic spoiler for you is to consider setting a fast minimum shutter speed when using Auto ISO.

With lens stabilization on modern lenses (and some cameras), the old minimum shutter speed numbers don't always apply anymore when it comes to camera shake. Vibration reduction (VR)/image stabilization (IS) technology is revolutionizing the "hand-holdability" of lenses that have it, rendering sharp results at very slow shutter speeds that were previously impossible to use without camera movement blurring the image.

This technology has been continually updated, improved, and incorporated into new lens designs. The latest incarnations claim you can shoot sharp shots up to four shutter speeds slower than would be possible without it. That means that, if a shutter speed of 1/125 of a second is fast enough to eliminate blur from camera movement when using a lens without this technology, you can now shoot at 1/8 of a second while hand-holding your camera (provided the subject is stationary) (**2.25** and **2.26**). Amazing. But remember, this technology will not work to stabilize subject movement; for that, there is no substitute to fast shutter speeds.

But like most tools and techniques, you need to try it yourself to figure out how it works for the type of photography you do. Remember to turn this feature off when your camera is on a tripod, because the mechanism can actually introduce blur into a photo when the camera is anchored down. I also shut it off at fast shutter speeds of 1/500 of a second or higher, but I have to remember to turn it back on.

It's nice to have this feature as an option, and it goes a long way toward eliminating the need for a tripod, yet many experienced photographers and photo educators will tell you that you don't want to depend on it because you can't be sure of the outcome. Taking chances by just triggering the shutter is never a bad idea, though, and VR/IS encourages this risk-taking.

And even though most digital sensors give you amazing low-noise/high-ISO performance, it's always wise to keep the ISO down for maximum quality, and VR helps here too. Vibration reduction is a tool that lets you lower your ISO and maximize quality, as well as stabilize the viewfinder view, which makes it easier to track moving subjects, lock on focus point(s), and compose your picture.

That said, the most dependable way to eliminate camera blur is to use fast shutter speeds or anchor down your camera on a solid tripod. Even at relatively fast shutter speeds, when you critically compare two images—one taken with a tripod and the other hand-held—you might see a difference.

But tripods can also slow you down, which can be a blessing but is often a curse, depending on how and what you choose to shoot. Slowing down is just what you may need, letting you think and fine-tune your composition. It also lets you maximize quality by shooting at lower ISOs and experimenting with different f-stops without limits, since camera

2.25 and 2.26 Both of these shots were taken at 1/8 of a second with the wide-open aperture of the Nikon 70–200mm f/2.8 VRII Lens. The shot on the right had the stabilization feature (VR, which stands for "Vibration Reduction") turned on. It really works. © Steve Simon

shake won't be an issue at any shutter speed, even extremely long exposures (though anything moving in the frame will blur).

In my experience dealing with thousands of students over the years, too often I see tripods limit a photographer's visual exploration and volume. Many times they plunk down that tripod and stay put. For this reason I don't always advocate using one, though I encourage getting a tripod with a quick-release mechanism for fast attachment and removal. Personally, I much prefer the freedom and speed of hand-holding in the pursuit interesting and surprising compositions versus technically perfect, boring pictures.

I use a tripod when necessary, and "necessary" is in the eye of the beholder. When I do choose to use one, I always survey the scene by physically looking through the viewfinder, hand-held, before choosing my tripod location. Then I tweak my camera-on-tripod position further, shooting as I make these small changes.

THE ARGUMENT FOR JPEG VS. RAW

JPEG files are smaller, which allow more images per card and they take up less hard drive space for faster downloading, emailing, posting on the Web, printing, and editing. With JPEGs you can take full advantage of camera manufacturers' proprietary controls, like Nikon's Picture Controls and Canon's Picture Styles, to create out-of-the-camera images the way you like them (provided you nail your exposures). But these changes are baked into the file, and you can't alter them anywhere near the extent that RAW files allow.

JPEGs are a universal format supported by most image processing software and photo labs. High-volume editorial, sports, news, and wedding shooters can achieve similar quality to RAW as long as they nail their exposures and white balance, saving lots of post-processing time, which is crucial for tight deadlines or with a large volume of images where time is money.

THE ARGUMENT FOR RAW VS. JPEG

I advocate that passionate photographers shoot in the RAW file format for many reasons. RAW files take up more space and they always require some post-processing, but the advantages are many. Much like a "digital negative," RAW images are not compressed or processed and they contain maximum data. RAW format images give you the most latitude, allowing you to recover seamlessly from exposure and white balance mistakes (**2.27** and **2.28**). They also support higher bit-depth and different color spaces, meaning you can preserve more of the color your camera is capable of capturing.

And because you're in control of all image processing, you can make what might be better decisions than those being applied and baked into JPEG files. You can process the same RAW data in different ways, letting you generate more options from the same image. Your options can grow as imaging tools improve, breathing new life into old RAW images. And you can always convert a RAW file to any other file format—including JPEG—but you can't convert JPEG to RAW.

If you find yourself taking on high-volume jobs in the future, you might consider shooting RAW + JPEG, where you have the safety net of RAW to fall back on if the JPEG is off, particular in tricky lighting conditions.

For serious shooters, the RAW advantage is convincing. Many RAW processing programs like Aperture and Lightroom take these big files and provide speedy processing and much flexibility, as well as the ability to convert RAW into JPEG or any other format while leaving the RAW file untouched as a permanent digital negative.

2.27 and 2.28 You can see that I made an exposure error in the unprocessed RAW file. But a RAW file gives you maximum latitude to correct errors you may have made in exposure and white balance, so nobody has to know. With JPEG files, you're much more limited when things go wrong. © Steve Simon

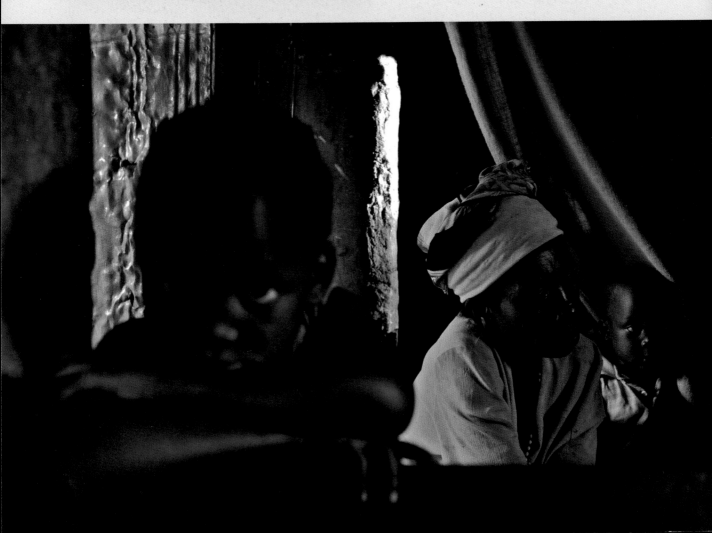

YOUR BEST FRIEND: THE HISTOGRAM

How do you know for sure when to override your camera's meter? I've mentioned that my experience has given me the ability to assess a situation quickly and know if my exposure strategy needs to include deviating from the Aperture Priority Matrix Metering reading that my camera suggests.

Interpreting the histogram is always the best exposure indicator—much better than the image on your camera's review screen, which can be used to evaluate composition and focus but is much less accurate for determining exposure.

A histogram is a bar graph that represents the actual pixels that make up your image: shadows and dark tones are on the left; mid-tones are near the center; and light tones and highlights are on the right. Looking at the data of the histogram to assess the quality of your exposure is always more accurate than eye-balling the review screen image, which, if you're shooting RAW, is actually a JPEG version of your image and has often been processed slightly to look good on the back of the camera. And the review screen image will look different in different light.

As long as the histogram data stays between the borders on the right and left, your exposure is fine, regardless of the shape of the "histogram mountain" (**2.29**). There is no ideal shape to a histogram; if there are more dark tones you'll see more of the mountain on the left, whereas more middle tones would mean more of the mountain will be in the middle.

What you do need to beware of are overexposed highlights, which means you need to reduce your exposure by setting exposure compensation (in Aperture Priority or any of the auto-exposure modes) into the negative (–) range. The opposite is true for underexposed shadows that clip to the left, in which case you should increase exposure compensation to the plus (+) range (**2.30** and **2.31**). By reviewing the image histogram, you can ensure that your exposures are in the right place and aren't clipping off the chart to the right or to the left.

The Perfect Histogram?

2.29 There is no such thing as a perfect histogram. But as long as all information is being captured by the sensor, you won't have a "mountain" of data clipping off the graph.

Shadow Clipping

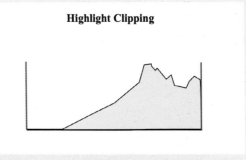

Highlight Clipping

2.30 and 2.31 As long as the data stays between the lines, you're capturing all the data from the scene. But when the histogram clips to the left, you're losing shadow detail; clipping to the right means you lose detail in the highlights.

Sometimes you'll have clipping in the highlights with a bright white sky, or specular highlights with no detail (like chrome on a car's bumper), and that's fine. The same is true for shadow areas in high-contrast scenes. Dark black shadows without detail are often a good thing for the image

(**2.32-2.41**). I sometimes see the overuse of tools like Photoshop, Aperture, and Lightroom to squeeze too much detail out of shadows and highlights, resulting in overprocessed photos that, to me, look unnatural.

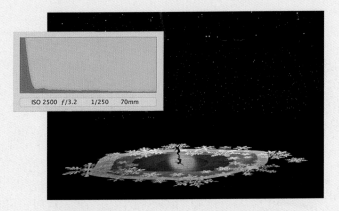

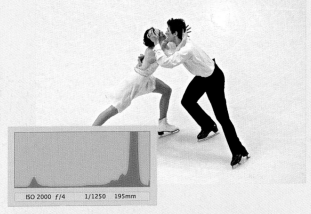

2.32 and 2.33 It's okay to have no detail in some dark areas. In theory, the histogram will not be ideal, but in practice it's perfect because the darkness is what I wanted in this shot.

2.34 and 2.35 In photos with a lot of light tones, you'll see the data represented in the histogram mostly on the right. The small area of clipping, where there is no detail, is the reflection on the ice above the skaters' heads.

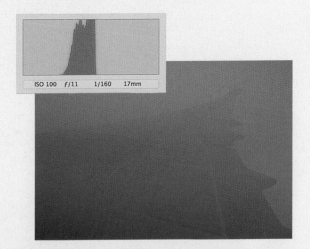

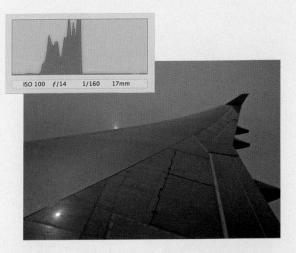

2.36–2.39 You can start to see how the histogram is affected as the image changes. The flat, wing-in-the-clouds image (2.36) has very few tones, all middle gray in the histogram (2.37). When the clouds clear (2.38), there's more detail and a wider range of tones reflected in the histogram (2.39).

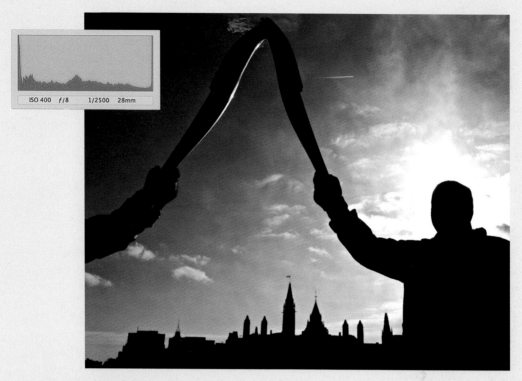

ISO 400 f/8 1/2500 28mm

2.40 and 2.41 This image is a good example of a lousy-looking histogram, but a photograph just the way I like it. There is both clipping in the highlights where the backlit sun is, as well as clipping in the shadows because it's a silhouette. In theory, this is a bad histogram. But learning to interpret a histogram for a given situation is important and will come with practice and volume. © Steve Simon

Photography is often a compromise, and short of shooting HDR—which lets you combine several different exposures for maximum detail in both shadows and highlights—there are many situations where you will have to choose between saving detail in the highlights or preserving shadow detail. These are often practical and artistic decisions that the smartest cameras won't be able to make for you.

When digital photography was first introduced, photographers migrating from film realized that treating digital like transparency film was the best way to ensure accurate exposures: underexpose slightly, and you'll retain all the detail captured by

the sensor and keep colors more saturated. But we know differently today.

Now we "expose to the right." The idea of exposing to the right of the histogram—or overexposing the image slightly—is predicated on the fact that when you shoot RAW, there is more information captured in the highlight areas of the image, considerably more. So if you capture the most information you can in your digital file, you'll have maximum flexibility when post-processing.

It's also true that there is more information in the highlights of your RAW file than even the JPEG histogram is telling you, and in post you can

get that highlight detail back. This is because the histogram you see is representing an 8-bit JPEG file, not the 12- or 14-bit RAW data that your sensor is capturing. The higher bit range means more information is being captured in your RAW file than with a JPEG. I mentioned earlier that when you look at the image on your review screen, you're looking at a JPEG version of the image, even if you're shooting RAW. The same is true for the histogram; it represents the JPEG preview, and not the RAW file itself, which likely contains more data that can be recovered in post.

When you underexpose and then correct the underexposure in post, you get more visible noise in shadow areas, which is something most of us want to avoid. Keep in mind that different sensors enable different degrees of recovery, so you need to get to know what works best with your camera. Most cameras allow you to customize what comes up on the preview screen. I set mine so that the histogram is visible. I glance to make sure the exposure is where I want it to be, adjust as necessary with the exposure compensation dial, and then continue working.

There's another way to ensure you're aware when you've lost detail in the highlights. Most cameras let you select a blinking highlight warning that alerts you to clipping in the highlight areas of your photo (**2.42**).

When you enable the highlights to show in a camera's display mode menu preference, overexposed areas usually show up as blinking light areas within a black mask, affectionately known as "blinkies." It's a warning that your highlights are being clipped, which will be confirmed when you check the histogram. So again, if you don't want

to lose highlight detail, you need to compensate by reducing the exposure or setting the exposure compensation in the minus range until the blinkies go away.

Remember that the blinking highlights represent a JPEG version of that image, even if you're shooting in RAW, so there may be detail that can be rescued and returned to the image even when the blinking highlights say otherwise. This is when having some experience with capturing highlight detail comes in. But it's a delicate balance; the blinking highlights combined with experience will ultimately teach you how far to go.

I often suggest that new photographers turn on blinkies as a warning, but eventually, when interpreting histograms becomes second nature, you might find the blinking lights are more of a distraction than a warning and shut them off like I do.

2.42 Turning on the highlight warning, known as the "blinkies," lets you know when you're overexposing the scene so you can tweak it to avoid highlight clipping. Eventually, you'll be regularly checking your histogram and might choose to turn it off like I do. I find it annoying!

EYE ON THE PRIZE

When you look into the viewfinder of most DSLRs today, you'll find it's all there—all the information you need to keep your eye on the viewfinder, because camera engineers know that the more your eye is on the viewfinder, the more you increase your chances of getting the shots you want.

This is why I turn off the image review screen, calling up the image when necessary or to check my exposure histogram. When the image pops up after every exposure I find it distracting, and I urge you to turn off the automatic image review screen. You can always review it, simply by tapping the image review button when necessary to check focus, composition, and the histogram for exposure.

Part of using the camera in a natural way means keeping your eye to the viewfinder window and tweaking both the composition and the exposure combination of shutter speed/aperture to render the scene the way you want it. Your shooting process will get faster and more natural as you move through the volume, but keeping your eye to the viewfinder will mean more and better work.

Lastly, at the end of every shoot I make it a habit to zero out or reset my camera to a good starting point for the next day. I keep a protective, clear, high-quality neutral or UV filter on my lenses but no lens caps, so I'm always ready to grab the camera out of the bag and shoot immediately (and avoid the embarrassment of aiming my camera at the subject with the lens cap on).

Before I put my camera away, I make sure it's on these settings: Aperture Priority, an all-purpose ISO of 400, or Auto ISO and the lens wide open, a great starting point. (I like that I get minimum depth of field, which adds emphasis on whatever I focus on and maximum high shutter speed.) Exposure compensation is reset to zero. I also check that any changes made from the previous shoot are where they should be, from turning off auto-bracketing to weird autofocus settings I may have experimented with. I want to be able to lift the camera out of the bag, point, shoot, and get a good, sharp, well-exposed image of whatever I aim my camera at. From there I tweak as necessary.

Step two

ACTION: Volume, Volume, Volume: Just Shoot It

Getting through the volume will make you a better photographer. Give yourself a deadline to start shooting right away. Do a picture-a-day blog. Schedule a two-hour block every week to go out and shoot. Work on your project. If you don't have a project, go shoot on the street.

Exercise: Choose one subject and challenge yourself to take 40 completely different compositions of the same subject or scene. Stay in one location and play with lens-to-subject distances and framing. It will stretch your visual muscles and make it easier to try new angles on future shoots. This exercise will get you shooting and moving around more, and it will help you to "work it," the next step in your journey toward becoming a great photographer. Just shoot it.

3.1 The world's largest cow, Salem Sue. New Salem, North Dakota. © Steve Simon

WORK IT: DON'T GIVE UP ON THE MAGIC

"I work from awkwardness. By that I mean I don't like to arrange things. If I stand in front of something, instead of arranging it, I arrange myself."
—Diane Arbus

If you've read Step 2, where I described what's involved in getting through a volume of work and why it's important, you know that completing the ten steps and becoming a great photographer might take a little more time than you first thought.

Like so many things in life, shortcuts can get you there quicker, but oftentimes the journey is the destination—if so, a long, slow ride will give you the maximum benefit. This chapter provides a compositional template to help you determine the best camera positions along with various strategies for establishing a compositional process for achieving the volume of work discussed in Step 2.

or the awesome power of a bullet exploding through an apple, Edgerton was able to show us the innate beauty in a world of stop-motion that we had never seen before, with flash durations of 1/10,000th of a second or less.

That same spirit of seeing in new ways is a key to doing work that upends our traditional view of the world. Embracing that new way of looking at a familiar subject is the end result of working your compositions.

However, the art of composition is not a science. Photography is personal. It takes a long time for photographers to learn to trust their intuition, especially when the creative process can feel so technical when using a tool like a camera.

WORK THE SCENE

Once your photograph is found, working the scene can mean a subtractive process as you eliminate clutter, cleaning up and organizing image elements to focus attention on what you deem important. Scan the edges of the frame to make sure you're not missing anything, and look for details that can improve the image by cropping them out or including them within the frame (**3.9–3.14**).

Sometimes there is an energy and movement created with a strong composition, where the lines and curves of image elements keep the viewer's eye inside the frame. Then there's the content itself, and what it might mean to—and how it will be interpreted by—the viewer.

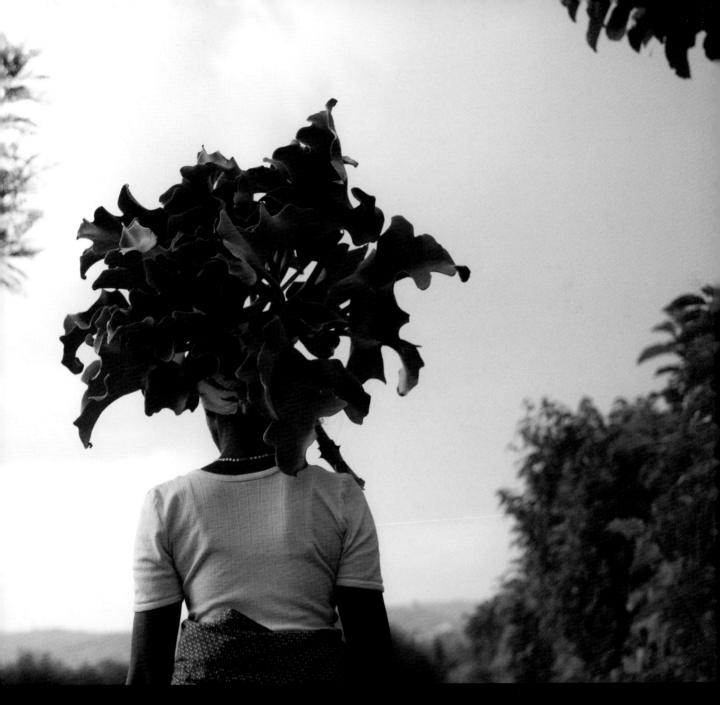

3.9–3.14 Working the scene. The first shot was my starting point, but as Suzane Nyirabukara walked away from me toward her home in Kigali, Rwanda, I thought it was a more interesting shot from behind. I followed her, shooting and cleaning up the frame as I went. © Steve Simon

CHANGE YOUR VANTAGE POINT

As we wander through life, we see the world from perhaps our most common vantage point: standing up, at eye level, and at a distance from our subject that can be described as our comfort zone—not too close, not too far away. In the compositional dance, *this is just the starting point for photography.* I'm advocating you consider shooting a little more than you normally do, which will make Step 7, "The Art of the Edit," a bit more challenging. But having to make difficult editing choices is a good thing; it means you're getting lots of strong frames.

Filling the frame is often a good idea and can help define the focal point of your image or the point of interest that makes your photograph unique. My photographer friend Bill Durrence has a mantra that I also share because it helps many photographers find aesthetic focus: Take the picture, then move three steps closer. Take another, then move three steps closer. Repeat (**3.15–3.17**). We need to shake ourselves out of our comfort zone and see how things look from different angles and perspectives—sometimes uncomfortably close.

Show viewers of your work a new view of a common scene. Explore different points of view by getting down low, up high, in close, or some other unexpected camera position. This is where the dance should take you. You can't be timid when determining your camera position. Find the best place to shoot by boldly exploring the scene.

National Geographic photographer Sam Abell spoke about how the photographic process is often a form of chaos with much that is out of your control. What you can control is the framing. Once selected, if life is moving about within the frame, with luck and timing all the forces come together to produce a great photograph. But much is out of your hands.

"Making a picture just right takes time, even when the thing you're photographing isn't moving. Instead, you do the moving—closer, not so close—change lenses, commit to a tripod, micro compose some detail, step back, reconsider, recompose, repeat. And when it looks right it also feels right—just so."

—Sam Abell, from *The Life of a Photograph*

3.15–3.17 By moving in three steps closer, then three steps closer again, I ended up with a much more powerful image than the one I started with. © Steve Simon

THE PROBLEM WITH ZOOMS

So many of us are using zooms these days, and with good reason. The quality of zoom lenses is now so good that they rival the quality of prime lenses, which have traditionally maintained optical superiority.

It used to be that if an SLR camera came with a lens it was usually a 50mm "normal" lens, but today's DSLRs almost always come with zoom lenses. I maintain that for new photographers in particular, zooms present too many choices, adding to the overwhelming number of decisions that already have to be made. I suggest using fixed focal-length lenses when you hit the compositional dance floor, or

shooting with zoom lenses racked to either extreme and zooming with your feet, as Diane Arbus suggested (**3.18** and **3.19**). With experience, you will learn when to finesse your compositions with slight adjustments of the zoom's focal length.

In the meantime, there are several other choices to be made. Decisions about camera angle, shutter speed, aperture, distance, light, and the moment the picture is taken all have profound effects on what will be emphasized and communicated in the final photograph. By working through a number of these technical scenarios, you can later determine what best resembles your vision of the scene. Give

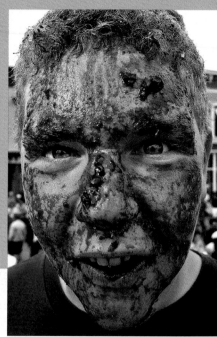

3.18 and 3.19 You can see the compression and limited depth of field in the image of the young boy in Kenya taken with an 85mm lens (right) and the blueberry pie–eating portrait shown with a 24mm lens at close proximity. There's an intimacy that the wide angle gives that you can use to your advantage. Mmmm, pie... © Steve Simon

yourself options. Try them all and learn. Working the scene allows you to make strong images with subtle degrees of difference. And with experience, you will have a clearer idea of which technical approaches to employ.

We have some control by choosing how we work. Different lenses, from wide angle to telephoto, change and alter shapes and relationships between foreground and background objects. Longer lenses give flatter, more compressed perspectives, whereas wide-angle lenses communicate intimate perspectives, which "read" and are communicated in the final image.

When time allows, it's a good idea to stop, think, and strategize because there are lots of decisions that need to be made. Choosing selective focus or maximum depth of field; blurring through slow exposures or stopping the motion entirely; determining sharpness and clarity—each of these decisions tells a different story. We decide what story to tell. Often you need to work through a number of these technical scenarios to determine what best resembles your vision of the scene.

I tend to use wide-angle lenses most often, for the more intimate depiction of the subject and the scene that I like for my work (**3.20**). Just be careful when you use them. Whenever possible, keep the lens perpendicular to the subject to minimize distortion. I'm also careful when using very wide lenses. I don't want the first thing the viewer of my image to say is, "Wow, that's a wide-angle lens that took that." I want the viewer to see the content. This is why extreme wide angles should be used carefully and with caution.

To play with new angles and camera positions, you might want to try your camera's Live View feature, which can be very helpful if you want to get down for a very low angle or hold it up over your head for an elevated perspective. In what we used to call the "Hail Mary" shot with film cameras, I can hold up my DSLR with LiveView activated and actually see and frame the image with hands extended high.

CHOICES AND LIMITATIONS

The compositional dance is about figuring out a way to move you and your camera, which in turn moves the smallest of details inside your viewfinder for maximum visual impact. You can make use of all photographic techniques to create the atmosphere or emotion you are feeling and want to transmit. It's

3.20 Don't be afraid to move in close in order to frame your subject with a wider lens for a more intimate view, like in this image of a man attending the Veteran's Parade in New York City. © Steve Simon

about recognizing and understanding what it is that attracted you to the subject matter in the first place, and then determining—through concentration and instinct—how best to communicate those feelings through the photograph.

Sometimes you need to stop and think about what you're doing, making sure you're heading in the right direction with regard to your approach to the subject. Having a clear vision and idea of how you want to render your subject is half the battle. It gives you direction and helps guide you to get what you need for the particular assignment or project.

It's not a question of recording a literal description of what's in front of you, but rather creating an image that provokes an emotional response from your viewer—perhaps responding in the same way you did when you decided to take the photo in the first place.

Even for experienced photographers, working the photo is all-important. Sometimes in the field I think that one shooting situation or photo is going to be "the one," but it isn't. Even after a life of obsessing with photography, I'm never really sure which photograph will end up being the best. Sometimes it is one I don't even remember taking: a look, a gesture, a spontaneous moment captured on impulse that was so fleeting it was not consciously seen.

3.21 and 3.22 This woman inside a church in Lesotho was very emotional and expressive, so I continued to photograph, varying my distance—moving a bit closer, then further back—and chose the best frame later when editing. You want to give yourself some difficult decisions in post by doing a good, thorough job in the field. © Steve Simon

It is one of my greatest joys in photography—the unexpected surprises that pop up on my computer. So, I advocate that you keep shooting as you dance with your camera—all the while, feeling your way through, shooting on impulse and taking chances (**3.21** and **3.22**). Your medium is digital; you can always delete later, so shoot freely.

MORE DECONSTRUCTION

Okay, let's talk a little composition theory. To help you work your compositions more thoroughly, let's discuss the visual elements that contribute to the success of the image, then the arrangement of those elements within the frame. These choices are often intuitive, but they come from experience. As we develop our critical thinking skills, it gets easier to articulate our feelings about photographs. And the more we study what are acknowledged to be good photographs, we see what is common among strong images—the characteristics they share, as well as the picture components that make the images communicate so powerfully.

Let's break down some of the picture elements that can be used to your advantage as you work out the most effective framing for any particular subject matter.

Aesthetically, the elements include *shape*, the two-dimensional outline of an object; *texture*, the surface of the shape that may or may not be visible depending on the way the light hits the surface; *form*, the three-dimensional aspect of the object; *color* or *tone* (black and white); and, of course, *light*, which will have major impact on how all those elements will be perceived.

Color can dominate an image and contribute to the meaning in a photograph. Former *National Geographic* photo editor and *Washington Post* multimedia guru Tom Kennedy said that good color "amplifies the content" of a photograph.

But it can also be a distraction. When shooting color, it's important to locate potential color distractions and find ways of framing that minimize them. This is why monochromatic color images can be so effective, and why the golden hour is a time many photographers choose to shoot, to bathe the image in warm light that tends to minimize diverse color distractions. The bonus is that the sun is low in the sky, and it adds a three-dimensional look to the landscape as your primary subject or back/foreground (**3.23**).

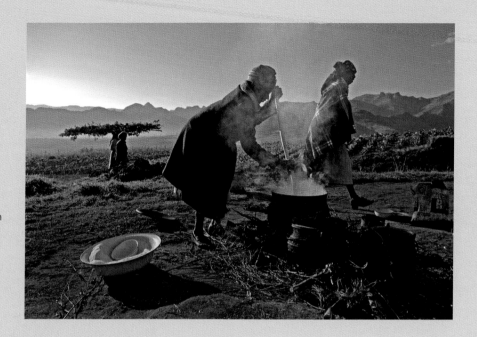

3.23 This golden light is in the early morning—another great time to shoot, when the light is low and even, creating strong shadows and accentuating detail in textures, as well as providing a warm bath of light that tones down distracting colors. Mapuste Moriti stirs the pot early in the morning in Lesotho. © Steve Simon

THE ENEMY

Is autofocus the enemy of good composition? Some might argue yes, that with the main focus point of many cameras right smack in the center of the viewfinder it's only natural that a photographer's first instinct is to center their main point of focus and shoot. But most cameras allow you to move your focus point around the frame so there's no need to be a compositional slave to the focus points in your viewfinder, especially when doing the compositional dance (**3.24**). Instead, lock in focus and recompose.

Depending how long you've been into photography you may remember the days when manual focus was the only option. It was a skill that many great photographers spent years developing. Often the best sports photographers were like the athletes they covered, mastering the hand-eye coordination needed to quickly lock focus on fast-moving subjects while triggering the shutter at the decisive moment.

I remember when my eyes first started to weaken and I couldn't depend on my focus judgment when manually focusing. Fortunately for me, it was happening just as autofocus technology was starting

to improve. But don't think that autofocus does all the work for you. Similar skills, concentration, and dexterity are required with autofocus as when manually focusing, but used well, the percentage of sharp images goes up. Even with the amazing autofocus capabilities of DSLRs right now, there are often times when manual focus makes the most sense when composing your picture, particularly in low-light situations with fast lenses wide open for selective focus.

Sure, you can place your autofocus point on different parts of the frame, but you are only able to do so in fixed positions. With manual focus, you can compose the scene, focusing on, say, a specific face way off to the side, whether it lines up with a focus point or not. If that person moves you can refocus quickly, all the while waiting for the best moment to trigger the shutter.

Street photographers have long used a technique called "hyperfocal distance," which relies on depth of field to get them sharp images faster than any autofocus camera with no need to turn

3.24 Move your autofocus points to control your composition, putting your main subject where you want in the frame for emphasis. © Steve Simon

3.25 A photographer uses a rangefinder Leica to photograph the cityscape of Istanbul. Rangefinder photographers have long used the technique of pre-focusing using hyperfocal distance to work quickly with no need to move the focus on the lens. © Steve Simon

a focusing ring. The master Henri Cartier-Bresson used a Leica, and Leica shooters know their manual focus rangefinders so well they often set their focus manually without looking, and/or use hyperfocal distance (**3.25**).

Older lenses allowed you to set the hyperfocal distance by reading lens markings that displayed the maximum depth of field in-focus range for a particular f-stop. So if a photographer was using a 28mm lens, they knew the in-focus range might be three feet to infinity at f/16, if they set their lens to the hyperfocal distance of 5½ feet indicated on their lens. So they composed their pictures by placing subjects and picture elements that needed to be reasonably sharp within those distances. No need to focus.

So the Leica rangefinder became a true speed demon that even the fastest autofocus can't match, and it's still practiced by some rangefinder shooters today. (This theory holds true for any camera that lets you control the aperture.)

This is how the great street shooters could move and shoot so swiftly. True, sometimes the focus wasn't tack sharp, and if you've ever seen certain masterpieces up close, the pixel peeper in you might

comment on a slight softness. It just underlines the fact that for great photographs, content, mood, and composition will trump any underlying weakness in technique. Sure, you want to have it all, but a slight shortcoming in technique is not a deal-breaker.

DSLRs offer a great range of sophisticated autofocus options that are incredibly effective but can be hard to fully understand, and each manufacturer has similar but specific systems. Because focus is so important to the working compositional approach I'm advocating here, I'm going to offer a few suggestions, but knowing what works best for you is the key, so make sure you check your camera's manual to see what's available to you and then try it out.

The most important factor for me is being able to control where in the frame the camera will lock focus. Every manufacturer has its own system, but most have at least two main autofocus modes: Single and Continuous Servo.

In Single, the camera's autofocus tracks the subject and locks it into sharp focus. It's a one-frame-at-a-time shooting mode for subjects that aren't moving. A light, halfway press on the shutter release locks in focus. More pressure triggers the shutter

to take the picture. Once the focus is locked with a halfway press, you can choose to recompose and fire (**3.26**). This can work well with stationary subjects where the camera-to-subject distance remains constant.

Continuous Servo mode tracks moving subjects when you press down halfway. When your subject moves, the camera can track it and, in some cases (as with dynamic mode), actually predict where that moving subject is going to be and keep it in focus. So if something is moving toward you, then stops and continues on, it doesn't matter. The camera continually monitors that subject (as long as the focus point is on it) until you lift your finger off the shutter or take the picture (**3.27**).

A host of sophisticated autofocus options are available that build on these two main autofocus tracks. But autofocus isn't perfect. It's often not as accurate in very low light, and can be fooled by fences, highly reflective surfaces, falling snow or hard rain, glass, and other transparent barriers. You

need to be careful and recognize when manually focusing will ensure sharp focus on the right element in the scene.

Do not be lulled into a false sense of security with autofocus. I have been in situations where I ended up with back-focused images because I wasn't paying attention. Check your camera's manual and read the autofocus section thoroughly. Some autofocus points—usually those in the center of the array—are more sensitive and accurate than others.

The Nikon system, for instance, has on their high-end cameras a system of 51 focus points, where 15 of those points are what are called *cross-type sensors*. Cross-type sensors focus on both the vertical and horizontal plane and are more accurate, particularly in low light and with fast lenses.

Dynamic area systems allow you to choose the priority focus point to lock on your subject. If your subject deviates from that point, the autofocus system activates helper AF points that track the subject and maintain focus.

3.26 For more dynamic compositions, it's important to focus and recompose—or move your focus points to elements in the frame you want sharp—in order to move the emphasis away from the center of the frame. © Steve Simon

3.27 In Continuous Servo mode, you can track a moving subject, increasing your chances of getting it sharp. © Steve Simon

AUTOFOCUS TIP

I used to set the camera on single-frame shooting, center the focus circle on what I wanted sharp, then recompose and trigger the shutter. I would hazard a guess that this is the technique used by the majority of DSLR shooters. It's no wonder there are so many lifeless compositions being made—people forget to "recompose" and end up with static-looking, dead-center subjects.

I think there's a better way to use autofocus.

Most DSLRs let you take the autofocus away from the shutter release and move it to the little button on the top or back of the camera to the right of the viewfinder window, often labeled AF or AF-ON. This is my preferred technique and its effectiveness reveals itself when shooting things that move, as opposed to still life and landscapes, where it also works well. This autofocus technique gives you the best of both Single and Continuous Servo tracking modes.

To use it, you need to set the autofocus on your camera to the AF-ON button only, which disengages autofocus from the shutter release. So the shutter release activates the meter and the Vibration Reduction or Image Stabilization feature (if your lens has that feature), but it no longer will activate autofocus. You then have to set your camera to Continuous Servo mode, often by a switch on the front of the camera (but check your camera for specific instructions).

Once I've made these initial settings, I simply press the AF-ON button to focus, let go to lock focus, then recompose and shoot. It's as quick as using the shutter trigger to autofocus on Single servo and works similarly.

But in situations where I'm moving or the subject is moving, since the camera is set to Continuous Servo tracking I can keep the AF button pressed in and the camera's amazing continuous autofocus system tracks the subject all the while I trigger the shutter repeatedly. This allows me to get many more sharp shots in fast-moving situations.

With the old way, confronted with a change in subject from static to moving, I would have to reset the camera from Single mode to Continuous Servo tracking and back—which was cumbersome and took time and often meant missing the moment while making these adjustments.

It takes some getting used to the new system, and if you forget to press the focus button, no autofocus happens. But the majority of photographers I have turned on to this method like it and stick with it. After a while this new way to focus becomes second nature. I like it because I feel more in control, like back in the day when my eyes were sharper and I manually focused. Just be careful when you lock focus and recompose not to change the camera angle enough to lose your plane of focus. This is particularly critical when shooting wide open with fast lenses and their razor thin depth of field where even slight recomposing can throw your intended focus point out of focus. In these situations, minimize your recomposition by moving focus points around the viewfinder. ■

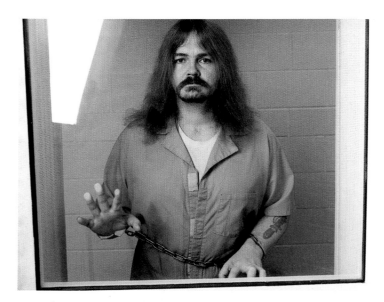

3.28 Ronald Smith—Death Row. The red tape was long but after a year of writing letters to the prison, Ronald Smith's lawyer, and Ronald Smith himself, I finally was given permission. Some stories seem impossible to access, but you would be surprised how many times seemingly impossible permissions are granted to photographers; it's almost always worth a try, with persistence often rewarded. © Steve Simon

PATIENCE IN COMPOSITION AND LIFE

Learning and growing as a photographer is a lifelong process. Everything you experience in your life can be infused into the work you create. Patience is not only a virtue in life, but can also be a huge asset for improving your work.

Life rarely gives you fully finished photographs suitable for framing. It's just not that easy. Maybe every picture you've ever taken could have been improved. If that's true for many of your images, then you might agree that working the photo a little more is a good idea.

It's true that all subjects are not created equal, and there may be certain limits that come with specific assignments or shooting situations (**3.28** and **3.29**). So finding situations with visual potential is key, and I'll discuss this in more detail in Step 4. But there are photographic gifts around every corner and infinite situations with visual possibilities waiting to be recognized. Confucius said, "Everything has its beauty, but not everyone sees it."

3.29 I waited all night for this picture. Knowing the balloons would be released from the ceiling of Madison Square Garden when George Bush and family walked onto center stage, I shot and waited and shot, eventually getting this image that shows Mr. Bush very prominently in the frame, even though he's a small figure in a complex image. When you're ready to see it, getting the shot requires preparation, eye to the viewfinder, moving and tweaking and waiting for the moment to materialize. It also requires patience. © Steve Simon

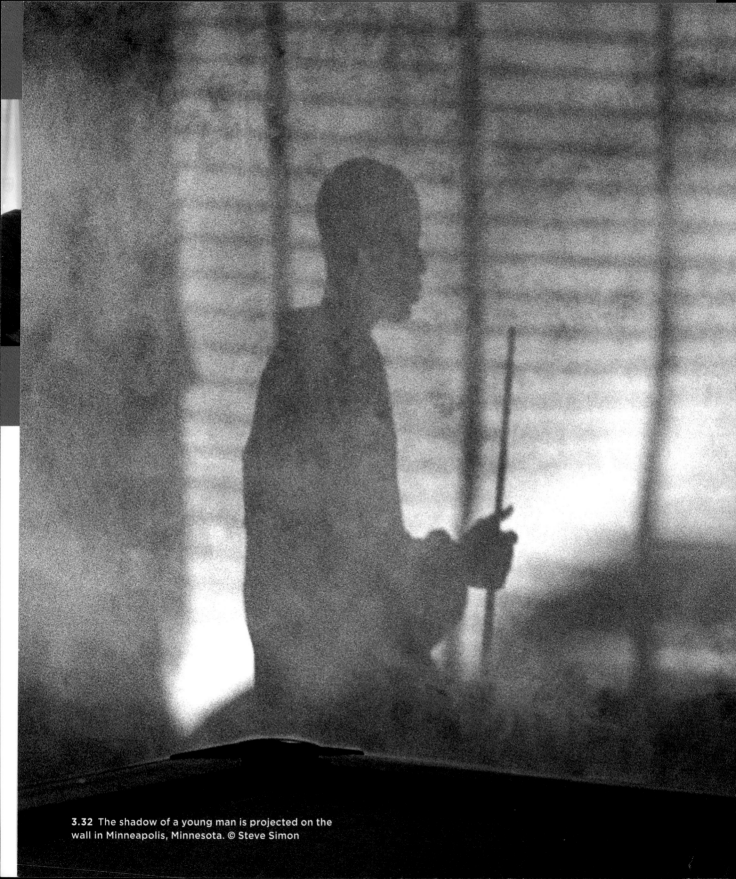

3.32 The shadow of a young man is projected on the wall in Minneapolis, Minnesota. © Steve Simon

Rule of Thirds

The rule of thirds says you should divide your frame in thirds, both horizontally and vertically, then place your main subjects or elements at or near the intersection of the lines (**3.32**). One of the reasons I have heard the rule of thirds might be pleasing to us it that it mirrors the composition of the human face—eyes being in the top third, mouth on the bottom third.

Leading Lines

A higher vantage point can sometimes alleviate the chaos of an eye-level viewpoint, giving you symmetry and movement within your frame (**3.33**). Scan the area for places that would let you shoot from above, such as hills, roof decks, anywhere that might allow you to look down at the scene. You sometimes have to ask, and if you're in a place for a few days, the sooner you get the process started the better.

Frames within Frames

When you go to a gallery and see any kind of visual art, it is often mounted in a frame. Frames occur naturally in the world, too, and it's a nice device to use in your images when the opportunity presents itself (**3.34**).

Scale

Including elements in the scene that provide a sense of scale can alter what the picture is communicating and make it stronger (**3.35**).

Out-of-Focus Foreground

Use that foreground by placing something in it. An out-of-focus foreground can still be "read" by the viewer quickly and will often not only contribute to the mood and information being conveyed, but might add nice contrast and emphasis to the areas that are sharp (**3.36**).

3.33 The line of kids waiting their turn for the swing is a leading line that takes your eye to the child on the swing. © Steve Simon

3.34 A nurse makes a house call in Lesotho. The image was framed within the frame of the window. © Steve Simon

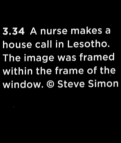

3.35 These schoolgirls provide a sense of scale for the landscape. © Steve Simon

3.36 The woman in the foreground is prominent within the frame but selective focus kept the sharp focus on the child.
© Steve Simon

Horiz

Placem
tor wh
too; pl
(splitti
the im

Sor
level,
a croo
Still o
necess
from

Lessons Learned

DON'T GIVE UP ON THE MAGIC

"Photographers stop photographing a subject too soon
before they have exhausted the possibilities."

 —Dorothea Lange

The compositional dance includes a work ethic that you try to squeeze the best possible photo out of every shooting situation. Always work hard and long on every assignment or photographic opportunity. (If you're reading this book, you know it's really a labor of love that pays off in great photographs—making it worth the effort.)

The picture shown in 3.41 taught me an important lesson about recognizing situations that are better than the ordinary, and working the scene until it goes away.

I remember following two boys who were each carrying a painting, and their father lagging behind outside the frame. I'm not unhappy with the resulting photograph, but the experience taught me a lesson. When the fast-moving boys turned the corner, I stopped shooting and went the other way. Why did I stop? I'm not really sure.

I figured I had a decent image. The fact that I didn't continue following and shooting this scene nags me and reminds me not to take anything for granted. I pledged from that day forward that I wouldn't give up on a moment, on a potential great photograph, if I didn't have to—even if I think I may already have something good. I didn't have to stop when those kids turned the corner. And although I had taken a picture I thought I liked, if there were better photographs to be had I will never know.

Now I always follow the magic through until it goes away, the light fades, the subjects are tired or the moment is gone. Photography is a passion and it's fun, but it's important to push limits, work a little harder, and see where it takes you. This is the compositional dance, too.

3.41 Don't give up on the magic. © Steve Simon

3.42 A good composition will move your eye around the frame, keeping you within the picture's borders, as with this image taken at Coney Island, New York. © Steve Simon

I always keep in mind what photographer Melissa Farlow once told me back in the days of film. She said that many times at the end of a shoot, when it's late and she's tired and she thinks she has her picture, she will put one more roll into the camera. Sometimes that last roll pushes her to a place she could never have anticipated or predicted, and those last photographs are better than anything she had taken previously. It's all about working the opportunities, pushing boundaries, and taking chances (**3.42**). ■

Step three

ACTION: Work It

When you look at my series of Salem Sue, the big cow in North Dakota (pages 64–65), you can see that the one common element in every image is the cow. It was a lot of fun for me to spend the day there and make those pictures, but it also taught me a lesson about putting in the time and challenging myself to come up with new and original frames of one main subject. Choose a landmark or icon and see what you can come up with if you take a similar approach. You don't have to limit yourself to one day; this could become a longer project. I know photographers who have photographed the Empire State Building, for example, from different vantage points in New York City over the course of years.

4.1 You need to go it alone and find a way to the photographic zone of concentration to do your best work. In highly charged situations, I do everything I can to stay focused, concentrating on staying calm and making sure I do the right things to get the shot. My adrenaline is pumping but I try to stay calm. © Steve Simon

THE LONELY ADVENTURER: CONCENTRATION AND NEVER LINGERING IN YOUR COMFORT ZONE

"Sometimes I have taken photographs and just felt so excited that I could barely hold the camera steady, and the photo was boring."
—Robert Rauschenberg

There's no doubting the fact that photography can be fun, and it's often a great experience to spend the day shooting with other photographers. But I maintain that to do your best work you need to be laser-focused and go it alone.

Shooting at your highest level requires you to direct all your attention to the subject before you move into the "photographic zone," a place of high concentration (**4.2**). You've probably experienced that feeling when you're truly concentrating on the task at hand and distractions disappear. When you're in the photographic zone, you are present, in the moment. Time itself seems to slow down or become irrelevant as you focus your efforts and your camera on your subjects. Your ability to ignore distractions increases.

If you can find your way there, you will be rewarded with great images. But getting there requires working on the previous steps, letting the technical aspects of your camera fade and fuse into your background process. In the photographic zone, you move around—eye to the viewfinder—constantly exploring, sometimes thinking, sometimes just feeling your way through.

And, as you learned in the last step, your comfort zone is only the starting point from which to work harder, to dig deeper visually.

4.2 Concentration is key to finding your way to the "photographic zone" from which you do your best work. A young cowboy from Raymond, Alberta, is deep in concentration. © Steve Simon

LEARNING TO CONCENTRATE

My best shooting experiences meld the physical—the act of shooting—with the mental and emotional (which becomes second nature with experience) to get to a place where I'm in that zone (**4.3**). It takes a presence of mind that comes with practice and discipline.

We are all constantly working in a kind of shorthand; our eyes are open, but we may not see. If you've ever driven a car while deep in thought or talking on your speaker-phone, you understand auto-pilot mode. During this time you often have little or no recollection of what you saw as you were driving—a bit scary, actually. We can function at both tasks because we *look* with our eyes but *see* with our brains. We're not concentrating on what our eyes are showing us; we look at the road, the lights, and the other cars enough to safely get where we need to go, but we're not seeing the way a photographer needs to see to do good work. As Albert Einstein said, "Any man who can drive safely while kissing a pretty girl is simply not giving the kiss the attention it deserves."

Finding our way to the photographic zone involves thinking before you shoot and being aware. Henri Cartier-Bresson spoke of how difficult it was for him to be lucid and photograph in his home environment, where "you know too much, and not enough."

It is true that visiting new places and cultures can inspire you. In theory, you should be able to make better, more exciting and visually stimulating images than when you're shooting in old, familiar settings. I know how hard it is to motivate myself in my own backyard at times, but when I travel I see with fresh eyes; everything is new and I'm inspired (**4.4**). As a photographer, if you can learn to make the ordinary extraordinary, imagine how good your photos will be when you're lucky enough to be in an extraordinary environment?

4.3 When you're in that zone, all distractions melt away and you can focus on your subject. Canada Day block party, Raymond, Alberta. © Steve Simon

4.4 It's sometimes extra hard to get inspired in your own familiar territory. But as you take off for a new and inspiring destination, someone else may be landing in your backyard with the same excitement you feel about your destination. If you can find a way to make great work at home, there's no limit to what you can do when you go somewhere that excites your senses. A two-second exposure of a plane making the turn to land at JFK in New York City. © Steve Simon

But from my experience, exciting surroundings don't always translate into great pictures. When you travel to an exotic location, not only are you on high alert visually, but your brain speeds up, and all your senses are stimulated as you wander about. The ability to maintain your cool, calm, and concentration amid the chaos of a new and vibrant location is key to coming away with strong images, and it's also very challenging.

When you return from that exciting new place, you are going to want those images to visually communicate everything you experienced in the field,

without the sights, sounds, and smells to help communicate your message. So, in a visually stimulating environment, the bar is raised. Yet if you don't concentrate, you may just be going through the photographic motions and not doing the things you have to do to make your pictures great.

Here's how I work to focus my heightened sense of awareness and maintain concentration in highly charged shooting situations. When I go to a new place and culture, I allow myself some time to look around and soak it all in. I've done my research. I generally know where I am and where I'm going,

though I'm always willing to let serendipity take me in a new direction if better images may be around that corner.

I pause and take a deep breath. I make sure my camera is set for the shooting conditions I'm under and I go to work (**4.5**).

I'm patient. My time is usually limited so, if possible, I want to have a look around the entire periphery of where I'll be shooting, noting areas that have the best visual potential. I try to hold back and observe before shooting because I want to invest my limited time in those places that experience tells me will maximize my results. I know that all subjects are not created equal, so I want to put the odds in my favor by choosing subjects for their visual richness and potential to yield the strongest images, and spend time there.

As you learned in Step 3, it's often best to spend more time shooting fewer different scenes and to go deeper with your work to maximize your photographic chances. It's especially true when there's great content to capture. You want to push yourself out of your comfort zone by shooting that literal record of the scene first—as a starting point—and then move deeper into the process of the compositional dance.

It's probably hardest for me to do when I'm dealing with delicate or new and unfamiliar places and situations (**4.6**). This is where instinct and intuition kick in.

As much as I'm advocating getting out of your comfort zone, it is important to be comfortable while shooting. It's hard to do your best work when you don't feel both physically and psychologically comfortable in a place, so dress appropriately for the weather and pack light, working within your camera kit's limitations. Remember, you can only have one camera and one lens to your eye at any one time.

Then, when you're relaxed and have permission from your subject or the powers that be at the venue, you can photograph freely with an uncluttered mind and concentrate on the picture-taking task at hand.

4.5 The more you have going on in your environment, the more important it is to take a deep breath and concentrate. A busy market near Kigali in Rwanda. © Steve Simon

4.6 A memorial to the victims of the Rwandan Genocide near Kigali. © Steve Simon

INSTINCT AND INTUITION

Learning to trust your intuition takes time, and if you've moved through Steps 2 and 3, you're on your way. But to be able to trust your intuition and become a great photographer, you first need to master your technical skills.

I want to differentiate between instinct and intuition, both natural tendencies we draw from every day. For me, instinct is more about survival than photography. As I wander with my camera, I try to be in tune with my instincts to keep me safe and out of trouble. I have photographed in dodgy areas, and I trusted my sixth sense—my instinct—to guide me through those situations (**4.7**).

The camera can act as a shield, separating you from the reality of the moment. I have experienced a false sense of security by viewing the scene through the viewfinder rather than with my own eyes. There are many places and situations I have been with my camera that I would not have otherwise. My camera has been my ticket to some amazing places and an excuse for starting conversations with fascinating people. I'm grateful for that.

But sometimes, instinct tells me, "Okay, Steve, that's enough, we gotta go." Other times it prevents me from taking a picture altogether—out of concern for my own safety. I've always done well listening to that inner voice that alerts me to a potentially dangerous situation and tells me what to do about it. I try not to offer too much information to strangers; if I'm traveling alone, I never divulge that fact. It's a fine line between saying no to potential amazing opportunities, so let common sense be your guide. No picture is worth a serious threat to your safety. When there's a lot going on, it's challenging to keep yourself present, aware, and in the moment, maintaining concentration.

In 2007, I had the great privilege to travel to Somalia, Rwanda, and the Democratic Republic of Congo with the former head of Médecins Sans Frontières (Doctors Without Borders), Dr. James Orbinski. In 1999, Dr. Orbinski accepted the Nobel Peace Prize for the organization, and I was working as a still photographer on *Triage*, a film documentary based on his experiences (**4.8**).

4.7 In my experience, the camera can act as a shield, separating you from the reality of the moment. Let your instincts guide you and keep you safe. Aryan Nations World Congress, first published in *Life* magazine 1998. © Steve Simon

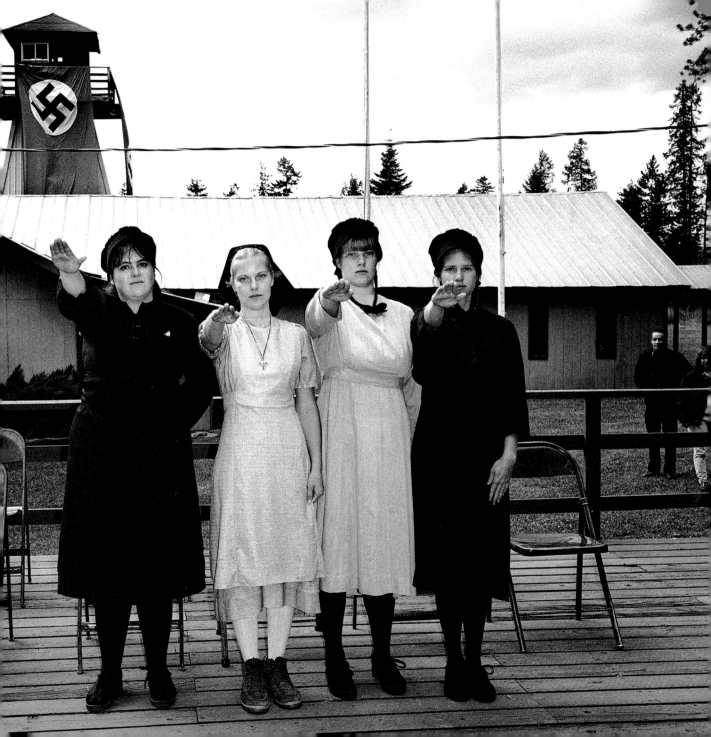

4.8 Dr. James Orbinski at the memorial to victims of the genocide in Murambi, Rwanda. © Steve Simon

Dr. Orbinski has had to deal with the most horrific human scenes, from the genocide in Rwanda to famines in Somalia and other humanitarian catastrophes. He is an inspiring person, always leading by example and doing the right thing.

In Rwanda during the genocide, he and his team would routinely work 18-hour days, dealing with horrific wounds in the most dangerous circumstances. The only way to survive, he said, was to be in the moment, concentrating on the task at hand. If he allowed himself to drift from his concentration and start to think about the reality of what was going on around him, it would be impossible to function.

IN THE MOMENT

Not to even think of equating what Dr. Orbinski has endured compared to most photographers in precarious circumstances, but the idea of being in the moment is one that resonates with photographers because it is that state of total concentration in which we do our best work. It's particularly important when you're in highly charged and challenging situations.

In difficult physical or emotional shooting situations, you should maintain a clear sense of purpose. People sometimes ask how it is that I can take pictures in clearly private, personal, often sad and difficult moments, like at a funeral. I am not a voyeur in these situations; I'm there with the permission of the family, organization, or business, and they know why I am there: to take pictures. They know the reasons for the images and where they might be published. They also have agreed to participate and let me into their lives because they sincerely believe, like I do, that pictures can make a difference. Photography can help promote awareness and positive change. Under these conditions it inspires and motivates me to do my best work, and I hope that my good intentions are met with positive action (**4.9**).

As a documentary photographer, to do your best work and to tell the story you can't hold back. It's not a time for timidity. You need to concentrate and make the best image by boldly finding your best shooting position, keeping a low profile, and working quickly and quietly.

Intuition for me is more of a photographic feeling. It guides my camera to the right places, past obstacles, and in new, interesting directions. Aside from letting my intuition guide my compositional dance while shooting, there are a couple of important lessons I've learned when it comes to intuition.

First, it has been my experience that when I have a feeling that I didn't quite "nail it"—if there's any doubt in my mind that I may not have captured the shot I hoped to get—I continue to work harder. Those times when I didn't listen to my inner voice telling me to keep going, I was almost always disappointed with the results.

This lesson harkens back to the film days, when you didn't have instant access to the image you just

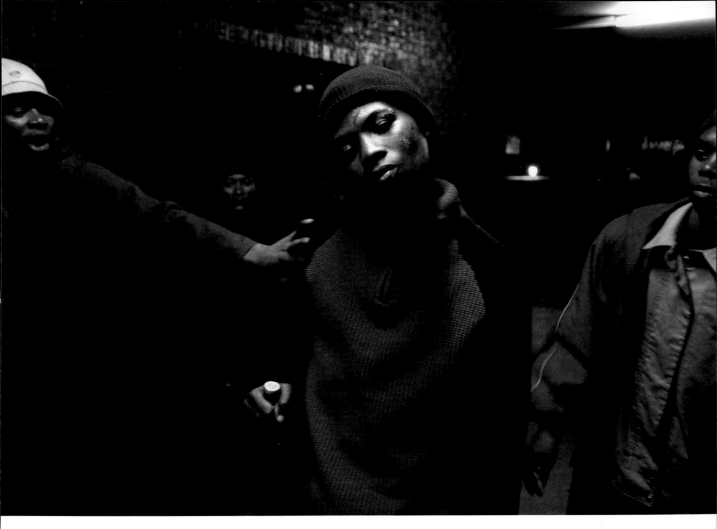

4.9 There was a moment between me and my subject that translates well to the viewer. Taken with a wide-angle lens in close proximity, there is intimacy and you can feel the tension, with the man on the left adding to the immediacy of the moment. Photographed outside the Sekekete Hotel Bar, Maputsoe, Lesotho. © Steve Simon

shot. So you continued to shoot a little more. It's a work ethic that film shooters still abide by. It might be because, when you take a photo with a DSLR, the mirror pops up for an instant so you don't actually see the moment of exposure. If you "saw" it, you didn't quite get it.

Other times I need to keep an open mind about the experience of shooting. There have been times in the field where I've worked hard, shooting and working the scene, with an idea—before even looking at the shots—as to which images would be the ones I would be selecting.

But I have proven myself wrong many times. Because great photographs can be caught—without thinking, in a fraction of a second—I may not even remember taking certain images, yet they become the selections from the take. There's a weird sort of guilt that happens for me when I don't feel I "earned" the photo, because I triggered the camera on impulse or instinct, maybe not even having remembered doing so. Of course this too is part of the photographic process; the degree of difficulty is often irrelevant—it's about what the image communicates.

Lessons Learned

INSTINCT, INTUITION, AND CONCENTRATION

"When I have a camera in my hand, I know no fear."
—Alfred Eisenstaedt

There is no question in my mind: concentration is a major factor in closing the gap between the photo you hope to get and the one you end up with. It doesn't matter if it's a highly charged episode or a mundane one; when I let my concentration lapse, I'm often disappointed.

This picture (4.10) goes back a long way, but I remember the day very well. It was July 31, 1987. I was a new photographer at The Edmonton Journal, where I had started my photojournalism career a year earlier.

I was working the afternoon shift and had just finished gassing up my car when reports of funnel cloud sightings came over the newspaper's radio system. A moment later, I looked up and saw those funnel clouds; in fact, they transformed into a tornado seconds after I saw them.

The problem was, from my industrial location in the city's east end, there were a lot of obstructions and I didn't have a clear view. I was nervously excited as I took a quick picture with my Nikon F3 film camera, and stepped on the gas to find a better spot to see the tornado.

There were not a lot of cars on the road at 3 p.m. in this part of town, so I was able to drive fast, one eye on the road, the other on the amazing weather phenomenon in the sky. I drove for what was likely less than a minute to find the open space from which I took this picture.

Though I was young, I had been shooting pictures since I was 11 years old. I knew what to do. The light had dropped remarkably for 3:00 in the afternoon on a midsummer's Edmonton day. I remember the exposure because I had to push the 400 ISO negative film two stops to get a relatively fast shutter speed of 1/250th of a second, wide open at f/2.8 with my 180mm f/2.8 Nikkor lens.

4.10 The Edmonton Tornado, July 31, 1987. © Steve Simon

I was watching this massive tornado, which was probably a mile away, move relatively slowly across my field of view. I had time to take a bunch of pictures, as fast as my motor drive would let me. The massive power of this tornado was in stark contrast to where I stood recording it. It was raining lightly and relatively calm.

I changed to my 35mm f/2 lens and took a few wide shots with more of the landscape surrounding it. Because the tornado was moving across my field of view and not toward me, I didn't feel threatened, but when I started to see the debris circling the outer edge of the tornado, my instincts told me it was time to leave. I was probably shooting for about 30 seconds. I jumped in my car and drove away from the tornado, toward the office where the film was processed and the image made the front pages of newspapers all over North America and around the world.

The damage was extensive, and 27 people were killed and hundreds more injured. The tornado was rated at F5 at its peak, with wind speeds above 250 miles per hour. I was very lucky to be able to concentrate and shoot from a position of relative safety. My experience at the time allowed me to keep my mind and camera sharply focused on the tornado, ensuring I would get the shot. Keeping your cool and concentration is essential to doing good work, and it's a skill that will develop over time when you put your mind to it. ∎

FIGHTING PHOTOGRAPHER'S BLOCK

A wise man I met in Japan more than 20 years ago described his process of problem solving. He said that when you are trying to come up with a solution to a problem and you've racked your brain and thought out all possibilities but still come up empty...stop.

Go back to the beginning and try a completely different route around that problem—maybe even the exact opposite route, or some other different approach that first pops into your head. In other words, reset to the beginning and try something completely different and new.

His words have always resonated with me, and I have used his suggestion successfully to fight a creative block. When I'm working the situation and things just aren't moving forward, I stop and try a completely different photographic approach. In a portrait session I might change locations from indoors to outdoors, or vice versa. If I'm shooting long, I might try wide. It's about shaking things up and not overthinking. It's about taking chances. Albert Einstein said it's okay to get crazy.

And when you try stuff and it works, these successes are woven into your brain and embedded into your process for future photo situations. Your photographic palette of possibilities is widened. You become a better photographer each time you stretch and try something new, especially when it works.

FINDING DIRECTION

When I covered the Republican Convention in New York City in 2004, there were literally more photographers there than any other assignment I can remember. On September 11, 2001, the world saw the horrific images—captured from every angle—of the terrorist attack on the Twin Towers in New York City. But at that time, despite how prolific the images taken of that tragic event were, there were far fewer cameras than just three years later. In 2001, cell phones with built-in cameras were first introduced, but in 2004 almost everyone on the streets was using cell phones to take pictures; the era of the citizen journalist was born and I was now shooting digitally for the first time.

As I photographed the protests at the 2004 Republican Convention, spectators and protesters were doing the same. I observed the police turning their video and still cameras on the crowds in areas they were securing. Then there were the thousands of press and photojournalists covering the event, literally recording everything related to the convention.

With so much going on, it was hard to know where to begin. Rather than just wander around and shoot, I was looking for a way to focus my attention to find direction in my coverage. This is how I often tend to work. As discussed in Step 1, when you know what you're looking for, you'll likely find it more often.

So when I started to brainstorm and really think about how to cover this chaotic and visually complex event, I came up with three main paths to focus my efforts and tell the story:

- The convention itself, and the 5,000 party delegates who gathered in the heavily fortified Madison Square Garden to nominate George W. Bush to run for a second term in office (**4.11–4.14**).
- The estimated 400,000 protesters who marched outside under the watchful eyes of police.
- The media: the 15,000 journalists who were there to cover the event and tell the story of the convention to the world. I wanted to pull back the curtain and reveal the backstage theatrics that are a part of modern-day politics.

4.11 A woman poses for the media inside Madison Square Garden at the Republican Convention in New York City. © Steve Simon

4.12 A family watches the speeches at Madison Square Garden. © Steve Simon

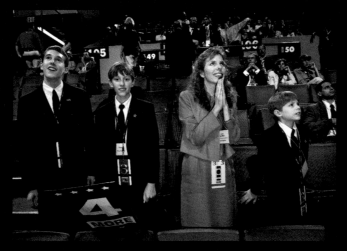

4.13 The late Jerry Falwell photographed during a break between speeches at Madison Square Garden. © Steve Simon

4.14 A man reads *The New York Times* inside Madison Square Garden. © Steve Simon

4.15 I try to limit my peeking at the image review screen because it distracts me from the task at hand—making photographs. When kids find out about the picture magically appearing on the screen, it can be a blessing or a curse as you continue to shoot, so be careful!
© George Barya

Once I had my direction, I was able to head out with purpose to seek the images I knew would give me the narrative I was thinking about. Knowing what I was looking for allowed me to concentrate on finding those images. I also recognized when I was in a situation that strayed too far from my self-assigned photographic mandate, and I knew when to move on.

You can do the same when you find your angle for the theme you are interested in covering. What is it that is compelling you to shoot this subject? What are the different angles and narrative tracks you can take? When I find my direction on a project, it doesn't prevent me from being open to serendipity. When bends in the road take me on a new path, I follow. But having a plan and direction in my work can keep me focused when the situation gets overwhelming.

IMAGE REVIEW

The image review screen is a huge blessing for today's digital photographers, and can speed up the learning curve and development of a photographer. But it can also hurt you.

I've used the image review screen as an icebreaker on rare occasions when I felt it could help to show a subject I'm photographing the image on the back of my camera. But most of the time I selfishly guard it. Things can go wrong. Once when photographing children in a village in Kigali, when the secret got out that the picture was immediately available on the back of the camera after the shutter was pressed, that was the end of the photo session. Children clamored around me to get a glimpse of the picture just shot. It was fun but not photographically fruitful (**4.15**).

There's also a danger of showing your subject the image and them reacting badly to what they see, sending the shooting session into a downward spiral that you can't recover from.

My main problem with the image review screen as brought up in Step 2—and why I turn it off—is that it breaks my concentration. I want to give my full attention to what is happening in front of me. I can always press the picture button to review, but mostly I ignore it. It takes some experience to build your confidence to the point where you "need" to look less. When I'm in the field and I know what I'm looking for, I shoot, shoot, and shoot. Short of checking the histogram to assess the exposure, I don't spend time looking at what I've just shot. I tend to side with master wildlife photographer Thomas Mangelsen.

"I was with a good friend in the Pantanal in Brazil this summer and I'm always giving him a hard time about chimping because we were watching jaguars, they're rare, they're endangered, they're skittish and your opportunity is short. The jaguar would be moving along the river, and I would be looking, looking, looking,

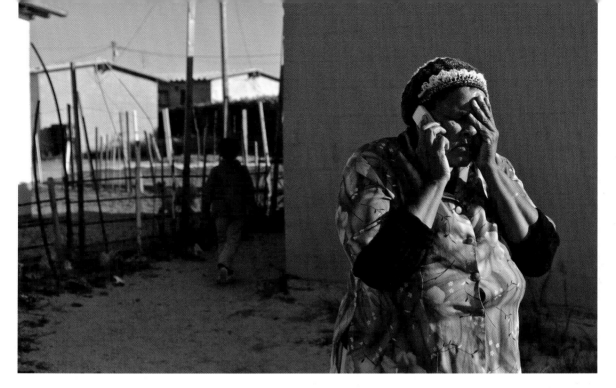

4.16 I always try to have some local support on the ground when I travel to a new destination. It makes a huge difference in speeding up the process to get images that are more intimate and natural with people, and locals can often tell you the best locations from which to shoot. Rita Hoza, 59, has lost children to HIV/AIDS. Outside her home, her 6-year-old grandchild Azile goes off to play with friends while Rita takes a call on her cell phone. © Steve Simon

and I'd look over at my friend and he would be chimping. I caught myself literally yelling at him a couple times. 'You know the jaguar's here, keep shooting!' But he was so consumed with seeing what he got and his rationale was to look for a mistake, maybe he needs to fix exposure…fair enough. He was chimping and editing in the back of his camera, deleting, deleting, deleting, and I just can't really tell. I can get the general idea of what I shot on the back of the camera, but I'm not so damn sure there might be something there I don't want to throw away. I spend my time looking for the good stuff as opposed to deleting the bad stuff. I don't really care about the bad stuff."

—Tom Mangelsen

THE FIXER

I maintain throughout this chapter that going it alone is the way to go. But sometimes, particularly while traveling in new and foreign cultures, you'll find a little help goes a long way. If you're serious about your photography, I can't say enough about hiring an assistant—in journalism circles, known as a "fixer"—who can help you navigate new and unfamiliar territory. There's no question that you can save time and money, and get images that you would not be able to get without the help of someone who is intimately familiar with the territory you are venturing into. This is particularly true when traveling in places where you don't speak the language.

All the knowledge and research in the world can't accelerate your assignment success like the help of a trusted member of the community you're in (**4.16**).

Most of my travel photography has been done with the help of locals, many of whom have opened doors for me and become friends as I've gone back to visit them a second or third time.

Once the doors are opened, a good assistant stands back and I go to work alone, but getting through that opened door is where the help is needed.

Community photography and travel sites might have recommendations for who to hire, as would the photojournalistic community on sites like www.lightstalkers.org. Local colleges and universities are another resource, as are local camera clubs.

PAYING FOR PICTURES

Coming from a journalistic and documentary background, I was taught never to pay for the privilege of taking someone's picture. From a journalistic context, it changes the relationship of photographer/subject to photographer/model, and the reality of what you are getting might be challenged since that subject is technically, albeit for a short while, in the employ of the photographer.

That said, I have often bought the wares of vendors I have photographed, or made a contribution to the family that agrees to let me photograph the funeral of a person who died from AIDS for a story on the subject (**4.17**). These contributions are often part of the local custom.

I'm always mindful of the fact that some people from poorer countries I visit look at me as a very wealthy man. And in comparison to workers who toil for a few dollars a day, I am. My camera body alone is worth more than many who I have photographed can make in a year of hard work.

The times I've been asked for money have usually been in high-tourist areas, and taking a snap or two of a person in traditional garb is not what I'm usually looking for—but there's nothing wrong with that. Why shouldn't your subject benefit from the transaction, particularly if you have designs on using the images for public display or to profit from the pictures? (There is more on the business side of photography in Step 10.)

On a recent trip to pre-revolution Egypt where tourism is the driving force in their economy, it was rare when I wasn't asked for a contribution from potential subjects, particularly in iconic tourist areas. When you've traveled a long way, why not take those pictures if there's no time to spend more than a frame or two to establish real connections with subjects for stronger, more natural moments?

Just make sure you carry small bills so that you don't have to show off a large bill in a crowded market or someone's home. Again, having a guide is a great investment and can help you cut to the chase of what you're looking for photographically.

Many more times than I've been asked for money, I have been asked if I could take someone's picture, and I almost always oblige. If that person has an email address, I will gladly email a photo to them—though I try hard not to make promises of sending prints (for fear that I'll forget to keep the promise). But Fuji and Polaroid both have instant-picture cameras available as of this writing, and the gift of a photograph can go a long way in establishing a good rapport with your subject and can be a meaningful token of your appreciation for the time they invest with you. In lieu of instant pictures, there are great little battery-powered printers that can print a digital image in seconds.

THE WARM-UP

Do you ever go out for a shoot and feel a bit uninspired? I suspect you may not always feel like you're at the top of your picture-taking game. Here's an idea that seems to work for me: warming up. Athletes and dancers stretch and limber up; musicians tune up and practice before going live; why not photographers? The idea of mental exercises or warming

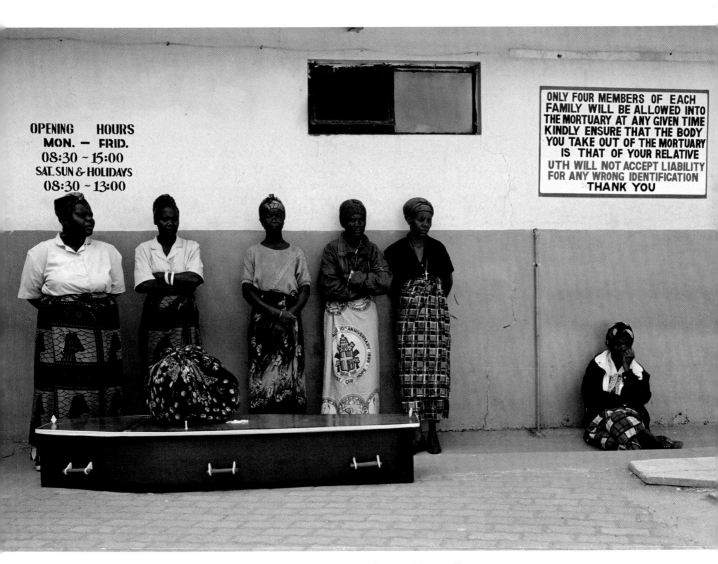

4.17 It is customary for those in attendance at funerals in Lusaka, Zambia, to offer a contribution to help the family. Because of the AIDS crisis, there are so many deaths that families line up to wait to prepare and pick up the body. © Steve Simon

up before shooting may not be part of your process, but when finding your way to that place of concentration, you'll find that it helps (**4.18**).

I listened to a podcast not long ago with a wedding photographer named Joe Buissink. He mentioned a technique he uses to train himself to be a better photographer. Basically, when he sees something that would be a good picture but he's without a camera (not everybody always wants to have a camera with them), he will say the word "Click" out loud, or snap his fingers. This physical act, he says, helps to train him for capturing moments when he is working, making him a sharper, better photographer. Interesting.

I've mentioned previously that when I get to a new shooting venue, before I start shooting I like to get a lay of the land and choose the places where I want to concentrate my time. There are other times, however, where warming up helps break the ice and gets my photographic juices flowing.

4.18 Warming up before a dance class at the Merce Cunningham Dance Studio in New York City.
© Steve Simon

Warming up means picking up my camera and starting to shoot as soon as possible—something, anything as an icebreaker, not waiting for that perfect picture but working up to it by limbering up my photographic muscles.

My best shooting experiences meld the physical act of shooting (which becomes second nature with experience) with the mental and the emotional to get to a place where you're in that zone. I just can't turn it on like a switch; I need to warm up to get to that place.

Putting in years as a newspaper photographer, I often had to go out and find pictures, inspired or not. Those times when I waited for something better instead of stopping and exploring a lesser photo opportunity would often lead to regret, since the missed opportunities were often better than the ones I ended up seeing.

Photographer and author Ben Long (www.completedigitalphotography.com) uses warm-up techniques he learned in improvisation classes. Ben was inspired by the poet and screenwriter Al Young, who spoke at a workshop he attended almost 20 years ago. Mr. Young didn't understand why most people didn't warm up before writing or performing other mental pursuits. "He told us he would write something other than what he was working on, to warm up," said Ben, "to get in the space of writing."

Ben, who has also done some acting, says that in improv you just can't get to a higher level of creativity without warming up. "Warming up helps you to react in split seconds, being physically present and tuned into your environment in a very profound way."

Step four

ACTION: The Lonely Adventurer: Being Choosy

Go to a place that offers a lot of activity in a confined space. It could be a market of any description, an antiques show, a car show; you get the idea. Then take a walk around the entire space, noting the areas that most interest you photographically and have the most visual potential. Then begin shooting at your first choice and spend at least 15 minutes in each of your top picks, working and exploring the scene. Spending more time in areas with visual potential allows you to peel the onion to get beyond the surface to more interesting photographs you wouldn't otherwise see. This becomes a good way to spend time and find your way into the photographic zone necessary to do your best work.

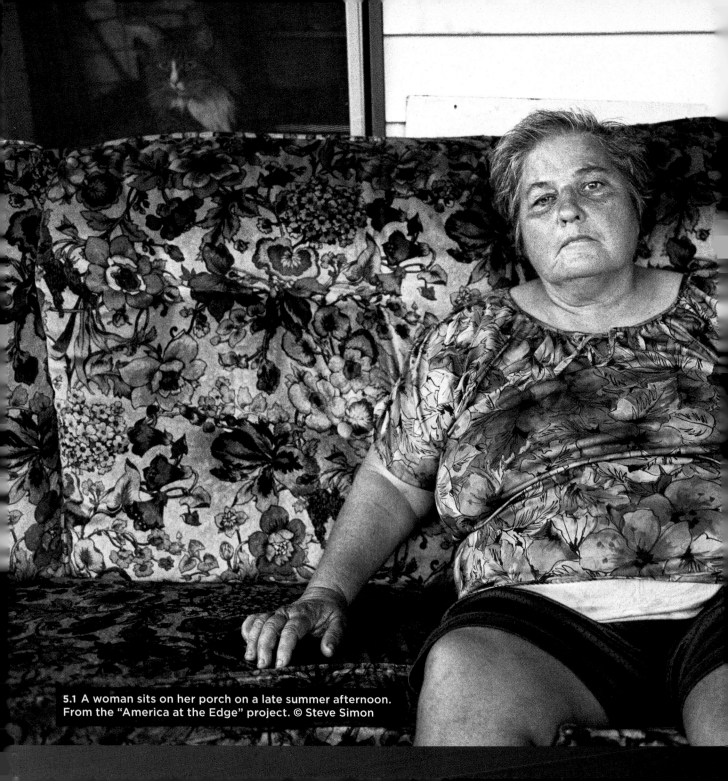

5.1 A woman sits on her porch on a late summer afternoon. From the "America at the Edge" project. © Steve Simon

THE EVOCATIVE PORTRAIT: PHOTOGRAPHING PEOPLE GETS EASIER

"The mask we present to others, and too often to ourselves, may lift only for a second—to reveal that power in an unconscious gesture, a raised brow, a surprised response, a moment of repose. This is the moment to record."
 —Yousuf Karsh

Photographs of people are arguably the most universally compelling genre of photography **(5.1)**. The human face is instantly recognizable and relatable. Strong portraits endure, and they stop time, at that moment, forever.

When I first started taking pictures, I was immediately drawn to photographing people on the streets of my native Montreal. It was a challenge and a thrill. My first street shots were done secretly. I would slink through the streets, inconspicuously capturing moments without engaging or meeting people. As a shy kid, I didn't find it easy to speak with strangers.

But my camera got me over that fear. It was an excuse for meeting and photographing diverse and fascinating people. These encounters have proven to be many of my most rewarding moments and have enriched my life. That said, approaching people to take their picture isn't easy, but it's necessary. I like to give the analogy of jumping into cold water at a lake: it's uncomfortable at first, but when you get used to the water temperature, it feels great.

One of the big takeaways from the Ten Steps is to always stray from your comfort zone, whether it's moving around physically or trying new ways of doing something that scares you. For a lot of people—myself included—dealing with strangers, particularly in foreign cultures, is a big stretch that can be scary. You don't have to do it, but when you do, the rewards can be great. Next I'll suggest strategies that make it easier for you to approach people and get the kind of people pictures you want.

PORTRAITS BEYOND THE SURFACE

It's not that the mug on your driver's license or passport isn't a good picture of you. It's a recognizable depiction, but it often lacks the qualities a good portrait will transmit—revealing something of your character or personality.

My focus in this section is not about commercial portraiture. That's a whole other area of expertise.

The people pictures I speak of are not out to please or flatter the subject, though I hope my subjects like the images we take together. I'm talking about capturing an evocative moment, revealing a truth, a relevant and accurate interpretation of that person from a very personal perspective. No one portrait will truly capture or completely represent a complex person, but your depiction of them can reveal a vision of them on that day; it can tell one story about them. Like Richard Avedon said, "All photographs are accurate. None of them is the truth."

As photographers, we have a lot of power to determine what that final image will look like. We can emphasize or deemphasize physical characteristics through choice of light, angle, focal length, and even the moment we take the shot—which can deliver a variety of different interpretations of the same person, with no two alike. A commercial portrait photographer might choose the softest light and smooth the skin in post-processing, whereas a photojournalist might do the exact opposite, with direct, harsh light and no retouching. Cartier-Bresson talked about how a woman he once photographed was worried about her wrinkles: "It's life; it's a mark of life. It depends how people have been living. This is written on their face. After a certain age, you've got a face you deserve, I think."

When you look at some of the most successful portraitists past and present, their ability to deliver original work is consistent. They have a strong point of view, and the vision they have established includes revealing aspects of the person's personality that engages the viewer.

There is perhaps no more simple-looking portrait technique than that of Richard Avedon, whose stark white backgrounds and imperfection-revealing large-format images exhibited big, powerful portraits that illuminated his vision. Avedon mastered

his technique (which was not so simple) and had a style and look that was instantly recognizable. His images are compelling in their simplicity. When you hear how he described the intensity of the portrait session and his concentration, you understand that he was looking for something—a look, a moment during the session that would express a truth about his subject.

"I often feel that people come to me to be photographed as they would go to a doctor or a fortune teller—to find out how they are. So they're dependent on me. I have to engage them. Otherwise there's nothing to photograph. The concentration has to come from me and involve them. Sometimes the force of it grows so strong that sounds in the studio go unheard. Time stops. We share a brief, intense intimacy. But it's unearned. It has no past...no future. And when the sitting is over—when the picture is done—there's nothing left except the photograph...the photograph and a kind of embarrassment. They leave...and I don't know them. I've hardly heard what they've said. If I meet them a week later in a room somewhere, I expect they won't recognize me. Because I don't feel I was really there. At least the part of me that was is now in the photograph. And the photographs have a reality for me that the people don't. It's through the photographs that I know them."

—Richard Avedon

So maybe you don't want to become the next Avedon, but you do want to improve your people pictures. Doing so requires a melding of many different skills. Your subject can feel and be vulnerable in front of the camera. It's your job to make them feel a part of the process whenever possible. Photographing people tests all your photographic chops; the good news is, you can do it—and I've got a few strategies to show you how.

CANDID PORTRAITURE

My approach to dealing with people is to first not have to deal at all. If I see something happening in front of my camera, I boldly go up to the scene, find my framing, and shoot (**5.2**). I wasn't always able to be so bold, but I learned from experience that if you hesitate, you often miss the shot.

Because I tend to shoot wide angle for the vast majority of my work, when I move in close I get noticed. When someone sees me, my first line of defense is to say, "It's okay, just keep doing what you're doing and ignore me," or something to that effect. Sometimes that's enough for people to just carry on; I've been given permission and can begin to work the scene. Other times, they want more information, at which point I explain that I'm a street photographer and I'm just taking some shots. If that's not enough, I go on explaining why I'm shooting. Often the moment is gone or it just isn't the same, and that's okay. Other times it gets better. But thus far, I've managed to stay safe and out of trouble.

Some say it's better to beg for forgiveness than ask permission. Magnum photographer Bruce Gilden wanders the streets, camera and flash in each hand, and quickly moves into the faces of oncoming pedestrians, popping the shutter and flash at the same time—usually before the subject knows what just hit them. It's an effective technique and Bruce's work is incredible, but most people find his way of working too intrusive for their own taste.

In the end, everyone's comfort zone is different, but to get the shots you want, you need to stray from it.

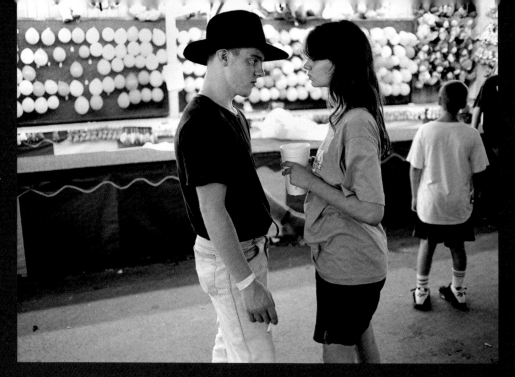

5.2 This couple never saw me, even though I was just a few feet away with a wide angle lens. Sometimes people notice; other times they don't. I have strategies for all cases.
© Steve Simon

ACCESS IS EVERYTHING

As photographers, we need to be bold in order to find the best place and angle to shoot. Gaining trust and access is crucial, because once you have permission to shoot freely, you can do just that and work the situation as detailed in Step 3.

Access and permission needn't be formal. When I photographed the people on election night in Harlem who gathered to watch the results on a big screen, I would stand in front of them, camera dangling around my neck or in my hands. With a nod or a look, communicating without words, I would get a green light to shoot, and they would continue to watch election results or just ignore me so I could capture real moments (**5.3**). This is often the technique I use to get close to people with a wide or normal lens. Even when you're in a foreign environment and don't speak the language, you can use expression and gesture to "speak" with those you encounter (**5.4**).

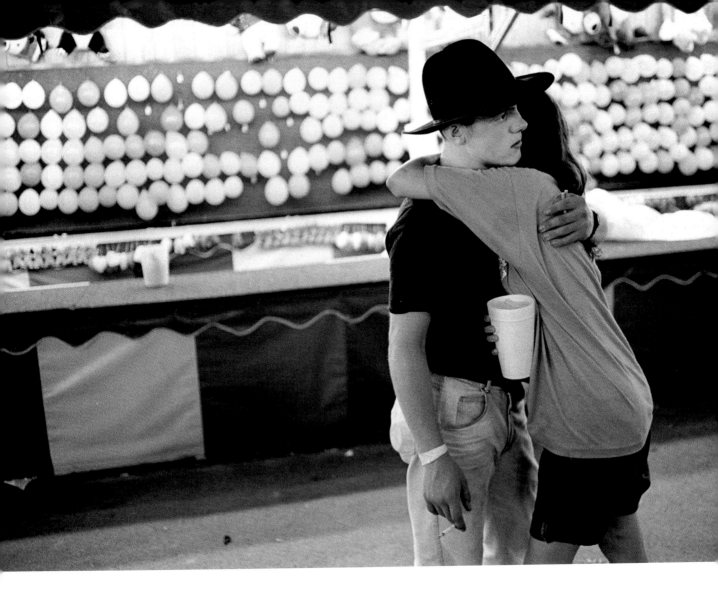

But as much as I like getting in close, you need to work up to it. Most people don't appreciate having a lens stuck in front of their face. Establish the relationship and warn people you may move in closer, unusually close. If they are prepared for it, they won't react negatively and you can get the shot you moved in for.

5.3 (Following pages) There's an intimacy that is communicated by moving in close with a wide angle lens when photographing people. On election night in Harlem, I photographed people watching results on the big screen. Most people don't appreciate having a lens in their face so you need to work up to it. You can often ask permission without words, with a nod or a glance and once you have permission, you can get the shots you moved in for. Keep the camera as perpendicular to the ground as possible to minimize distortion. © Steve Simon

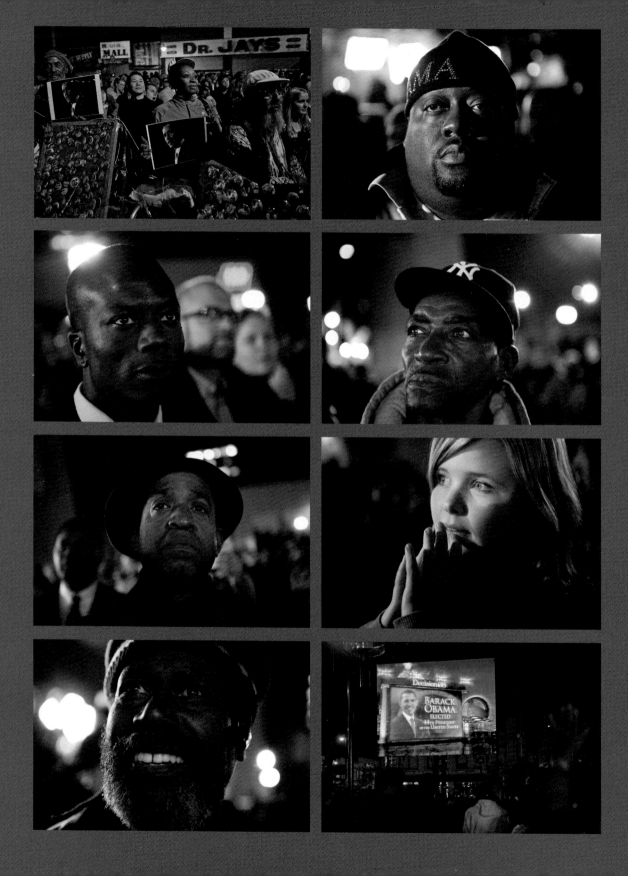

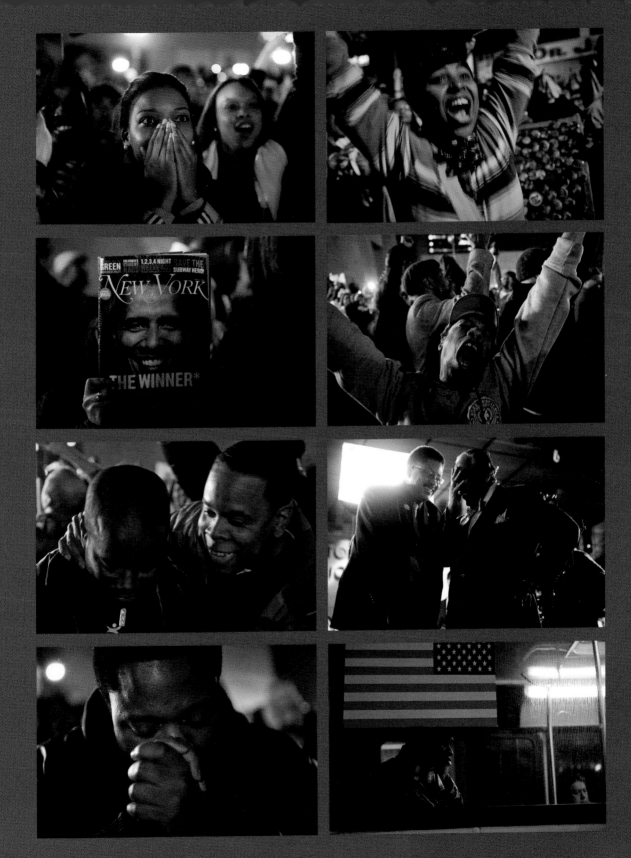

5.4 Photographing at the Republican Convention in New York City, I met this Lincoln impersonator. I was right in front of him with a wide lens, and he simply looked my way. You can often ask for permission without words—with a nod or glance—and the moment stays pure. © Steve Simon

TALK TO STRANGERS

Depending on your shyness level, it can take varying amounts of practice to figure out your own strategies for getting close with strangers in order to make the images you want.

If I see a person I want to photograph, I don't ask if I can take their picture. I ask if I can speak with them for a moment, because even if they agreed to let me take a shot, their expectation would be just one or two frames. But I don't want to take just a couple of images. I want to take several because I know that the best pictures often come as the shoot evolves, and as my subject and I get more comfortable together—many, many frames down the photographic road.

If they agree to talk, a conversation is started and my odds of getting their permission increase. In my experience, most people are polite and agree to a shoot after an explanation of my intentions (**5.5**). Some ask why, and my answer ranges from my general passion and philosophy for documenting life with my camera to explaining a specific project or assignment I am working on. I am ready with an elevator pitch that is honest and sincere.

Many people just don't understand why you would want to photograph them since they are not famous or related to you. Why would you want a picture of someone you don't know? In my experience, a first polite "no" can move to "yes" through a photographer's sincerity and enthusiasm. Most people end up feeling flattered.

Often times my conversations with strangers spark new visual ideas and my initial attraction to them as a subject deepens into something stronger and more meaningful as we talk (**5.6**).

This process is different for every photographer. You need to figure out your best approach and let your instincts be your guide. It will take practice and you will be rejected at times (you can't take it personally; they don't know you), but you shouldn't give up. If you stick with it, you will get some great images, your confidence will build, and the accomplishment of getting past your fears by leaving your comfort zone will feel great and transmit to other areas of your life in a positive way. Don't be shy about approaching strangers. If you want to speak with someone and don't, the next time you want to approach someone it will be even more difficult.

5.5 I walked into this diner in Bethlehem, Pennsylvania, and encountered these customers. I explained that I wanted to take pictures, and after a while they forgot all about me and I was able to capture an authentic moment. People often don't understand why you would want to take their picture, since they don't know you and they are living normal lives away from the public eye. But when they realize your intentions, they will often allow you to proceed with the session and take their picture. © Steve Simon

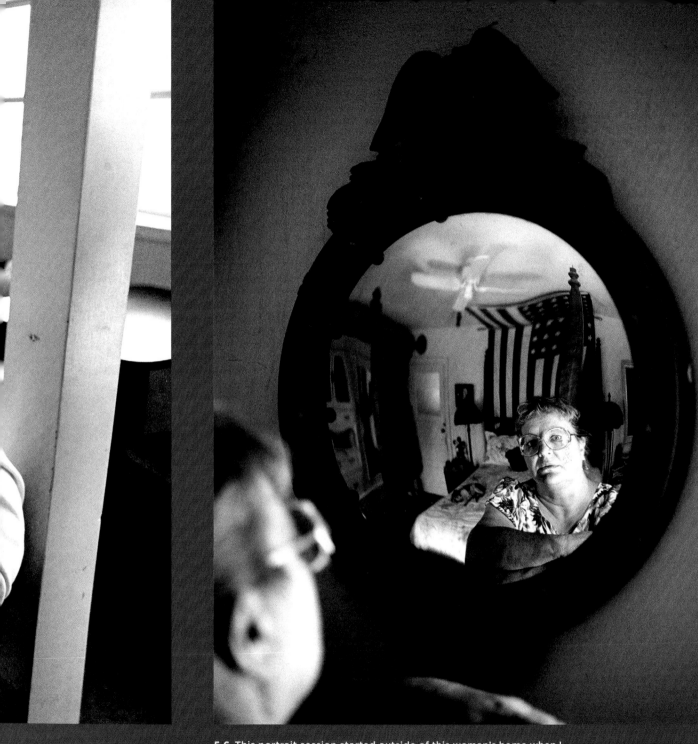

5.6 This portrait session started outside of this woman's home when I spotted her talking with her sister. As our conversation progressed, I told her about my "America at the Edge" project. Our talk turned to patriotism and she mentioned she'd had the American flag over her bed for years. Often, conversations with strangers lead to better and more interesting photos.
© Steve Simon

5.11 Winston Churchill by Yousuf Karsh, 1941.
© The Estate of Yousuf Karsh

How hungry are we for something better than ordinary? Just watch the seasoned photojournalists covering the White House and see how the volume of shutter noise goes up when the President does something, anything, such as a simple gesture like raising a hand or pointing a finger.

We photographers are hopelessly optimistic, always hoping for something good, something better. Work it to the maximum. If things aren't gelling, try a different tact. Move the session outdoors or to a new environment. Change lenses or just take a break to regroup and brainstorm with your subject.

When Yousuf Karsh removed the cigar from a startled Winston Churchill during a photo session in 1941, the resulting portrait of Churchill's scowl captured his grit and determination and was perhaps Karsh's best-known work (**5.11**).

FORMALITY

The human face is usually the most important element of any portrait. There are infinite variations of expression, each revealing and communicating something different. When you look at a great portrait, you not only see, you feel. William Albert Allard says he strives to make portraits that make you think you know a bit about the person: what he does, what he might like, what his life might be like, even what music he listens to.

And often, it's all about the eyes.

In the days of film it was literally impossible for me to edit portraits from a negative because the eyes were all important to the success of the image, and a slight, intangible difference between frames would often make or break the portrait. It has become a cliché to say that eyes speak volumes and communicate what can't be articulated.

Eye Contact, Or Not

When your subject makes direct eye contact with the camera, they have the same powerful connection with the viewer of your photograph as they had with the photographer. Therefore, if your subject is willing to reveal to you something below the surface, that deeper communication will be transmitted in your portrait (**5.12**).

The direct gaze can be powerful, but so too can a look beyond the camera. I often joke to the subject, telling them not to look at my camera but beyond it, toward the future. These types of portraits are often very natural looking and can appear candid. There is some debate as to whether or not they convey the same honesty of a direct look at the camera, into the eyes of the viewer of the portrait. It's a good idea to try both ways and figure out during the edit which one works best.

Be Ready for Spontaneity

After all these years as a photographer, I sometimes surprise myself with the results of a shoot. An image I thought was "the one" in the field ends up not quite working like I thought, whereas another

5.12 In a series of photos at the Twins Festival in Cleveland, I chose some images where the subjects were looking directly at the viewer and some where they looked away. When I have time in a portrait session, I always try to do both. © Steve Simon

forgotten moment ends up in the final selection. Part of the reason for this is a look or a gesture; a spontaneous happening you capture on impulse is fleeting and may not have been consciously seen. These photographic surprises are one of my greatest joys of photography. You need to be ready with the reflexes of a sports shooter to capture these moments, and it's good to encourage spontaneity through interaction with your subjects (**5.13**).

It is the small and subtle elements that can vault a good portrait to greatness; to get there, you need to work your subject and situation hard, all the while hoping for and encouraging spontaneity. I know from experience that some of the best moments happen after the shot is taken, when people relax. This is a time to stay sharp and keep shooting (**5.14** and **5.15**). You need to be ready for the unexpected. It's nice to spend a lot of time with someone and get a natural real moment, but the time it takes is not always possible.

Often in the strongest portraits, the people photographed look comfortable in the presence of the photographer. Keeping your subjects comfortable and involved in the process should be at the top of your list, since any portrait session really is a collaboration, a team effort. Sometimes that might mean sacrificing the best possible light or angle. Content and expression usually trumps technical perfection.

To make your subjects feel at ease often requires the photographer to take control. You should be confident in your demeanor and in your technical prowess. If you are working on a longer-term

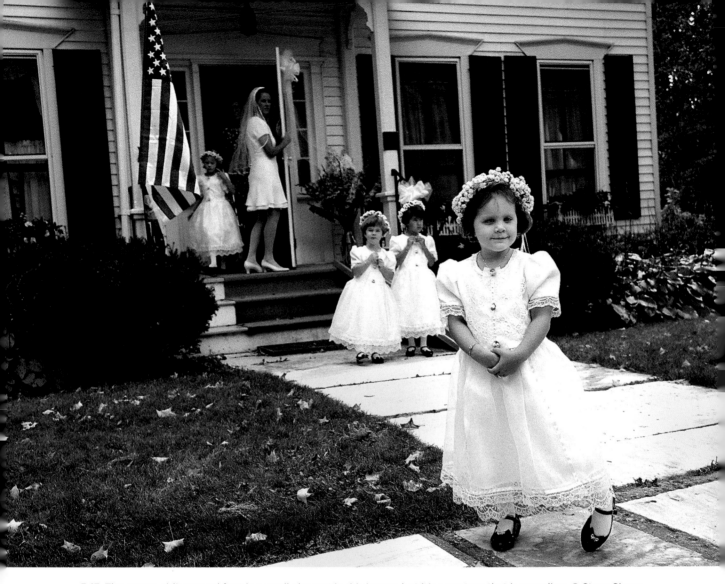

5.13 The young girl's curved foot is a small element in this image, but it's a gesture that is revealing. © Steve Simon

people project, spend time in the environment where you will work, and be patient. It takes a while before people relax, accepting you as part of the community.

Let's face it: most subjects are not professional models and are not used to having their picture taken. Just think about your own experiences in front of the camera. Most photographers I meet have felt the panic of being photographed and feel much more comfortable behind the camera. It's not easy being the subject, so anything you can do to

make the experience a positive one will further gain your subject's trust.

With your subject not knowing exactly what to do and looking to you for guidance, it helps to put them at ease by providing confident direction. Even if you don't feel so confident, the "fake it till you make it" rule applies. You need to be in control of the session but walk a fine balance, knowing when to pull back and let the subject be. Sometimes awkward silence can bring about a real and true depiction of your subject.

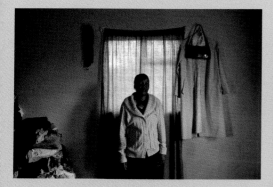

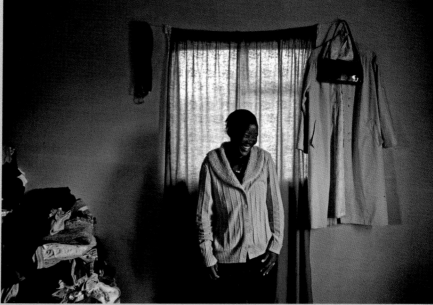

5.14 and 5.15 You need to stay ready. Almost expect good things to happen when the formal part of the photo session ends, because that's when people often let their guard down and the best portraits happen. © Steve Simon

WORK WITH ME, BABY

You may need to actually keep the subject from talking at times, and silence is welcome to avoid unflattering facial gestures frozen in time as a person talks—not what you're after. If possible, make sure distractions are at a minimum, which includes people who may make your subject more self-conscious.

It sometimes takes a while for people to relax and be themselves, but your confidence can help this process along with gentle encouragement as your shoot evolves. If you're struggling—technically or otherwise—your subject will sense it, and maybe even blame themselves for things not working. It's hard to recover when a shoot deteriorates.

As you know by now, I'm not a fan of sharing the image I just took on the back of my camera. It can deflate momentum that builds during the shoot, and there have been times when the person sees themselves and hates how they look, which is also difficult to recover from. That said, my colleague, photographer Joe Holmes, says he sometimes uses the image review screen as a way to diffuse tension. When he's on the street shooting and someone notices him taking their picture and appears to become confrontational, Joe goes over to them and says, "Hey, just got this great shot of you, take a look..."

Lessons Learned

THE CHIEF

For the portrait of 95-year-old chief Alina Seqhibolla, the light outside was bright and harsh. When I asked through an interpreter if we could photograph inside, she agreed. Once inside, however, I realized just how dim it was. The only light entering the one-room home was coming in from the door, and there was a small window near her bed.

I didn't have time to set up any flash equipment and I knew—with my D2x at the time—that I didn't want to raise the ISO any further; I wanted to keep it low for maximum quality. So with my camera and 17–55mm f/2.8 lens wide open at f/2.8, I braced myself and shot a series of images at 1/8th to 1/15th of a second (5.16–5.21).

I knew that many of the images would be blurred because of a combination of camera and subject movement, so I put my motor on high and took bursts of images, knowing from experience that some would be sharp.

The other problem I had was that Alina's facial expressions were often contorted, and I needed to take many more images than I normally do to get the one shot that depicted who I saw: this noble and dignified woman who was the respected elder and chief in her village. Out of literally 100 frames taken in the space of just a few minutes, this was the only image of its kind, the one I was hoping to get (5.21). Working it and a little luck will help make things happen for you. ▪

5.16–5.21 A series of near misses, all shot at slow shutter speeds, led to the final successful image.
© Steve Simon

THE PORTRAIT ASSIGNMENT

Throughout my career, portrait assignments have proven to be a wonderful way to connect with new people, and sometimes they lead to new jobs and new friendships. Most importantly, they have provided me with opportunities to hone my relationships with my subjects and let me become more comfortable photographing people.

When an assignment comes in, I quickly do my research. Even if the person is not well known, often there will be access to an image of what they look like on Google Images, which helps me prepare and pre-visualize, along with seeing how other photographers have interpreted them in previous portrait sittings.

The assigning photo editor usually lets me know any expectations for the portrait and how it will be used. If it's needed for a specific story, sometimes a draft version of that story is available and can stimulate ideas for the shoot. It's nice when the editor allows you the freedom to come up with your own ideas for a portrait (**5.22**).

After my research, I usually have an idea as a starting point, even though I may not have any idea of what our meeting place will look like. That said, I try not to get tied to preconceptions since new and better opportunities often present themselves, and I want to be open to them. When I arrive at the portrait session, the first thing I do is scout out a location. I look for the available light as well as relevant and aesthetically pleasing backgrounds. Time is often short, so your first choice of background may be the only opportunity you get (**5.23**).

"By now I've learned that the most important thing to do when you photograph somebody in a room or outside is not look at the subject but at the background."
—Alfred Eisenstaedt

The environment you put your subject in will speak volumes and can aesthetically enhance the portrait, providing compositional emphasis on your subject. Look for symbolism, icons that can be subtly included within the frame. The background doesn't have to be obvious or literal, and perhaps you will decide to shoot with selective focus to throw the back- and foreground out of focus to add emphasis to your main subject. It's amazing how little needs to be sharp in the background yet still "read" well while emphasizing your subject as your main focal point.

Usually the more time you have, the better, but you don't want to overstay your welcome. Fight to take the time you need but sense when the subject is getting weary.

It's a good idea to try different setups, varying depths of field and different points of view. Learn through experimentation. Close-ups of the face, stepping back to reveal the environment, and then even further back, will give you options, so work it and edit later. As so often has been my experience, the simple compositions are often most effective; the less-is-more rule is in effect.

5.22 The strength of the grandmother's hands tells the story without including her face in the portrait. © Steve Simon

5.23 Once I find a great backdrop, then I can go to work concentrating on the moment and expression. © Steve Simon

5.24 *On the Waterfront* Academy Award–winning writer Budd Schulberg. I had time to meet with Mr. Schulberg, collaborating with him on the portrait session and which locations might work best. © Steve Simon

I love it when I can meet with the subject before the shoot, talking about the session and listening for suggestions while letting them know what I'm planning. It's a collaborative effort. I usually start by letting people just do what they're going to do, without manipulation. After the initial conversation, I try not to talk too much during the session, just the occasional gentle direction and guidance and encouragement. I need to be in the zone, concentrating, keeping my eye on the prize: a strong and evocative portrait (**5.24**).

Having the subject do something with their hands is worth trying—resting the chin on the hand, for example—but I always like to try out what I may ask them to do to see how it feels. It's a good idea to start collecting tear sheets of portraits that inspire you, images you can emulate and improve upon as you develop your own portrait style.

THE LIGHT

A lot of important elements go into making a great portrait, and you should never underestimate the quality of light. Good lighting can help tell the story of the person you are photographing. We need to control it, contain it, manufacture it, and finesse it to do our best work. It doesn't have to be complicated, but lighting your portrait subjects should be consistent and appropriate.

In Step 6 you'll learn how to follow the light. Light is always changing, and the right light is not always there when you need it. The need to control the light and shadow in our portraits is one of our most difficult and challenging tasks. I'll discuss a few easy ways to put the available light to work for you and enhance it with a few simple techniques.

Then there is the quality of light. A cloudless midday sky with a small orb of a sun creates hard-edged specular light with harsh, deep shadows, emulated by the bare bulb of the on-camera flash. But when photographing people, you're often looking for a soft light.

Bigger Source, Softer Source

The bigger the light source, the softer the light, and the closer the light source, the softer the light. The characteristics of light include color, quality, and direction; and the same principles apply, whether it's light from the sun or your flash.

5.25 A softbox, or light diffuser that fits over the strobe, was used here and resulted in a soft, flattering light.
© Steve Simon

When the sun is behind the clouds, it illuminates a large area of clouds that become the light source, blanketing the earth with a softer, lower-contrast, almost shadowless light. This portrait-desirable soft, diffuse light of a cloudy day or shaded area is emulated when you bounce a flash off a wall or ceiling. The large area of the wall or ceiling becomes a big, soft light source. This is important to know, since the best piece of advice I can offer you when it comes to flash is to get it off the camera, physically or by bouncing the flash-head off a wall or ceiling (**5.25**).

The direction of light is also important because direction determines where the shadows fall, and the interplay of light and shadow creates the illusion of three dimensions in a two-dimensional photograph.

Because light is so important to the portrait, one of the first things I do is access the natural light and then consider how I might need to enhance it with a reflector disc or a flash. Can I move my subject to areas where the light is nicest for the portrait? I'm looking for the shaded areas, or I might want to backlight them by placing their backs to the sun and

adding a couple stops of light, which overexposes the image for a soft light on the subject and dramatic, blown-out highlights in the background.

If I determine the available light is not perfect, I want to use flash in a way that looks natural. Emulating a bath of soft window light with a simple bounce off a wall can provide spectacular results.

Keeping It Simple

One of the misnomers of flash photography is that it's for when the light is low. I actually love to ramp up the ISO and see what the available light does, because if the light is even, in dim situations it's often better to let the available light illuminate the scene than have a flash take away the mood of the light. In very bright light, flash can be a big advantage, filling in harsh shadows for more pleasing results.

As you've learned by now, I always recommend keeping the technical simple, so you can spend your time dealing with the subject, moment, and framing. For this reason, I'm going to talk about what you can do with just one supplemental light or reflector, and you can do a lot. It's not hard to add a second "hair" light or a third fill light to your main

ones for more traditional corporate editorial work, but for now, we'll keep it simple.

When you've chosen your spot, you need to really look at the light. If it's soft and even, you may not need to add light at all. As mentioned before—but it bears repeating—today's amazing digital sensors give you beautiful results when the light is low, even without the need for flash.

But as a professional who encounters a wide range of different photographic situations, you need to be able to deliver great photos when the light is not so even or great. I often use those small spring-loaded reflector discs that come in white, silver, and gold. These discs work particularly well when your subject is backlit; you use the disc to reflect the light back, bathing your subject in soft white light, or you can create harsher but still neutral light with the silver reflector (**5.26**), or warm up the light with the gold reflector.

I find the gold reflector a bit too much for my taste and prefer a more neutral light, which I can warm up in post-processing if I want to. If I'm working without an assistant, I might ask a bystander to help me by holding the reflector. Sometimes I travel with a light stand and clamps that I can place a flash or reflector on. It takes some practice, however, to determine the angle that works best with these reflectors, and in bright light, you need to be careful not to blind your subject as you adjust the angle of the reflector, causing them to squint into the camera. Start with the reflector down at your feet and gradually move it angled up to "find" the light to reflect back at your subject.

With one camera and one flash, there's a world of light you can create to best tell the story of your subject, and it's not hard to achieve. Every flash picture is really two images in one: an ambient light exposure controlled by how long the shutter stays open (shutter speed), and a flash exposure determined by the power of your flash and the aperture setting.

By managing both of these "exposures," you can choose to have the flash dominate the exposure or make the ambient light dominate, or you can balance the light equally, all by manipulating shutter speeds and apertures as well as ISO.

5.26 A light was reflected back into the faces of the family by the silver reflector in the shot on the right, which can make a huge difference in unflattering and harsh light. © Steve Simon

5.27 Fill flash added catchlights to the eyes of this cowboy at a rodeo in Raymond, Alberta. © Steve Simon

Usually I have an idea of what I want to do with my subject, and I start with an ambient exposure to see what the scene looks like and how I want to use flash to tell the story of that person. Often it's the ambient light that tells the story of the environment and I can enhance the mood by keeping it bright or subduing it by darkening it.

We are all about taking control to make the kinds of portraits we want. So learning your flash by choosing to use the manual setting is a good idea since you'll always get a consistent output for predictable and consistent results, and many of today's flashes afford you the flexibility of shooting from full power to 1/128th power, a seven-stop range. Then it's a matter of trial and error to determine the right exposure and balance of flash to ambient light.

That said, these days, through-the-lens (TTL) flash takes care of all the guesswork for you. TTL flash gives you perfect exposures much of the time while allowing you to choose your shutter speed for controlling the ambient light, and it's something I've learned to trust (**5.27**).

I also love the look that high-speed sync now allows, letting you shoot with the Nikon or Canon system, for example, using your flash at shutter speeds of up to 1/8000th of a second. You can now

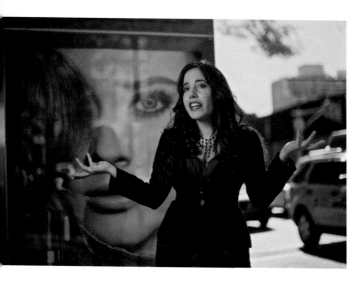

5.28 By using high-speed flash sync, I was able to photograph this woman in bright noon daylight with one SB-900 flash at a high 45-degree angle to the subject, at f/1.4 for a studio-like light and great selective focus to add emphasis to the subject. © Steve Simon

5.29 A flash positioned at a 45-degree angle and up high helped separate author Dennis Lehane from his background. © Steve Simon

let the flash dominate the scene and work with wide apertures for shallow depth of field, emphasizing your subject's eyes. But the high-speed sync drinks up a lot of battery power, and if you're using it regularly it's a good idea to look into a supplemental battery pack system.

Most camera systems let you wirelessly place your flash wherever you want and trigger it. An off-camera, 45-degree angle that's up high is a great starting point for you to experiment with. I sometimes use the TTL connecting cord with my flash, which lets me hold the flash off camera in one hand and shoot with the other. The simple process of taking the flash off the shoe and using it in this way lets me give my subject a natural, three-dimensional light (**5.28** and **5.29**). I like the cord in these situations because it's consistent and always fires. Occasionally, when using wireless systems—particularly without a radio slave—if you block the infrared window the flash won't fire.

Because of the great high ISO sensors now incorporated in digital cameras, I'm experimenting more with continuous light sources. There are a variety of LED daylight-balanced lights on the market that let you add small amounts of light to highlight your subject subtly from the environment surrounding them. With continuous light you don't get the intensity or short duration of flash, but you can see as you go, which can really speed up the process in fast-moving situations, particularly when you can have a two-legged light stand move with you and your subject, aiming the light where it needs to be.

You'll quickly learn best practices through the jungle of mixed lighting a people photographer is likely to encounter. With experience and practice, you'll learn to quickly figure out the best lighting fixes for difficult situations, so you can get to the important stuff, like dealing with your subject and capturing a strong and dynamic moment with great light.

Step five

ACTION: **The Evocative Portrait: Dreams and Fears**

Photographing people gets easier, and being able to connect quickly and meaningfully is a skill that improves with practice. I know that for many of you, photographing people and going up to strangers is a one-two punch outside your comfort zone. All the more reason to take on this Step 5 challenge.

In a busy public place, go up to three people you don't know, camera around your neck, and start talking. Tell them who you are and what you are doing. You can use this challenge as your reason for starting the conversation.

See if you can convince your subject to tell you their biggest fear. It could be the fear of public speaking, fear of death, fear of flying, anything. You probably want to lead up to this request—don't hit them with it at the beginning of the conversation. Or you can choose to ask them what their secret dream is. It might be what they would be doing if they had a wish that would come true. Or it might be a dream they had when they were a kid, one that has yet to come

true. If you can encourage the person to open up to you, you may want to record the answer and then take a portrait of them. You want your subject to have enough time so that you can work the session and try a few different things.

The portrait should reflect their dream or fear. You might ask them to think about it when taking the picture—if it is appropriate to do so. Get some images where they make eye contact and some where they don't. Be aware of the entire frame and watch the light, perhaps altering your location for a better background and light. Go for a very tight close-up, or a long shot silhouette, whatever works. Think moody. Be creative.

The more you approach strangers in a friendly way, the easier it will get and the more confident you will become. This step can be very challenging, and not all subjects will have the time or the inclination for you to pull this off. Don't be discouraged if people refuse; persevere and you will be rewarded.

6.1 Natural light is always changing but rarely does it change this fast, as fire-breathers create fire and light during the Saint Jean Baptiste Night's Parade. © Steve Simon

FOLLOW THE LIGHT... AND LEARN TO MASTER IT

"Light makes photography. Embrace light. Admire it. Love it. But above all, know light. Know it for all that you are worth, and you will know the key to photography."

—George Eastman

In the perfect storm of image elements that make up a great photograph, the odds are against us. Finding great light and strong content, then figuring out the best camera angle and framing, capturing the decisive moment with the right lens, with the focus locked on, and with the best (and correct) shutter speed/aperture combination for that image is no easy task, particularly when many of these things are out of the photographer's control. You don't need them all to come together for every photo to be successful, but why settle? Aim high. When the planets align, it's that rare great picture we're always striving for.

A way to increase the odds is to find and follow the light, because where there is great light there are great photographs to be made. Light helps tell the story of the photograph; it can set the mood. The right light will transform an otherwise ordinary scene into something extraordinary.

With light being so crucial to our photographic success, it makes sense to find the good and interesting light, then photograph where it falls and follow it as it moves. Or be patient and wait for the light to come to you as you photograph a majestic landscape, studying the light as it changes and shooting as it does, so you are present and ready when it's at its most beautiful.

Over the course of my career, I have had great opportunities to observe and record light at different times, seasons, and places in the world. I've come to realize just how fast it moves and changes. Landscape photographers know a sunrise or sunset may require the reflexes of a sports photographer when the sun dips below the horizon and white clouds turn pink, but only for a fleeting moment (**6.2**).

There is really no bad light per se, but perhaps there is inappropriate light depending on your

6.2 Light is always changing, which is why you sometimes need the reflexes of a sports photographer to capture it before it goes away. © Steve Simon

subject matter. There are pockets of harsh midday light in the city illuminating street life in strong graphic ways, which can make great photos (**6.3**). The bold, harsh light may not work for a portrait but might be ideal for architectural details. These scenes are often high-contrast—sometimes beyond the capability of a digital sensor—forcing decisions on what's most important, shadow or highlight detail.

The bigger the light source, the softer the light, so on overcast days that small orb of the sun lights up a large area of the clouds blanketing the sky, which becomes a giant soft light source for much less

contrasty light with less distinct shadows created. Colors are often muted and more saturated. Bad weather often equals great light. When light mixes with smog, fog, rain, or snow, the results can be breathtaking.

As the sun goes down and the ambient light combines with natural light, it's still a good time to shoot, followed by the often stark and contrasty nighttime light with its unique photo possibilities and challenges. As we follow the light, pay close attention to the quality of low light, since—with the high ISO capabilities of many DSLRs—we can now

6.3 All types of light can be appropriate—depending on the subject matter—and it can add to the narrative of what the photo is saying, as with this image of a young man looking toward Ground Zero in New York City. © Steve Simon

6.4 Sometimes I just let the natural light be. In my experience, it's not about quantity of light, especially with the high ISO capabilities of many digital cameras these days. It's about the quality. The Mate family in their home in Mabote, Mozambique. © Steve Simon

record it like never before. We have become pioneers in a new era of available light photography; if you can see it, chances are your digital sensor can capture it with a quality never previously possible. Success is no longer dependent on quantity of light, but *quality* of light, even in small amounts in dim places. Throw a tripod into the mix and there truly are no exposure limits. See how long exposures affect the light for ethereal images of clouds and water recorded over time.

I often much prefer the mood and nuance created by available light (**6.4**). I tend to think of flash, reflectors, and other supplementary light as a way to enhance and fix the available light when necessary. For my taste, low light—particularly when it's an even light—usually yields much better results than anything I can create with flash, except the odd light touch of fill. It's no great surprise, because often the goal for masters of flash photography is to emulate natural light. Given the opportunity, I like to photograph a scene both ways and learn from the results.

6.5 There's never a bad time to take pictures when it comes to light. Car lights are reflected in the metal fence in Kigali, Rwanda. © Steve Simon

So with all this great light, how's a passionate photographer supposed to take any time off? We love what we do, and it's nice to know there's no bad time to take pictures; there are great pictures to be had any minute of every day (**6.5**). As you begin to look at and follow the light, it opens your eyes to photographic possibilities you might not have noticed before, which can help you see the world through your viewfinder more clearly, boosting your photographic confidence.

Observe how the light changes relative to your camera position as you do the compositional dance to find new angles, and also see how light direction affects your subject. The direction of light is an important consideration and can be used to your advantage.

Side light and back light are two powerful ways to use light, and they're determined by your camera position relative to the light source (**6.6** and **6.7**). Portrait photographers know that when you photograph people with their backs to the sun, harsh light falls on their backs and it's the indirect soft light illuminating the face. But backlighting is tricky; you have to find the right exposure, usually overexposing the scene dramatically, and sometimes the resulting flare enhances the picture (but sometimes not). Backlit flare can be nice but it's unpredictable, and every lens creates different degrees of it. You must have experience to use backlit flare with consistency.

I love the occasional backlit silhouette, but for greatest effect the shape of the silhouette should be recognizable. Capturing a silhouette this way

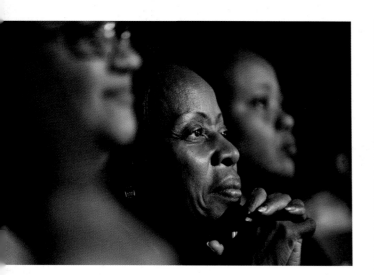

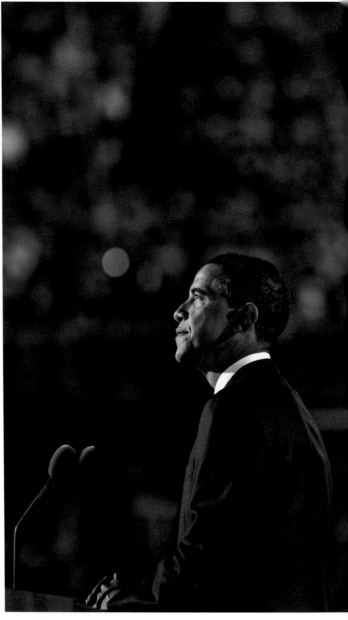

requires skill, patience, and timing to avoid blobs of black on light. I try to position myself so that I can catch the perfect profile of a person, for example, and work it as silhouetted figures move.

FOLLOW THE LIGHT

Every shooting situation requires a photographic strategy. How will I shoot this? Which lens, which shutter speed/aperture combination? What do I need to do technically to achieve my goal of creating an image that tells the story I want to communicate about this place, event, or person?

Adopt a similar strategy for following light. When you go outside, observe the light. Where is the sun? As you look around, notice which areas are in sunlight and which are in shade (**6.8**). To begin, go to where the sunlight bathes the scene. If it's too harsh for the subject matter you're looking at, there are likely shady alternatives nearby. There's also reflected indirect light, which can be soft and beautiful.

I like to keep notes on observations I make about light, including times and places when I notice the light is particularly interesting but I don't have time to stick around and wait for pictures.

6.6 and 6.7 Side light is a great light for people pictures; it's soft yet reveals texture, which shows form and depth. © Steve Simon

6.8 When you're observing light, notice how much it can change, and how quickly. © Steve Simon

Lessons Learned

FIND THE LIGHT AND STICK WITH IT

My focus has always been about content first and everything else second. I found that my obsession with content sometimes meant I wasn't paying attention to light, and the work suffered. As with great news photographs, content can trump all the other elements in a compelling, technically challenged photo. It took me a while to understand that combining good content with great light would be the best starting point for me and my camera.

Experience has taught me to rely on instinct for choosing people and places with visual potential, and then to be patient. Sometimes you have it all—the landscape, the gear, the exposure figured out—you just need to be patient and wait for the light to come. Light is often the transformative picture element that is worth the wait.

The beauty of working on a project or theme is it lets you revisit a place more than once and to view it in different light. If you didn't get it the first time, perhaps the light will work better the fourth or eighth time. When I visited the taxi rank in Maseru, Lesotho, I looked for the light and started shooting in that area. I stayed in the one place where the light was great, taking a variety of shots of passersby, until the warm glow of the setting sun faded. Very little post-processing was needed to enhance what the sun was doing (6.9–6.14).

I think one of the great things about light in the natural world is that you just can't predict it. You can hope for the best, and sometimes expectations are exceeded, but you won't know for sure until you experience it. No two sunsets are the same, and part of the joy of photography is this serendipity of light.

We follow the light to put the odds in our favor, which means planning to shoot when the light is best—and that's often early morning sunrise and later afternoon sunset. When you drag yourself out of bed for sunrise, you're often rewarded. Sunrise and sunset have long been a favorite shooting time for the three-dimensional qualities they bring to our two-dimensional images. ▪

6.9–6.14 The golden glow of the setting sun bathes the scene in warm light, which helps minimize distracting colors. © Steve Simon

6.15 Children photographed in the golden hour. Manica Province, Mozambique. © Steve Simon

A NOTE ABOUT POST-PROCESSING

This book has been about taking control of the photographic process. Remember that we're not done dealing with the light in the photograph until we've interpreted the final image in post. Post-processing lets you lighten, darken, saturate, and desaturate specific areas of your image to add emphasis and lead the viewer's eye within the frame. Small, subtle dodges and burns can make a big difference in your final result. We can finesse the scene with amazing precision, and it's our second chance when dealing with color. Distracting colors can be desaturated, whereas others can be made more intense in precise measures.

COLOR

Before I talk about using color to your advantage—and the ways to get accurate color renditions of your scene through white balance settings—here's a quick warning about color.

It's not easy to make great color photographs because color can also be distracting, taking your eye away from the focal point of your image. Just as your eye is drawn to light areas in the frame, certain strong colors can have a similar effect. Harsher light can bring out the contrast between colors, sometimes washing them out where they fight for dominance in your composition. But color can also be soft and inviting (**6.15**).

This is why the golden hour, that coffee-commercial light at sunrise and again at sunset, is a time many photographers choose to shoot. At dusk and dawn, when the sun is low in the sky, not only are shadows and textures most pronounced, bringing a three-dimensional look to the landscape, but the light is often a golden color, immersing the scene in warm and even light. It has the effect of toning down any potentially distracting colors by bathing all colors in a warm glow.

Many people enjoy capturing a beautiful sunset, but when the sun dips below the horizon, they put their camera back in the bag and go on with their night. But don't leave yet, because when the sun goes down (or before it rises) there's a time when the sky takes on a deep blue color. It's called the "blue hour," a phrase originally described in the writings of the famed entomologist Jean-Henri Fabre, who described it as a moment of transformation at dawn, the transitory phase when nocturnal insects calm down and daylight insects awake, before the birds begin to sing (**6.16**).

From a photographer's perspective, the blue hour refers to the twilight morning/evening light that is somewhere between complete darkness and subdued, fading daylight.

6.16 A two-second exposure during the blue hour. © Steve Simon

It is a particularly good time to record cityscapes, where warm artificial light complements the deep blue sky nicely. I've always known that some of the best twilight photos can be captured when the sky is not yet pitch black, where enough ambient light exists to act as a reflector and fill in the dark areas of the scene where no detail would otherwise record on the sensor. There's even an iPhone/iPad app to predict the blue hour in your geographic location.

COLOR TEMPERATURE AND WHITE BALANCE

All light sources emit light of a certain color. From the warm reds and yellows of sunrise, sunset, and incandescent lighting (low-numbered color temperatures measured in degrees Kelvin, or K) to the cool blues of open shade and twilight (with high color temperatures), our eyes automatically and naturally make the adjustments so colors look true under a variety of color temperatures. But our digital cameras need to be adjusted to remove unsightly color casts, particularly where skin tones are involved. Your camera's white balance setting lets you remove unrealistic color casts so the colors you see are recorded accurately.

The Auto white balance setting on digital cameras works very well under most daylight conditions, but tends to fall short in fluorescent, incandescent, and mixed lighting conditions (**6.17**). That's why digital cameras give you a variety of white balance settings, including Incandescent; a variety of fluorescent choices (since fluorescent color temperatures can vary greatly); Cloudy; Shade; and the ability to dial in both specific color temperatures and create a

Custom white balance setting, which lets you measure color temperatures in the lighting conditions you're shooting in and get a specific custom correction for very accurate color rendition.

There are many reasons why serious photographers shoot RAW, as described in Step 2. One is the complete control of white balance settings, even after the picture is taken. In other words, it doesn't matter which white balance setting you used when you took the picture; with RAW files capturing complete digital information, you can change the white balance setting after the fact with no degradation of the image. If you shot in Daylight white balance under incandescent light, you can correct it by simply moving the white balance sliders in your post-processing software of choice with no negative consequences.

White balance can also be used creatively to affect the color and mood of your photos, and it can be fun to experiment, particularly with landscapes and cityscapes where the true color can be interpreted (**6.18–6.23**).

6.17 Auto white balance has improved with each successive generation of camera. Here, the camera nailed the white balance even though there's a mixture of cool daylight and warmer sunlight illuminating the inside of the room. © Steve Simon

Incandescent

Daylight

Flash

Cloudy

Shade

Fluorescent

6.18–6.23 You can use white balance as a creative way to add different colors to your image. This is the same scene with six different white balances. Note the subtle differences between some of them. Some photographers prefer the warmer effect of the Cloudy setting for all their daylight shots. © Steve Simon

6.24 If you have time to do a custom white balance, it can make getting your skin tones right much easier in post, even when you shoot RAW. © Steve Simon

But when it comes to skin tones, you generally want them to be accurate and pleasing. One of the best ways to get close to natural skin tones in camera is to do a custom white balance, which measures the color temperature of a scene and sets the white balance accordingly (**6.24**). Most cameras offer this feature, and it's easy to perform. On Nikon cameras, for example, just set the white balance to Pre (Custom Pre-set) and have your subject hold a white piece of paper—or a commercially available gray/white card—filling the frame with the white or gray; you don't even have to focus the camera. Take a picture. You will hear the shutter click as your camera takes a white balance reading. If your exposure is good, you'll see a flashing "Good" appear on the camera's top control screen. That's it. You've set a custom white balance; the next time you take a picture, you'll be using the custom white balance

preset you just made. Some cameras let you store and name frequently used custom white balance settings for future use.

Sometimes you can't get close to your subject to do a custom white balance—like when you're in the stands at a sporting event or theater. Another way to take a custom white balance is to hold a white translucent material over the lens and aim the lens at the light source. Products like the Expo Disc are designed specifically for this purpose, but I've heard that photographers use everything from a coffee filter to the white plastic lid from a peanut can with great results. It's the same process, but instead of aiming your camera at the white paper or gray card, hold the disc over the lens and aim the lens at the light source illuminating the scene. Once you've been given the "Good" symbol, you can begin shooting (**6.25**).

It's true that shooting RAW lets you fix the white balance after the fact, but even in RAW I've had difficulty at times finding the right skin tones with the white balance sliders when the light was mixed and funky. Custom presets get me close, and a best-practice philosophy incorporating custom white balances can save time and make for a most efficient workflow. Whenever you want to get the white balance as close as possible to neutral, a custom reading will get you there.

Many cameras with Live View let you do a "poor person's custom white balance" by simply going to the white balance setting and changing the color temperature (it's the sub-command dial on Nikon cameras) until the color looks natural to your eyes. This will often get you close to what a custom white balance will give.

A great way to monitor your white balance—and skin tones, in particular—is available in the RGB histograms display on most cameras. In Step 2, I discussed histograms as the best way to evaluate your exposure, but the RGB histograms display can warn you of color balance problems and indicate when skin tones are in danger of clipping.

6.25 Inclement weather can be some of the best light for photography. © Steve Simon

It's important to realize that your overall histogram can look great, yet one of the color channel histograms can be clipping badly, causing you to lose detail specifically in the color of that channel. Wedding and portrait photographers have long known that skin tones are mostly represented in the red channel. That's because the standard luminance (or brightness) histogram displayed on your camera in playback mode is an average of all three color channel histograms. So the red channel might be blowing out highlights, while the blue and green channels are far from clipping. Average them out and you've got a misleading, healthy-looking histogram.

6.26 Sometimes it's okay to clip the highlights, as when you're in a backlight situation like this one with President Bill Clinton at the Democratic Convention in Denver 2008. If there's no detail in specular highlights anyway, or in white cloudless skies, then clipping is fine. With a volume of work, you learn to interpret the light represented on your histogram. © Steve Simon

Many cameras have a "highlight" option on the camera where overexposed areas blink on the LCD, a warning that you clipped highlights and no detail will be recorded (**6.26**). You can move the highlight channel from luminance to any of the three individual color channels. If you photograph people as much as I do, it makes sense to keep the red channel histogram as your default, so if you set the highlight warning on your display, the blinking highlights warn you when the red channel is clipping.

When a histogram has clipped to the right and a highlight warning tells you of clipping in highlights, the way to fix it is to reduce the exposure. If you're shooting in an auto mode like Aperture Priority, reduce the exposure with the exposure compensation dial. Sometimes this fix means you end up with an overall underexposed image, but the only possible compromise is to add some fill light to the scene.

With RGB histograms, generally all three channels should be similar in shape and registration. But if one of the color channels is out of register, it points to either an image with that color dominating the frame or a color cast of that channel's color. So if the red channel is very different from the green and blue channels, it's a warning that you either have a reddish cast, or at the very least a lot of red is present in the image. Identify the color channel that is out of register and reduce that color for proper white balance.

You may not know that all histograms on your camera represent a JPEG file—even when you're shooting RAW. That's because there's a small JPEG file built into every RAW image. So when you see blinking highlights and clipped histograms, remember that they represent a JPEG version of that image, so there may be detail in the RAW file that can be rescued and returned later in post-processing. Blown-out highlights can't be salvaged with JPEG, but even if the histogram says there's no detail, your RAW file may still have recoverable detail. You will learn from experience shooting RAW just how much extra detail is available beyond the JPEG histogram.

BLACK AND WHITE

How do you know when to choose black and white over color? It's purely a personal preference, but there are some good reasons to convert. Color sometimes can be a distraction, while black and white is a way to cut straight to the content. There is a timelessness to black and white that is rooted in photography's history, whereas color came along relatively recently. Walker Evans, it is said, would wait days to capture the right light for his simple, austere, endlessly influencing black and white documentary photographs.

When I began my coverage of the Republican Convention in 2004, I knew that color might hijack the meaning of the photo, so I took away the colors, especially the overwhelming reds that dominated many of my photographs. The black and white depiction most closely matched what I wanted to say with that work (**6.27** and **6.28**).

Sometimes the choice is pragmatic, as when you're dealing with technical issues like color noise or funky white balances and skin tones. In the film days, you had to commit to photographing in black and white while viewing the world in living color through your viewfinder. But black and white is a visual mindset and you need to be thinking how the transformation of color to tones of gray will translate to the final image.

Most post-processing software offers you color filter presets that are a great starting point for your black and white conversions. For landscape images, I tend to start with the red and orange filters, lightening or darkening green tones with the green slider. Yellow and orange filters for skin tone conversions lighten the skin. Whatever your starting point, you have full flexibility to bring out your inner Ansel Adams and interpret, finesse, and transform your color world into black and white.

6.27 and 6.28 Sometimes your choice of black and white is about cutting to the content of the image when color gets in the way of that content. A woman holds up her purse at the 2004 Republican National Convention at Madison Square Garden in New York. © Steve Simon

Step six

ACTION: Follow the Light

The exercise of following light will help you to see and learn its effect. How is the light affecting the things it illuminates in your line of sight? You'll be more attuned to the light, and the process of seeing where it falls and what it does will eventually become infused into your picture-taking process. Just as technical aspects fade to the background with a volume of work and experience under your belt, so too will your ability to see and take advantage of light in your images.

You'll begin to understand just how fast light moves, and how everything in the world is constantly changing at every moment. As photographers we have the mighty power to freeze the moment forever. Your newfound awareness of light translates into all areas of your life, helping you to appreciate the aesthetics of your environment.

6.29–6.40 Following the light on a walkabout outside my home in New York City. By following the light, you'll find yourself in places where the aesthetics brought out by the light will inspire you to see and capture more, better images. © Steve Simon

This assignment asks you do what the title says. It's best if you choose a sunny day for this one, where the strong light from the sun will be more obvious, as will contrast levels in areas that include light and shade.

When you go out the door of your home, or when you get downtown in the city you're shooting in, look up in the sky for the sun. Look for areas illuminated by direct sun, then move to those areas and start shooting. Where the sun beats down, the light will be interesting—harsh, perhaps—but as you move around the scene and see how the light illuminating your subject changes, you'll begin to learn how to react to the light instinctively, swiftly getting yourself in the right position.

I followed the light outside my apartment in New York City, from the first frame right outside my front door, to the subway, and eventually emerging from the underground near Grand Central Station to continue the exercise (**6.29–6.40**).

THE ART OF THE EDIT: CHOOSE WELL AND BE THE BEST YOU CAN BE

"The photographer is like the cod, which lays a million eggs in order that one may be hatched."
—George Bernard Shaw

The art of editing is a crucial and challenging task for any photographer, almost as important as the shoot itself. If we select the wrong photographs, no one gets to see how good we really are. If you embrace the concepts and ideas in this book, you will end up with a greater volume of work to go through.

The Ten Steps are designed to lead you to your photographic goals, but it might make the job of editing a tough one, which is a good thing. The more good work you produce, the tougher the editing gets, and you want to be making tough decisions as you choose among a lot of very good frames. Good editing means squeezing your best images out of each and every shoot.

7.1 In an absolute downpour, I saw these kids heading home from school. But this final image wasn't immediately apparent to me; it required careful editing to extract this image from the original frame (see 7.19 on page 179). © Steve Simon

To be clear, I'm not talking about post-processing, though the two go hand in hand. I choose Aperture as my post-processing and cataloging tool, but programs like Lightroom are also very good. It's a given that you need to be strong when it comes to post-processing skills, which will get better with training and practice. But Step 7 doesn't talk much about the software—it deals with selecting your best work—and to do that, you need to know your endgame.

Editing for a book is not the same as editing for an exhibition or newspaper/magazine piece. And it's different from the act of selecting the single best image from a series to be printed and hung on your wall.

YOUR OWN BEST/WORST EDITOR

Editing is a learned skill that develops over time, but it has its limits. After more than 30 years of editing, I'm often a lousy editor of my own work.

It's not that I don't know strong images from weak ones; it's just that I find it difficult to know that I've absolutely made all the right moves in choosing my final selections. It is hard to edit your own work objectively because you're so close to it.

That said, you are also your own best editor. So how can you have it both ways? Let me explain.

The late, great Garry Winogrand was a prolific street photographer. As you read in Step 2, he died of cancer at the age of 56, leaving behind a lot of unfinished business. There were 2,500 36-exposure rolls of mostly Tri-X film that were shot but not yet processed, 6,500 rolls of film that were developed but not contact-printed, and another 3,000 apparently untouched, unedited contact sheets. Thousands and thousands of unedited frames.

If you go through the Step 2 process, you might agree that the more you shoot, the better your work gets.

We can only imagine how a power shooter like Winogrand would have embraced the digital tools of today. But all that unedited film is only partly a result of his untimely death. Winogrand almost never looked at his film immediately. He was in no rush to edit and deliberately waited a year or two to lose his memory of the take (**7.2**). Garry Winogrand, in his own words from a column by Frank Van Riper in the "Camera Works" section of the washingtonpost.com:

7.2 Most of us don't have the time to let our images age before editing. We do need to make sure that our edit is thorough and trust that we have selected the strongest frames out of every shoot.
© Steve Simon

"If I was in a good mood when I was shooting one day, then developed the film right away," he told a class, "I might choose a picture because I remember how good I felt when I took it. Better to let the film 'age,' the better to grade slides or contact sheets objectively."
　—Garry Winogrand

Wildlife master Tom Mangelsen acknowledged that he often waits a while before seeing his work. Mangelsen might be even more prolific than Winogrand.

"Some of my colleagues; every frame they look at the back of the camera to see if they got it. A lot of times I don't even look until later—the next day, or maybe months. Literally, I have somewhere around 15,000 rolls of film that I've never looked at. That's on film. There's over a quarter million digital frames I haven't looked at yet. I think it maybe is a bit like Winogrand. I feel that removal of the personal experience is healthy when you're looking at images and editing. The goal for me is so much more for the experience of shooting, being there, and that process often overrides the desire to edit or see the image. I keep thinking it will be a rainy day, or I'll break my leg, or maybe something health-wise will change things and I'll have time to read all the books that are on my shelf and do all my editing."
　—Tom Mangelsen

I talked about concentration and closing the gap between the picture you envision and the one that you get in Step 4. There's also the idea that a picture you love may not transmit that same love to viewers. Have you ever been excited about a photograph that met with a less than enthusiastic response when you showed it around?

Years ago I ran into the newspaper office where I was working and basically yelled, "Stop the presses!" about an image I had just taken. Well, after developing and editing it (this was still the film days) I realized I didn't quite have what I thought I had.

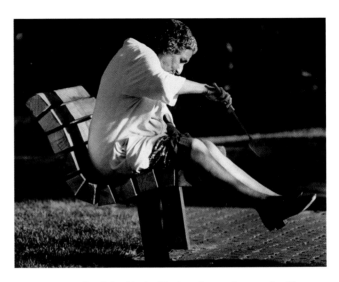

7.3 An example of the kind of feature image I was asked to go out and find on a slow news day. I learned never to talk things up before I verified that I got what I thought I did. Digital now gives you that confidence. © Steve Simon

Oops, never mind. Sometimes, and it's quite normal to do so, we subconsciously attach our experience of making the photo to the photo itself (**7.3**). When stripped of the sights, sounds, and remembrances of the moment, the image may not have the communicative power that we initially associated with it.

The viewer of the photograph only has the two-dimensional image, and if the sounds and smells and excitement of the moment are not transmitted by the photo, the viewer may not appreciate it in the same way you do.

One of my frustrations from my newspaper days was that contact sheets were rarely available to us, and even when they were, the act of judging images through a glass or plastic loupe on a tiny, poorly printed contact sheet was impossible to do well. It was even tougher with negative film, having to look at and imagine negative images as positive prints when editing. Those killer shots were easiest to pick out, but often when it came to portraits it was hard to predict the exact expression of the person, particularly that all-important gaze from the eyes, where

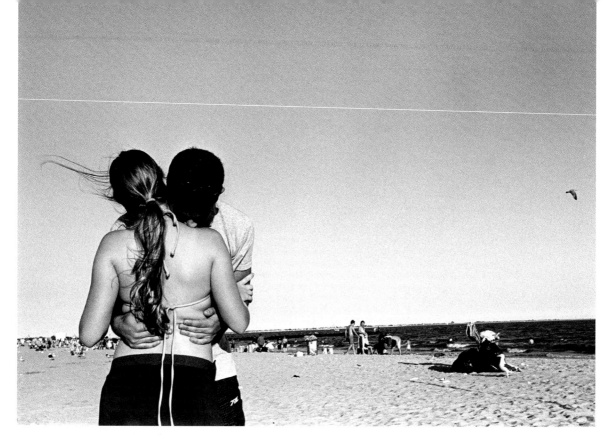

7.4 To edit well, you need to be on the lookout for subtle details that enhance the photograph. The bird on the far right balances the girl's hair lifted by the wind and makes a good picture...better. © Steve Simon

even a subtle difference could have a huge impact on that picture's success. Some photographers claimed they could see the subtle changes frame to frame, but I never bought it.

For those of us who had the opportunity to shoot film before digital, we know that today's digital tools allow us to view every image and every detail within that image with amazing clarity, pixel by pixel, seeing every subtle difference between frames and, in particular, what the eyes are communicating (**7.4**). There are no excuses for not finding the best from every shoot. Images you might have missed when eye-balling a contact sheet with a loupe should not be overlooked on your computer screen. Editing digitally is a wonderful thing.

But nobody's perfect. When you edit your stuff, you are bound to make mistakes—which is all the more reason to be cautious of throwing stuff out. I don't believe in deleting images in the field; with the abundance of cheap, big memory cards, there's just no good reason for it. I don't even like to look at the LCD screen while shooting, never mind deleting. I prefer to concentrate on the photographic scene in front of me.

When Tom Mangelsen or Garry Winogrand let the film "age" before they edit, the time lapse allowed for a colder, more objective look at the work minus the memories attached. But let's face it, most of us can't work this way, nor should we. But one thing we can do is go back through previous work

from time to time with fresh, always maturing eyes. This process can yield some overlooked gems which, for whatever reason, you failed to pick in the previous edit.

One way to emulate the Mangelsen/Winogrand editing experience is to revisit older bodies of work. You may find the editing experience revealing. As you grow, evolve, and mature as a person and photographer, so too does your "editor's eye." Photographer Andy Freeberg (andyfreeberg.com) went back through his archive with a person whose talent for editing he trusted and came up with an entirely new portfolio of work. It was there all along; he just didn't see it the first time.

As much as it might be nice to experiment with editing a long time after the shoot, it's not a practical editing system for most of us. The good news is that, in my experience, often that first impression—when your gut speaks to you about which image to choose—is the best decision.

FIRST IMPRESSIONS

With the incredible editing tools we now have at our disposal, it's a lot harder to miss the good stuff. That's not to say that it can't happen, but in Aperture, for example, you can see the entire image, then blow it up big and see all the small details (**7.5**). It's quite incredible how accurate you can be with your edit.

Here is my big-picture philosophy when it comes to editing digital images, and it works with whichever post-processing software you choose: Do what I do or, better still, adapt it to your own way of editing.

I take editing very seriously and I apply some of the core concepts covered in previous steps to editing. The same instincts that urge me to trigger the shutter when capturing a fast-moving moment are at play in the editing process.

For me, the first edit is similar to the shooting process itself. I don't want to think too much here;

I want to react. I approach the first look with reverence because it only happens once, and I want to make sure I have enough uninterrupted, quiet time to concentrate during my edit. I like to go over my entire shoot in one sitting whenever possible.

What has become extremely important to my workflow is to be confident that every editing session is comprehensive and thorough. As my volume of images increases, I don't want to have to go back to a previous shoot with the uneasy feeling that I didn't edit everything thoroughly, that maybe strong images were missed. I don't have the time to re-edit, so I do a good job the first time, every time, so I know that my best images are chosen and there are no diamonds hidden among the masses. I might choose to revisit older work in the future, but I need to know that I've done my best job editing on every shoot. If you're smart enough to determine a system of what stays and what goes, I don't think you will

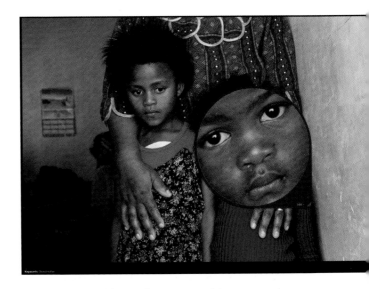

7.5 Editing tools like Apple's Aperture let you zoom in close on every detail, pixel by pixel, so there's no excuse for missing the right frame. © Steve Simon

have too many regrets in your photographic future, and you can keep a handle on an always growing archive.

When I'm in the field I might use my laptop to edit, but my home office has a big monitor in a neutral–colored, appropriately lit room to display each frame in all its glory. I advance frame by frame using the arrow keys and tag everything I think is a keeper, without intellectualizing or even thinking, just reacting with a one-star badge on all the keepers.

Like most photographers, I have great expectations. My standards are high and I hope to hit a grand slam on every shoot, but I know from experience that not every shoot yields portfolio-worthy imagery. I get that. So what I'm trying to do is narrow down the very best frames out of every shoot.

One star is applied to any image I think is a keeper, whether that means the image is in focus, publishable, or can be used in a professional display in a publication, slideshow, or on the Web. As I go through the work, image by image, it's a simple question of yes or no.

After the initial run-through, I take a break (time permitting) and then get back to a second and third look. I apply two stars on the second run to images I see as above average.

Round three is when I get down to business, comparing similar images as well as checking sharpness. This is when I edit down to a group of main selects that may not be four- or five-star lightning but are the best from the shoot.

I'm just looking at the two-star images here. In this round of editing I either leave images at two stars, upgrade to my three-star select designation or, if they are portfolio contenders, I will give them four stars. Four-star images are the diamonds and jewels that surface once in a while but never often enough.

7.6 A typical edit includes one-, two-, and three-star rated images. The heralded and much desired four-star rating is given sparingly, but many four-star images become five-star portfolio photos if I work hard and I'm lucky. © Steve Simon

They are the images you remember from the shoot, the ones you can't wait to download and see on the big screen. The coveted five-star rating is for those images that are portfolio-worthy (**7.6** and **7.7**). The time it takes to complete my edit is dependent on volume and deadlines. If I need the pictures in a hurry, which is often the case, I do a quick edit and come back to the thorough edit later. Some shoots can take me as much time or more to edit as they did to shoot the images in the field.

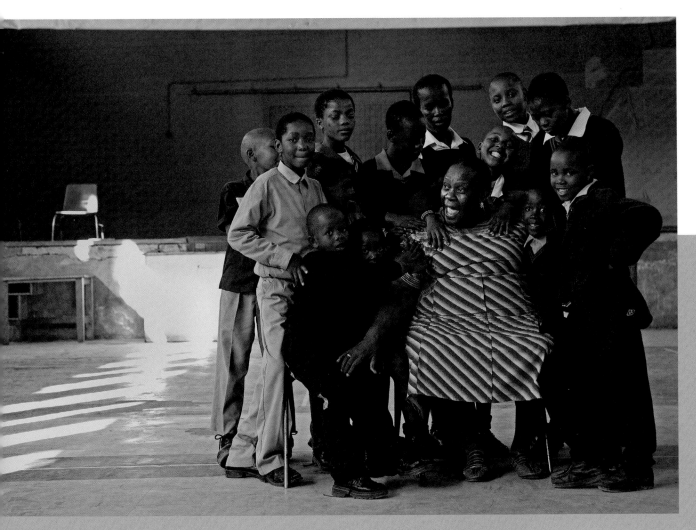

7.7 The Chosen One. I took a lot of frames, and by carefully editing I picked the one frame that best captured Flory Kolobe and some of the 80 orphans she looks after at her community center in Lesotho. It's not perfect—some of the kids' eyes are closed— but I tried to get the strongest and best frame as I do whenever I edit. © Steve Simon

Lessons Learned

TO DELETE OR NOT TO DELETE

With today's digital editing tools, it may be okay to free up storage by deleting unusable frames. But remember, like good wine or scotch, aging images often get better with time. Even ordinary images can take on historical importance, so think very long-term before you erase. There are many photographers I know who come back from a shoot and immediately copy raw files to a separate hard drive, maintaining the integrity of their complete shoot. I think this is generally a good idea.

A case can be made for not deleting anything when you look at the story of Dirck Halstead, who, when the Monica Lewinsky scandal broke in 1997, went back through his archive and found a very good frame of President Clinton and Lewinsky together (7.8).

"I have a theory that every time the shutter captures a frame, that image is recorded, at a very low threshold, in the brain of the photographer," said Halstead.

"I have heard this over and over from photographers around the world. It doesn't matter if the photographer saw the processed image or not. These split seconds, as the mirror returns, are recorded as 'photographic lint' on the mind of the photographer. When the photographs of Monica Lewinsky emerged, I knew I had seen that face with the President. I had no idea when or where. All these organizations started to go through their files and found nothing. I hired a researcher, and she started to go through the piles of slides in the light room. After four days, and more than 5,000 slides, she found one image, from a fundraising event in 1996."

That was 1996. Dirck Halstead's image ran on the cover of Time and won the Eisenstaedt Award for Magazine Photography that year. There were at least two other photojournalists shooting by Dirck's side that night. They had been early digital shooters, and to save space they deleted images deemed not newsworthy at the time. The only other photographer with a similar picture was an amateur photographer whose image ended up on the cover of *Newsweek*.

© Dirck Halstead - UT Center for American History

7.8 President Bill Clinton embraces White House intern Monica Lewinsky at a campaign fundraising event just days before the presidential election in 1996. Photograph © Dirck Halstead

From a digital photography perspective, 1996 was a very long time ago. What can we learn from this story? For one, maybe it's not a good idea to delete good images that might have value in the future. In addition, by taking the time to do captions and keywords, you'll be able to easily find a needle in the haystack as your digital archive grows. So keep the "Monica Factor" in mind when you consider deleting files. If you edit your one-star images like I do, you can probably delete the unrated images with a fair bit of confidence. But unless the photograph is "technically challenged"—way out of focus, for example—you might want to keep it around. ◾

PLEASE BACK UP IMMEDIATELY

The ten-step shooting style that this book encourages means shooting a larger quantity, which takes up more hard drive space.

The one thing I know for sure is the adage, "There are two types of digital photographers: those who have lost image files, and those who will someday lose image files." When I was struggling to find the best possible drives to store my precious and irreplaceable work, a friend of mine put me at ease. "All mechanisms can fail," he reminded me, even the best and most expensive—so it's less about brand names and more about redundant backup. I feel it's better to have three duplicate archives on cheaper drives than two on more expensive ones.

I am lucky to have all my raw final selects from the 2004 Republican Convention shoot, but I lost hundreds of others. To this day, I'm not sure how I deleted them. I now do everything in my power to prevent anything similar from happening again.

You should have at least two backups of your archive and a third that is off-site. I like the idea of having an extra backup of my four- and five-star selects, which sadly doesn't take up too much space because there are never enough of them. These are the images that, if you lost them, would be most devastating. They can be uploaded to cloud servers and backed up to DVDs and hard drives as an extra precaution.

DID I SAY "RUTHLESS"?

You need to be ruthless as an editor. Ruthless. As Ira Glass points out, sometimes taking something out from the edit is the hardest part.

"When you look at the footage, you know there's a feeling you had about it, which isn't in the footage. Then it's time to be the ambitious, super achieving person who you're going to be and kill it. It's time to kill and it's time to enjoy the killing because by killing you will make something else even better live. You have to be really like a killer about getting rid of the boring parts and going right to the parts that are getting to your heart. You have to be ruthless if anything is going to be good. Things that are really good are good because people are being really, really tough. I think that not enough gets said about the importance of abandoning crap."

—Ira Glass

You are setting your bar very high, and it's either all there within the frame or it's not. This is what should guide your editing decisions. You need to be realistic in choosing your selections. Of course, the type of work you pursue is going to factor into what you choose.

It's not always the sharp, perfect shots that end up on top. Technical perfection can be overrated when compared to the mood and atmosphere a photograph communicates. You need to know what to look for and be open-minded enough to recognize the lucky accidents when they show up. I sometimes find that my disappointment when discovering technical imperfections in an image contributes to my taking it out of the running too early. In many cases, strong content should trump technical shortcomings (**7.9**).

I've seen iconic imagery from famous master photographers that appeared a bit soft of focus, but it doesn't matter, as long as those technical imperfections don't get in the way of what is being communicated.

This is not to make an excuse for poor technique but rather to underline what is important. A photo for a catalog better have the product label tack sharp, but an image taken for your personal project may be more about the soft, dream-like scene or the motion portrayed by the movement of your subjects in the picture. It's hard to generalize, but it's a fine balance between being a ruthless editor and keeping an open mind when it comes to your choosing.

7.9 It's not always about technical perfection. When a woman protester at the Republican Convention in New York City is subdued by security, the movement in the frame adds to the urgency of the moment. © Steve Simon

MAKING THINGS BETTER

The editing process can teach you much about how you shoot and suggest how to make things better. Post-edit, I make mental notes if I'm disappointed or if I notice something I neglected to get. In other words, I try to learn from each and every shooting experience.

What did I miss? Did I perform my Ten-Step duties to the best of my ability by moving around enough, shooting enough, and varying my angles and distances from the subject? There are lots of

important answers to questions about the way you shoot that can be gleaned during editing (**7.10–7.18**).

And when it's possible, it has been my experience that going back for a second or even third reshoot can teach you much and yield spectacular results. You can move past your visual frustrations by learning from your mistakes and correcting them. There is no shame in admitting your bar is raised very high. Let your subjects know what it is you are after, or what you want to try again. They will often

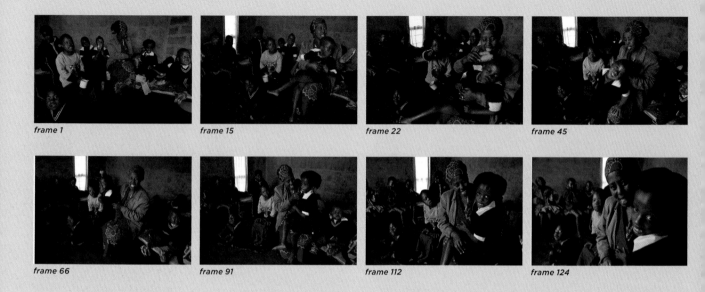

frame 1 frame 15 frame 22 frame 45

frame 66 frame 91 frame 112 frame 124

7.10–7.18 Editing is a good place to keep tabs on your process. In this situation, I shot a little more than I normally do, mainly because the light was low and there was a lot going on that was out of my control. I often use the digital "contact sheet" as a way to ensure that I'm taking my own advice from Step 3—moving around and trying new things. The last frame shown here was the final select, where the gesture of touch made this image stronger than the others. It took a lot of frames to get there. Mamello Mokholokoe runs Phelisanong, a community-based project to rehabilitate, educate, and train disabled children and youth (www.phelisanong.com). © Steve Simon

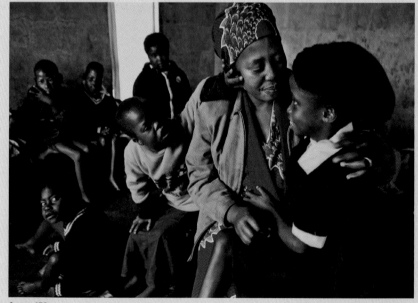

frame 139

appreciate (but not always understand) the extraordinary effort you are taking to get the best possible images.

After a thorough edit, and after selections are made, I then determine what needs to be done to enhance them further, bringing out the best of every image in post-processing.

The editing process is always on. From the moment we head out with our camera it starts. You're looking for things visual, editing out the things you don't want to photograph. In some ways the act of shooting is most concerned with editing out what we don't want in the frame. I know many nature photographers who start with a subject that interests them, then move in and around—scanning the entire frame, slowly excluding distracting elements until they reach their final composition. Cropping is a second chance to make things right (**7.19** and **7.20**).

Generally, I like to compose and crop in camera. I like the challenge of living within the shape of the frame. Depending on the final destination of the images, if I do crop I prefer to maintain the master aspect ratio so the shape and dimensions of the photos stay the same, particularly when hanging a series of images on a wall, or when displaying a body of work on my website or in a book. But that's me, and it's a personal choice for all photographers.

Post-processing can have a big effect on composition and how that image is perceived by the viewer. Enhancing the image by dodging and burning and correcting color allows me to play down distractions and lead the viewer's eye to important elements within the frame. These steps bring out the very best in your work. I tend to be a minimalist when it comes to enhancing my images. I like to make the best digital capture possible for my RAW file, and then process my images for maximum visual impact without overdoing things. I'd rather be out shooting than in front of my computer, but I will never let an image out into the world unless I've brought out the best in it through post-processing.

I said earlier that it's sometimes difficult to be the best editor of your own work because you're so close to it. At the same time, nobody cares more about your work than you do and, ultimately, you take final responsibility for it.

7.19 and 7.20 I didn't have time to get and use the lens I needed, but because I shot at a low ISO of 200, I was able to crop this shot while maintaining the master aspect ratio to pull out one of my favorite images from the frame. I thought the original was too centrally weighted, so I cropped to move the women to the right of the frame, bringing them closer while keeping the master aspect ratio of the original. I hated to lose the sky up top, but it's a compromise I made to keep the shape of the photo consistent with all my work. © Steve Simon

7.21 and 7.22 My experience photographing at Lac Ste. Anne was wonderful. People welcomed me and my camera into their private moments of faith. When the project was published, I kept coming back. © Steve Simon

EDITING WITH PURPOSE

How you edit will also be determined by the purpose and final outcome of what you are editing for. You are going to choose differently depending on how the photos will be used—whether for a book, a slideshow, an exhibition, a museum curator, or your mom.

I can't remember where I heard the idea that projects never really end; they are just abandoned. It's true to a certain extent. If you passionately pursue a subject, you may reach an end stage where you exhibit and publish the work, but it doesn't mean you stop shooting that subject.

I worked on a project called "Healing Waters: The Pilgrimage to Lac Ste. Anne," where for one week in the year, people travel to Alberta, Canada, and gather at a small lake that is said to have healing powers. I photographed this event and was inspired to go back. I edited the work and eventually decided to create a book, so I kept going back for more (**7.21** and **7.22**). Once the book was published, I still kept shooting, year after year, and who knows? Maybe someday I'll do a sequel to the book.

For me, following the Ten Steps means working every image, every session, and then ruthlessly editing it down to the very best. I can then look at the selects from one shoot and add them to my master selects for the entire project.

Working on a project, the editing process tells you what you have but, more importantly, it tells you what you don't have. It is at this stage where "holes" or weaknesses become evident and, once identified, you can fill them in and strengthen the entire body of work. If you're working on your own personal project, it's good to have interim deadlines or goals, but the editing process will tell you when you've got enough for the work to feel complete and be published.

I had an opportunity to do another photo book from work I was doing on the HIV/AIDS pandemic in some of the sub-Saharan countries I had been to. It was a great opportunity, so I put together what I had done to that point, and took my critical editor's eye to the work as a whole to determine how I could put them together as a book.

I had distinct goals for the project. I wanted to show through my photographs the powerful negative effect the scourge of AIDS has had on the people I encountered and the lives I observed. But I also wanted to show that, despite the devastation, life was going on and the people I encountered were often resilient and inspiring.

It was a tall order to fill, but knowing what I needed made me realize that I didn't have enough images to tell that story. I identified areas of the project that needed to be worked on to achieve my goals, creating a laundry list of sorts to give me the direction I needed when I went back to complete the project (**7.23** and **7.24**). This too is editing.

My project "America at the Edge" is one that has no deadline, so I keep shooting for it and someday

7.23 and 7.24 Editing told me not only what I had, but more importantly what I needed to get. I returned to Africa to work on my project with a mission gleaned through careful editing. I needed to illustrate the fact that so many people were dying because of the scourge of HIV/AIDS without being dramatically graphic like I had been in other work. So I hung around the cemetery.
© Steve Simon

I hope to have it published as a book. In the meantime, I keep adding to the work, and it's one of several projects I always have going at any one time.

When you're editing your project, it sometimes helps if you have a clear understanding of what your goals are for the work (I'll talk more about this in Step 9). Simply having a good title for a project can help focus your editing efforts, making it easier to cut images that just don't reinforce that title. If the project is called Dogs and you have an image of a cat, then save it for the cat project. Simplistic example, but you get the picture.

7.25 A second opinion is always a good idea. I seek out constructive feedback from all sources and it has made a big positive impact on my growth as a photographer. A hearse is parked in a driveway in East Detroit. From the "America at the Edge" series. © Steve Simon

GET A SECOND OPINION

Getting quality feedback on your work is very important but not always easy to do. Finding people who can articulate their critique of your images in a way that you can understand and use to learn, grow, and improve your work is essential to your development as a photographer (**7.25**).

Seek out respected opinions to learn how to make things better. I'll talk more about resources like online sites and camera clubs in Step 10, but generally it has been my experience that showing your work around and asking questions will help. We all want to hear good things in response to our work, but as great as positive feedback feels, I would much prefer constructive criticism that I can learn from, which helps me become a better photographer.

SEQUENCING AND ORDER

Always the first and most important consideration when editing is to make sure the best images are identified and marked. But the ultimate selection depends on how the images are being used. For long-term projects, you often need to use more than one image, and your choice of one image might influence your next selection. When choosing several images, you usually want every image to say something new about the story or message you are trying to communicate—unless repetition is being used as a visual device to make a point. Sometimes images fit together intellectually, yet they're not a visual fit.

Sequencing can be complex or simple, but it should be effective. A chronological order is a good start, but often the story can gain or lose momentum with the sequence, so spending time and thought on sequencing can, as with editing, make or break your project (**7.26** and **7.27**).

If you can put the work away for a while and let it percolate, then come back with fresher eyes, it will confirm earlier decisions or maybe reveal omissions you didn't see the first time around.

Robert Frank spent a year mulling over his sequence for "The Americans." There were no specific chapters but each of the four sections examined an aspect of American culture, with an American flag at the start of each section. He told students that his biggest challenge was the selection and elimination of prints.

To cull down to the eventual 83 images in the book, he made 1,000 work prints that he would separate by category: race, religion, politics, the media, etc. He then stapled prints to the walls or spread them around his apartment floor, gradually eliminating weak or too obvious images, or ones that didn't fit the theme and story he was telling.

The sequencing in "The Americans" is very deliberate; when you start with almost 25,000 images, you can understand how crucial editing and sequencing are to the final outcome. Many different books could have been produced, but because

he spent time editing and living with the work, the project revealed itself to Mr. Frank in 83 images.

The editing process literally takes as long as the shooting process did, and often longer in order to do it right. You need to live with the work for a while, like Mr. Frank did, and in my experience it helped to get outside opinions. But ultimately, it is you who has to take responsibility for the final outcome, and you need to feel satisfied that you've done your best job of it.

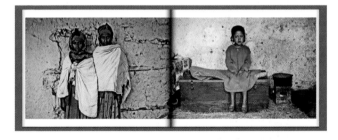

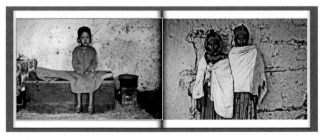

7.26 and 7.27 Sequencing is an art unto itself and should be given enough care and consideration because of the powerful effect it has on what your set of pictures ultimately communicates. It helps to have a respected set of eyes assist you and to take some time for your thoughts to percolate before locking in a sequence. © Steve Simon

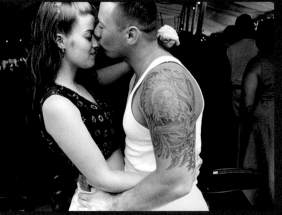

Sometimes visual elements are used to connect one image to another; other times it is the content itself. The final destination for your story will also help determine its content and sequence. Pictures on a page would differ from an essay to be exhibited in a gallery or as part of a multimedia presentation.

In a magazine or newspaper stories, thought must be given to the size of the pictures. Some photographs work well big or small; others need to be run a certain size to best communicate subtle yet important details. Tight and simple compositions often read well small, but they can also gain impact when printed large.

It's hard to get it right every time because there are a nearly infinite number of images we can make. The possibilities of a scene—including or excluding elements—are virtually unlimited during the in-camera as well as the post-processing stages. It helps to take a critical look at your work and think of how to make it better. Having a second set of eyes that can articulate and constructively criticize how images can be improved can make a huge difference.

In the creative picture-taking process, the choices you make are often intuitive, but they come from experience. As we develop our critical thinking skills, it gets easier to articulate our feelings about photographs and understand what others are saying about our work. It helps us to ask questions for a clearer understanding as to how we can improve.

POST INSPIRATION

I preach the gospel of programs like Aperture and Lightroom, which speed up your workflow and learning curve, giving you more time to shoot. They organize your photographic life, getting rid of duplicates and general digital clutter while helping you recognize connections and patterns in your work, revealing themes to be expanded upon and new projects to be pursued (**7.28–7.31**). I can use the software to play with sizes and order as I look for a narrative, or I can print them as an essay. When I'm ready, I can create a web page and email trusted mentors for advice. Or even put a book together to take around to show people.

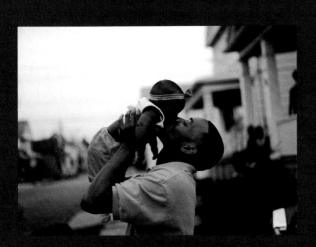

7.28–7.31 The kissing couples were all taken at different times in different places, while shooting unrelated subjects. But I can now create a "Kissing" album and drag all my similar pictures inside it. I can play with them, move them around, see how they work together, and watch the project evolve, inspiring me and helping me "see" more of these images when I'm out in the world.
© Steve Simon

I've been shooting for so long now that I begin to see similarities in photographs I take, even if they are continents or decades apart. It may be that a similarity in the composition, or the light, or a gesture. Or maybe the subject matter is similar—shapes, faces, or emotions evoked. Regardless, I sometimes get curious to see how images will play together, and from there, ideas and new bodies of work are born.

Since these programs create previews instead of whole digital copies when you duplicate them like this, hundreds or even thousands of versions can be experimented with, adding only a fraction of the space that new files in Photoshop would add. I can experiment with endless ideas, grouping photos into albums, which blossom into full-fledged projects. When I'm out on a shoot and I see a good picture unrelated to my current assignment, I shoot it, and there is a place for it or I make a new place; it doesn't get filed away and forgotten, and this has been a revelation for me that has made me a stronger photographer.

Step seven

ACTION: The Art of the Edit: Second Time Around

The whole idea of the innocence of vision is something I strive for when I shoot, and it involves unlearning the formulary patterns I repeat while shooting on a regular basis. It's interesting to go back and look at some of your early work, which may not represent the technical competence you now have as a photographer—but to see what it was you were drawn to and your approach to photography when you were just getting started.

This is an editing exercise that is designed to have you take stock of where you are now in your photographic journey, and move forward, faster, with confidence and direction.

We've talked about how life experience can affect your photographic vision and the ideas expressed through your work.

Go back and do a fresh edit and organization of your archive.

I realize that for some people this is a tall order. But the sooner you start and schedule a block of time every week to devote to this action step, the sooner it gets done. There is no real timeline, as long as you're working on it consistently; you'll finish when you finish.

If you've made it to Step 7, there have likely been changes in the way you look at your photography, and now is the perfect time to look back through all your surviving imagery and edit again. Maybe you'll find an award-winning series at the bottom of your hard drive. Step 8 is a good time to organize your archive so, going forward, you know where you stand. You may be inspired by finding lost gems or by rekindling projects or themes you had abandoned or not even noticed. Look for patterns in your work and images that connect aesthetically or thematically, and create new albums for them. This process will ultimately free your mind from clutter and reinvigorate you by having an organized, up-to-date, and backed-up body of work.

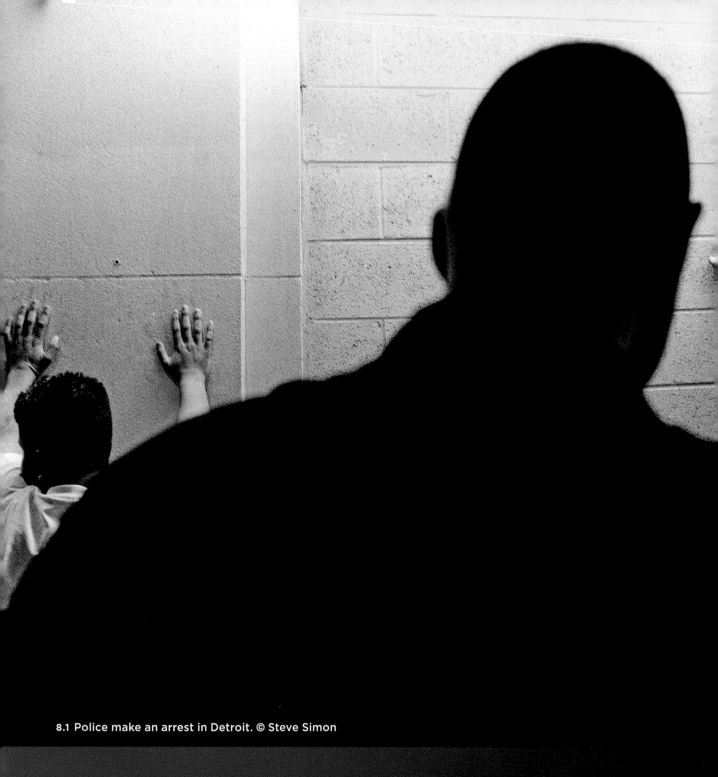

8.1 Police make an arrest in Detroit. © Steve Simon

ASSESSING STRENGTHS AND WEAKNESSES: NEVER STOP LEARNING AND GROWING

"Don't be so humble, you're not that great."
　　　　—Golda Meir

During the many years that I worked as a photojournalist, I developed the habit of taking time at the end of every year to look back and pull out my best work to enter into various contests. I was somewhat surprised and a bit dismayed after completing this annual ritual because the best of my best from the year—those truly special, magical moments when something extraordinary happened in front of the camera— were not that plentiful, or at least not as many as I expected.

I had to ask myself, "What went wrong?" The realization was that to get the great stuff—where expectations match the actual images—I needed to apply strategies to improve the work.

8.2 There is much wisdom to be gleaned by assessing your strengths and weaknesses. A sign pointing the way to Wisdom, Montana. © Steve Simon

A first-step suggestion I have for all photographers is to stop and take a critical look at your archive. Unless you do so, you might be destined to make the same pictures over and over. That may be fine if you've reached a certain competence level and you're comfortable with the work you are producing. But in my experience, learning and growing is always inspiring; to do so, we should learn from our mistakes (**8.2**). It's inspiring for me to see some of my photographic heroes like Eugene Richards, Josef Koudelka, and Jay Maisel doing some of their best work in their sixties, seventies, and eighties. The future is bright, says Jan Saudek.

"I believe all artists, if they are not lying to themselves, must believe that the best part of their work, or even their life, is in front of them. To look only to the past and to say 'those were the best years, when I was young' is to say that in the future there is nothing."
—Jan Saudek

By figuring out where our weaknesses lie, we can take steps to eliminate them.

Now that I'm a full-time freelance and documentary photographer, I actually shoot a lot less, as there are so many obligations on the periphery of my photographic life, from marketing and finding new work to mundane business chores that eat up my shooting time. But I continue to assess my work and take a critical look back at the year that was. It becomes a photographic road map from which I can update my portfolio, track my progress, and spot weaknesses that I can target by devising new shooting strategies and making changes in my approach (**8.3**).

On the plus side, I see what is working with my latest images and polish the strengths I possess as a photographer. I look at the work and ask myself questions. Did I work the image enough? Did I vary my coverage enough, or was I shooting from similar angles? How about lens-to-subject distances? Ultimately, the big question is: how can I make things better? There are usually many ways we can make our work stronger when we recognize its shortcomings.

If the previous steps have been resonating with you, then you're on your way to a new type of photographic work ethic that will pay dividends. But in this step I'm asking you to take a big-picture view of your work. Look for elements that can be improved, not only with the images themselves, but with your choice of subject matter and your shooting process.

What are your photographic weaknesses?

As I write this book I continue to teach workshops around the world, and I hear the same self-evaluations from Dallas to Dubai. At a recent workshop we closed the door and went around the table asking that very question.

"I don't shoot enough," said one workshop participant.

"Ditto," I said.

"I don't use flash well." "I'm a bit nervous about approaching people, yet I want to take people

8.3 Looking back can help point to future projects and opportunities, like a photographic road map.
© Steve Simon

pictures." "I take too long to shoot, I'm not fast enough." It was a very effective exercise that brought to the surface what people knew about their shooting techniques but had not figured out how to fix.

Once you have identified and listed areas with room for improvement, you can target a remedy to fix what is ailing your shooting. It's not such a mysterious process. When it comes to technical problems, answers can often be Googled in a few keystrokes; you'll find many free and comprehensive websites devoted to specific areas of photography.

But that's just part of the answer. The main answer lies in going out with your camera and addressing those weaknesses head-on. It requires smart practice, and truly learning from your mistakes by going out and correcting them. Step 2's idea of shooting a volume of work comes into play here. It helps get you to the other side of making great images.

In her book *Being Wrong: Adventures in the Margin of Error*, Kathryn Schulz talks about how wrongness is a vital part of how we learn and change our understanding of ourselves and the world around us. As photographers, making mistakes can be a good thing; I have made perhaps more than my share, but I learn from them. I tend not to make the same mistake twice.

As a young newspaper photographer, I once showed up for an assignment without my equipment (I thought it was in my car's trunk). In the film days I shot a bunch of frames before I noticed the rewind spool wasn't turning (there was no film in the camera). More recently, I fired a bunch of frames without a memory card in the camera (always set your camera up to prevent it from letting you shoot without a card; this time, the camera was a rental). I've dropped cameras and lenses, made mistakes in the darkroom, showed up to a surprise party on the wrong day—wait, that's not photographic—and probably many more faux pas that are too painful to remember.

The bottom line is I try to learn from the error of my ways so I don't repeat them, and I solidify lessons learned by adding them to my photographic process (**8.4**). The biggest takeaway from mistakes I've made is an obsession with always having a backup plan for when things go wrong. For professionals, there are no excuses.

LUCKY ACCIDENTS AND LEARNING FROM MISTAKES

And then there are the lucky accidents. One of my first mistakes is a favorite picture I took when I was 14 years old. Photographing with my Nikon FM film camera with a 50mm lens, I took aim at a swimmer diving off the high-diving board at a local outdoor pool. Now I don't remember the details, but what I do remember is seeing the image on the negative and feeling very excited when I projected it onto the easel in the darkroom. When the image of the young diver began to emerge under the red glow of the safelight, I was astonished because what I saw in the developer tray was not at all what I imagined when I clicked the shutter on that hot summer's day (**8.5**).

I had made a mistake that resulted in an image much better than I thought I would get, and I learned about the effects of backlighting and creating a silhouette that I remembered from that day forward and incorporate into my shooting when appropriate. Getting an image like that was exciting, and it's a feeling I'm always trying to recapture whenever I take my camera out of the bag.

I remember another lesson learned from a mistake I made on the very first commercial job I ever did as a teenage photographer. It was a 50th anniversary party for a prominent family in my community, and I really wanted to do a good job—so much so, that I decided the 35mm format wouldn't do this big affair justice. So I rented a medium format Hasselblad camera the night before the event. You can probably see where this is going. I'll keep this story

short since it's a bit painful to recollect, but I ended up with a bunch of different problems from focus to exposure. I had not used a medium format camera before and much of the process was uncharted territory.

I was able to salvage a few decent frames from this once-in-a-lifetime event, and I learned some important lessons: Be prepared; know thy equipment before you take on an important job with it; never buy a new piece of gear to use for an important job before first testing it and being comfortable using it; always zero your camera from the night before so you're ready for the next day's shoot. There are quite a number of lessons that this mistake provided. That's why mistakes, when no one gets hurt,

can be so helpful. Cherish and learn from them (**8.6** and **8.7**).

"Try again, fail again. Fail better."
—Samuel Beckett

Mistakes are an inevitable part of the learning process. Don't beat yourself up over them; learn from them. As I mentioned in Step 7, if you have the possibility to go back and reshoot—a "do over"—then take it. In my experience, having a second chance sends you back with a mission-correcting mindset and you can fix your mistakes. It's a photographic redemption, particularly when the reshoot results in a shot you really like.

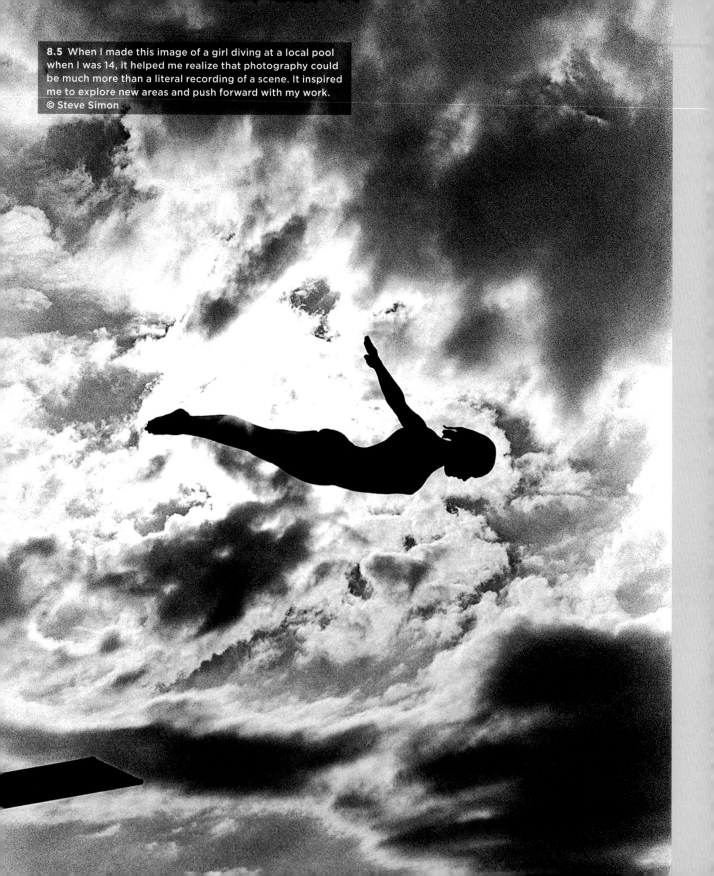

8.5 When I made this image of a girl diving at a local pool when I was 14, it helped me realize that photography could be much more than a literal recording of a scene. It inspired me to explore new areas and push forward with my work.
© Steve Simon

8.6 Mistakes have inspired me to experiment, like in this image of Cindy McCain leaving the stage at the Republican Convention in Minneapolis. I purposely pulled some images out of focus to see what they might look like. Really. © Steve Simon

8.7 Mistakes sometimes aren't as bad as you first thought. I was waiting around to get access to this clinic in Harare, Ethiopia, when I changed my camera's file format settings from RAW to JPEG Basic, the most compressed and least quality JPEG to make a few visual notes. Well...you guessed it, I forgot to set the camera back to RAW. I proceeded to shoot the next couple of hours this way and when I realized my mistake, I was devastated. But the reality was, the images reproduced fine. I was able to make big beautiful prints and though shooting highly compressed JPEGs isn't recommended, I discovered that they can deliver excellent results. © Steve Simon

LOOK CLOSELY

As we've discussed, photography is a big umbrella under which there's room for an amazingly diverse range of work. Some photographers "pixel peep," striving for ultimate quality with every frame—and that's a noble effort. But technical perfection isn't always the answer.

There is a growing mass of photographers who express themselves through "mistakes." The imperfection of the images coming out of the "Lomography movement"—where people use cheap plastic "toy" cameras that have light leaks, which create mood and atmosphere for evocative imagery. There are dedicated pinhole experimenters who do beautiful work, dependent on the unpredictability and imperfections of those cameras. Technical limitations can be an advantage; in the end, the only thing that matters is that your image communicates what you set out to communicate, no matter how you took it.

Confinement can also work to your advantage when you're forced to shoot from a specific location. When you photograph big events like political conventions, you often don't have the luxury of moving freely. This forces you to work within the confinements of space and maximize the image possibilities that are within reach (**8.8** and **8.9**). It forces you to really look and discover what you might not have seen if you had the ability to move around.

I remember an assignment Canadian nature photographer Freeman Patterson once gave. He advised photographers to lock themselves in their bathroom with their camera and a macro lens and not come out until a 36-exposure roll was exposed with 36 different images. When shooting under pressure in a confined situation, it's amazing what begins to reveal itself when you concentrate and see what's there.

One of the great leaps for our digital photographic learning curve is the ability to see right away what went wrong or what went right and to tweak accordingly. We can spend time with metadata and study our camera settings to find patterns. With

8.8 and 8.9 When covering big events I am often given restricted access—like in this image of photojournalists at the 2008 Democratic Convention in Denver—which forces me to work within my boundaries and create my own photo opportunities. In my experience, for every camera position there is usually a strong image lurking within range, waiting to be seen and captured. Joe Biden hugs his son at the 2008 Democratic Convention in Denver. © Steve Simon

cataloging post-processing programs like Aperture and Lightroom, you can search very specific parameters—say, all images shot with a 24mm lens or every image you took wide open or at f/11 (**8.10**).

In an instant your screen is populated with these images, which can be an amazing teaching tool.

CRITICAL THINK

As mentioned in Step 7, finding a second set of eyes to convey to you why images work or not can be hugely beneficial. Friends and relatives are great, but pats on the back are less useful than meaningful, constructive criticism. To be most effective in both giving critique and understanding fully the

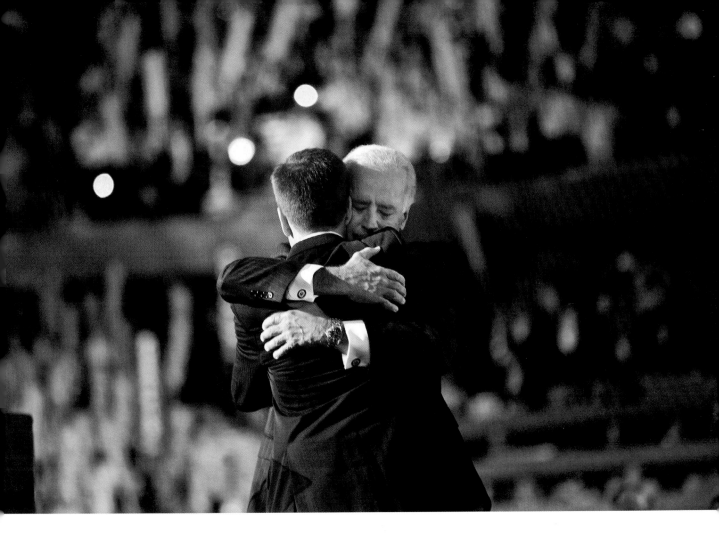

8.10 Searching images through EXIF data can teach you much. Here I have searched my Aperture library for every photo taken with an aperture greater than f/4, a focal length of 24mm or less, and shutter speeds of 1/500th of a second or less.
© Steve Simon

constructive criticism coming your way, it's good to have a grasp of critical thinking to help you articulate what it is you say about photography and what others are telling you.

Critical thinking is about making judgments that can be articulated and defended. The key to making good judgments is to understand how evidence supports or opposes a claim. Of course, "evidence"—when it comes to a creative pursuit like photography—is going to be subjective.

The process of critical thinking requires you to do some thinking about the subject to become aware of your own assumptions about photography so you can be cognizant of them when you listen to others comment on your work. For example, if we assume that documentary photography is, for the most part, real moments caught without interference by the photographer, then if someone says the image could be improved by moving things around (as opposed to moving yourself around), we can respond and steer the discussion to a more relevant path

So many variables can affect your interpretation of a photograph. Photographing people from above with a medium telephoto lens can be flattering to a subject, but so too can photographing from below. The portrait photographer Yousuf Karsh would often elevate his subjects by looking up at them from a lower angle, which, along with his mastery of lighting, would tend to glorify his famous subjects.

Shooting in color or black and white can have a profound effect on the images you make. Black and white generally cuts to the content of the image and can provide a more timeless interpretation, but it can dilute the mood or softness of a color image of the same subject (**8.11** and **8.12**).

Contrast and light can also profoundly affect how the viewer interprets the photo. Harsh, hard light, and high contrast versus soft, lower-contrast lighting will give viewers a different take on the same subject.

The following are some of the variables you should consider when articulating your feelings about a photograph:

- **Shutter speed.** The freezing of movement or showing the blur with slower shutter speeds has a big effect on what and how the photograph communicates.
- **Focus.** Using selective focus or great depth of field.
- **Lens selection.** Telephoto lenses isolate, crop out, and flatten, while a wide angle includes more and can distort and exaggerate for effect, if the photographer chooses to do so.
- **Camera position.** Where you shoot from is all-important in determining what and how much you will include in the frame. Using the same lens from different camera positions results in very different images. Camera angle also changes emphasis and background within the frame for dramatic differences in what is communicated.
- **Cropping.** We crop all the time, even during the original exposure, by what we choose to include in or exclude from the frame. But we have even more control over what is being communicated by cropping the image in the post-processing stage. You can save or improve a photo by cropping out parts that distract or interfere with composition. You can also change meaning in a photo by cropping out key elements.

When determining what is and what isn't working, make sure you understand what is being said about your work, and ask questions to clarify your understanding. Everyone has biases, even the great masters, and not everyone is able to communicate their feelings about visuals in an effective way. It's always good to get a number of opinions when it comes to critique, and it's important to realize the spirit in which critiques are given.

In a personal critique session, let people talk and try not to interrupt. It's a great thing when you have

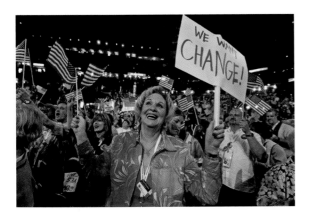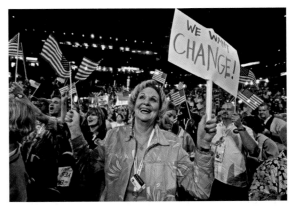

8.11 and 8.12 Determining when to shoot in color or black and white is a personal preference. When color amplifies the content, I prefer it; when it distracts, I may choose black and white. Photograph from the Democratic National Convention in 2008. © Steve Simon

someone willing to take time to discuss your work, so make sure you're listening properly and asking questions when appropriate.

When I look at a portfolio or a series of images, I like to see them all first before I open my mouth—maybe even take a second look and process my thoughts before I speak—to give the most effective critique I am capable of. If you use this approach, that means you've seen all the images and have come to some conclusions as to its strength and effectiveness as a body of work. Questions a single image might raise are often answered by subsequent images in a series.

When making a point about a photo, answering the question "Why?" can often be most useful. Just like other areas of the photographic process, the more you critique, the better you get at it, and the better the questions you can ask when others are looking at your work.

You have the answer, Grasshopper. Who better to answer your concerns than the person who knows best: you.

Once you identify a problem, some of the answers might involve seeking out a photo support group like a club or Flickr group, and practicing your critical thinking processes. Taking a workshop or course with the right teacher can have a great positive impact. And then, of course, there is practice.

I suggest creating an album of images you can learn from—images that you're unsure about or you've been disappointed in, as well as ones you feel are successful—and flag them for critique. If there's something you don't understand, you can seek help from others who may be able to articulate answers to your questions.

It's sometimes uncomfortable to get an honest critique of your work, but it's so important to your development as a photographer. Be open. Listen and decide if what is being said is something you can use. Try not to be defensive. Embrace the help and don't take critique personally. It's a brave thing to put your guts on the table by showing your work, but it's necessary to learn and move forward.

Lessons Learned

GETTING NAKED

It's sometimes hard to recognize life-changing moments when they are happening, and if photography is life (or an important part of our lives) then this exercise was somewhat of an epiphany for me.

It was a Eugene Richards workshop in Maine, many years ago, and a group of 14 students signed up, attracted by the shear force and power of his compelling work, which often dealt with difficult real-life documentary topics. His books have evocative titles like *Cocaine True, Cocaine Blue, The Knife and Gun Club*, and *Below the Line: Living Poor in America*, which say volumes about the content. The thing about how he works is, if he's not close enough to physically touch his subjects while looking through a wide-angle lens, then he moves closer. That intimacy is communicated to the viewer.

So, when on Day 1 of the workshop he gave each of us a photocopy of the poem "I Sing the Body Electric" by Walt Whitman, it came as a bit of a surprise. A much bigger surprise was when he told us, "Choose someone in the class, and interpret the poem through nude photography."

What? Did I just hear what I thought I heard? Maybe some of the participants were expecting this assignment, which in retrospect was somewhat legendary and had been given in previous workshops, but I certainly wasn't (8.13).

The class was made up of seven women and seven men of all ages, shapes, and sizes. Awkwardly, we all somehow found a partner to take on this hugely challenging (for me, at least) assignment. If you knew me, you'd know that I'm not one of those "let it all hang out" kind of guys. Why was he making us do this? Shouldn't we be out in a rougher part of town looking for gritty and real subject matter to focus on?

I was not the only one in the group blind-sided and uncomfortable with the assignment, but when the realization that this was a serious challenge put to us by a master photographer we all respected, we summoned up the courage and everyone went to work.

8.13 A drawing class in New York City. © Steve Simon

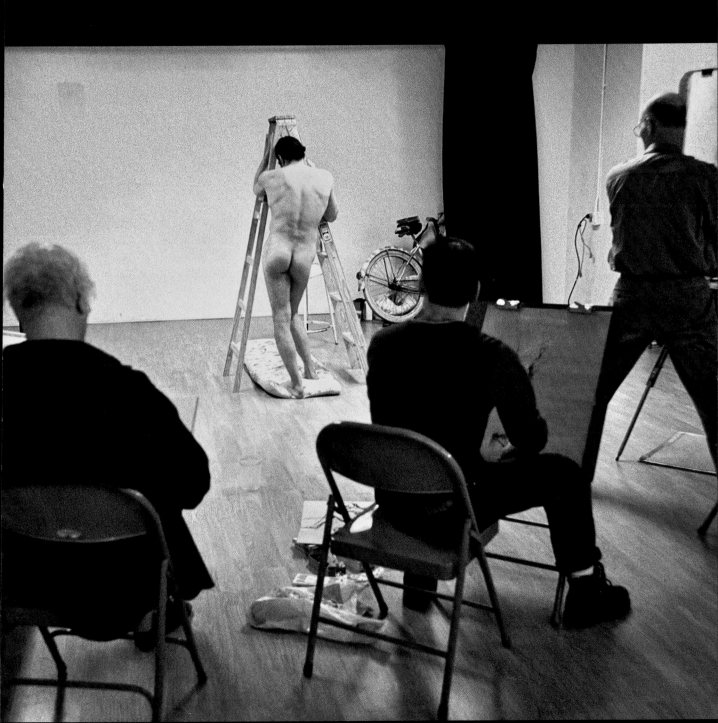

As a photographer, once I got past my fears and put the viewfinder to my eye, I didn't have the content to contend with as much as light, form, and texture. It was a great challenge to frame and say something aesthetically about the human form. But it took a while to understand just why a photographer like Eugene Richards would give us such an assignment, one that upended all my expectations.

Then I got it. It was an exercise in vulnerability. We were all interested in telling stories about people, often people who were on the margins of society. Our subjects are often vulnerable in front of the camera, particularly when they place their trust in the photographer. The photographer has the power. What does it feel like to be vulnerable in front of a camera?

Thanks to Eugene Richards, I now understand that feeling. To be naked in front of a stranger with a camera, I had never felt so vulnerable. Taking on that assignment was completely out of my comfort zone, and completing it was one of my greatest accomplishments. To her credit, my photographic partner was fantastic and helped make an awkward situation less awkward.

Once we got past our fears and concentrated on the photographic task at hand—looking at the light, composing for the strongest aesthetic, trying to make each other feel comfortable—it was a powerful, life-altering lesson learned.

The next day, when we returned to more familiar photographic subjects in the city, for me it was like a fog had lifted. Everything was brighter, sharper, and clearer to me. I went to work reinvigorated with a greater understanding and respect for the subjects I photographed and the process used to capture them. ∎

JUST SHOOT IT

The more you shoot, the more good pictures happen. This is something I know well, yet a weakness I struggle with is that I'm just not shooting enough. Due to the demands life imposes, shooting gets left behind. My answer is to make the time, schedule it so I can get out there with my camera and experience the joy of photography that got me obsessed with it in the first place (**8.14**).

8.14 A flower girl at a wedding in Juneau, Alaska. © Steve Simon

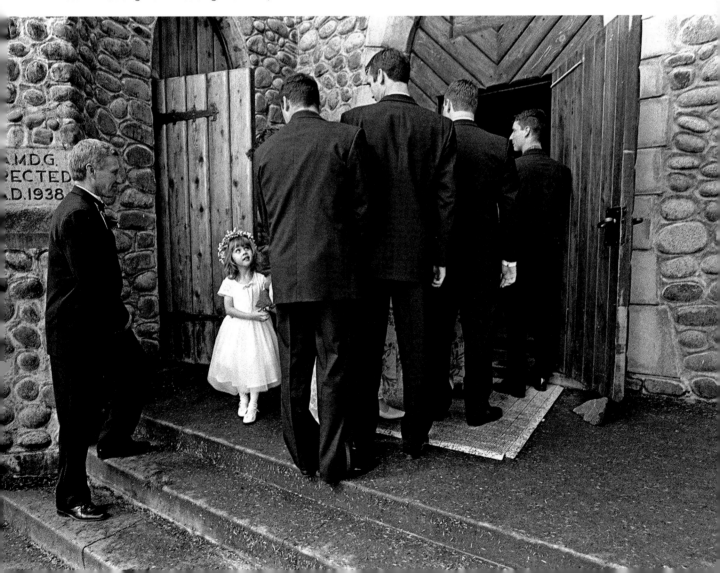

Step eight

ACTION: Strengths and Weaknesses: Just Shoot It

If you completed Step 7's action step and organized your archive, I hope having an organized, clutter-free, up-to-date and backed-up body of work feels great.

Step 8 is a good time to move in close for a critical look. I hope you are inspired by finding lost gems or rekindling projects or themes abandoned prematurely (or not even noticed). Look for patterns in your work and images that connect aesthetically or thematically and create new albums for them.

Think about how you're doing in relation to where you want to be. What is working and what isn't? What are some of the weaknesses you feel need to be addressed? Are they technical? Is your shyness holding you back or—maybe on the opposite end—are you too aggressive? Maybe you aren't shooting enough. Give yourself a deadline to start shooting right away. Do a picture-a-day blog. Schedule a two-hour block every week to go out and shoot. If you don't have a project, go shoot on the street. Just shoot it.

Or maybe you're shooting all the time without taking time to really analyze and edit the results to learn from them.

Write a frank and honest paragraph with regard to where you see yourself as a photographer at this time. What are your biggest frustrations? Where are your strengths? Weaknesses?

We've come this far and we've accomplished much already. We are at the point now where taking a look back, as well as looking at the road ahead, can help formulate a plan to move forward as we head into the remaining two steps. Ignorance may be bliss in some situations, but for the growth and evolution of a photographer, realizing areas to work on is a first step toward strengthening weakness and becoming a great photographer. You will get there—with perseverance, curiosity, and a willingness to learn from your mistakes.

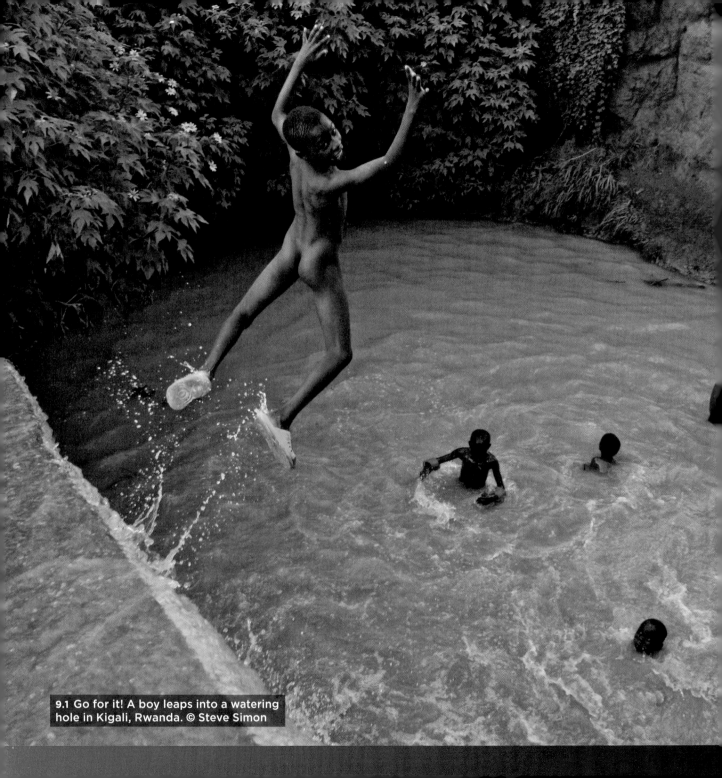

9.1 Go for it! A boy leaps into a watering hole in Kigali, Rwanda. © Steve Simon

ACTION PLAN: SETTING GOALS AND CREATING STRATEGIES

"A spirit in my feet said 'go,' and I went."
—Matthew Brady

It's time to take all the ideas and knowledge gleaned from the previous eight steps and create a plan of action to follow through to success. Now is the time to make an action plan to take your work to a higher level.

If your mission is to get to where you want to go with your photography, you first have to know where that is. Step 9 is about defining your goals and dreams as a photographer. These goals and dreams will motivate and inspire you. Moving forward, your vision should be clear and articulate. Setting goals and creating strategies to accomplish those goals is key.

9.3 We never know what the future holds, but we can plan to make it happen. Stop sign, Johannesburg, South Africa. © Steve Simon

9.2 Take some quiet time to think about your action plan. Clouds en route to Buenos Aires. © Steve Simon

Every photographer's action plan will be different. I encourage you to think and dream big, starting with a master goal list (**9.2**). Then you can determine your "goals hierarchy," breaking them down into bite-sized, achievable chunks.

Your master list may include general goals like "I want to shift my work life to a career in photography." Or maybe you want to create a book or have an exhibition at a gallery or museum. The generalized goals are a photographic bucket list of sorts, where dreams have no limits, creating your future in advance.

Curate your goal list carefully. Be selective and realistic, not in terms of grandeur, but with regard to how badly you want it. You should ask yourself, "Is this goal something I passionately want?" If your answer is yes and you're inspired—even if you don't know how you'll find a way right now—then it's worth it to take the necessary time and effort to achieve that goal because you're inspired, clear-minded, focused, and motivated.

I remember reading about a young Michael Jackson, who told an interviewer how reporters helped him by asking questions about where he saw himself in the future. It forced him to think about his life: where he was going and what his professional plans were. Take a look at your photographic life by thinking about where you are now and where you might want to go (**9.3**). Assigning goals to yourself is a good way to start a path to future photographic success and happiness, defined by *you*.

Take your master list and give further thought to each goal to break it down into its components. From there, you can be specific, monitor and measure your progress, and evaluate your results. But first things first.

GOAL NUMBER ONE

In my experience, getting your photographic life organized is a great first goal to set. Getting rid of clutter frees your mind for new and exciting opportunities, and it keeps you open to new ideas and sparks of creativity and inspiration. A big part of getting your photographic life in order is knowing where everything is. It has taken me a while, but by budgeting and scheduling time for organization, I finally consolidated and organized the many Aperture libraries in my collection. I then made sure everything was backed up once on site and once off site, and my five-star selections were also backed up to cloud-based servers and DVDs.

Digital photography is a leap of faith, so backing up your irreplaceable work is crucial (**9.4**). Hard drives die; DVDs deteriorate. It's ironic that perhaps the most archival form of a digital image may just be a print. I like to have several printed sets of my five-star selections as extra backups.

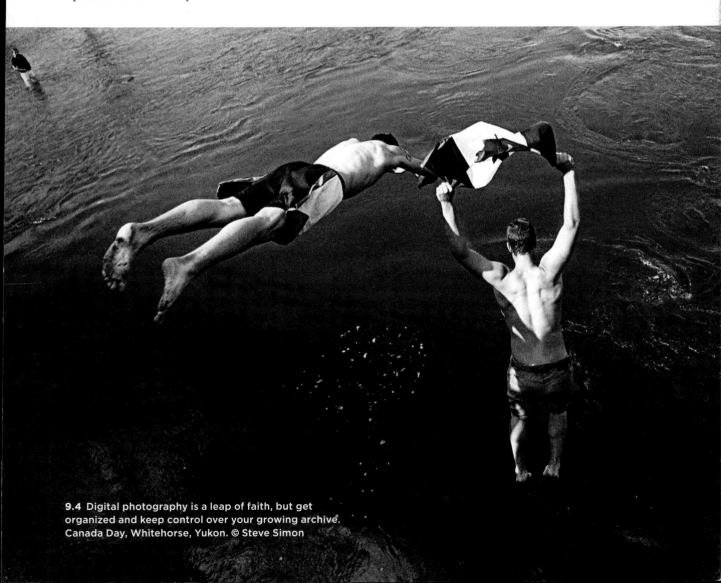

9.4 Digital photography is a leap of faith, but get organized and keep control over your growing archive. Canada Day, Whitehorse, Yukon. © Steve Simon

If you need to consolidate your archive, I recommend a post-processing software that also catalogs—such as Aperture or Lightroom—to help you keep track of the constantly growing "giggage" that makes up your entire body of work. Incorporate careful captioning and keywording into your basic workflow, which will make finding a needle in a haystack easy as you add thousands of images to your archive. If you still shoot film (or if you once did), make sure it, too, is organized and safely stored. Consider scanning your best film-based work and adding it to the digital collection.

Okay, you're organized. Feels great, doesn't it?

To help you configure your action plan, I have created suggested photographic goals and divided them into the following five categories: Projects, Artistic, Technical, Business, and Equipment. If you have specific categories beyond these five that apply to you and your work, add them.

Throughout my career, goal setting and list-making has been an important part of my success. For the best chance of success, get out your master list and begin to focus on your master goals to make them more specific and measurable. There is more on how to do this in the Action at the end of this step.

MARK THEM DOWN

For me, great ideas are like clouds drifting through my mind. They are here one second, gone the next. Many of these ideas get incorporated into goals and affect projects in a powerful and positive way, so don't let them get away. If I don't have a central place to record them, they get lost...maybe forever. Free your mind of clutter by consolidating all your thoughts and ideas in one place. Alison Morley at the International Center of Photography has students create a "UBook" as a personal diary of sorts. I suggest you create one to contain all your goals, notes, sketches, inspirations, ideas, doodles, storyboards, or anything that pops into your brain that you can use later.

It's hard to know when a great idea will show up. When it does, mark it down! The same goes for encountering great light or great locations you may want to revisit. Mark them all down with their own categories. Some people like the old analog way of recording passing thoughts; others prefer an electronic device they are comfortable with, from an iPad to a smartphone.

For several reasons, the iPad is fast becoming the ultimate photographer's "You Book." First, it is a great way to share your images with portfolio apps that showcase your work beautifully, perfectly suited to show off photography in an intuitive and high-quality way (which I'll talk about more in Step 10) (**9.5**). If it's not out yet, *The Passionate Photographer* companion iPad app is in development, so watch for it.

Second, as a media consumption device and learning tool, the iPad is fantastic. You can pack it in the front flap of many camera bags and backpacks, and it allows you to get online to learn, be inspired, and connect with the world.

As you begin to jot down your action plan, you realize just how powerful these tablet devices can be to keep you on track and plugged into the photographic world. By writing things down (there's even an app—Dragon Dictation—that lets you talk to your iPad/iPhone, transforming your spoken words into written text directly to the notepad, which can then be instantly emailed).

When you clear your mind of thoughts and ideas by making a record of them, your mind is free to pursue more creative challenges. The easier and more portable the device you use, the better (a small, cheap notebook can also work great). Beyond recording ideas, you can also connect and fire ideas to your Facebook and Twitter followers for a two-way creative conversation. But important tasks, like dealing with social media and email, can also present huge procrastination opportunities, so be careful.

For me, scheduling is very important to keep me on track. What's nice about the iPad or computer electronic calendar versus an analog one is you can

9.5 The iPad can make a perfect passionate photographer companion with a host of apps to keep you inspired and organized.

perpetually schedule items so they come up with the frequency you plan on, without having to physically write them down each time.

So I schedule my tweeting (more on this in Step 10) and email for an hour in the early morning and then in mid-afternoon, checking in periodically and looking for time-sensitive, important messages. But I try not to get side-tracked. I find that by scheduling tasks on my calendar, I'm more successful in getting them done.

Schedule "Passionate Photographer Step 9 Goal Check-In" to pop up six times a year to remind yourself to formally check and assess your progress. If things are not working out as planned, determine why not and make adjustments. It's a constant process of evaluating, tweaking, and taking action until your goal is achieved (**9.6** and **9.7**).

For technical goals that require you to learn new techniques, there are likely books, videos, and apps available to speed up your learning curve and make your goals easier to achieve.

PROJECT GOALS

Step 1 began with "Passion," and I'll start my suggestions for setting goals with one of the best ways to find said passion: taking on a photo project. More than one project or theme at a time is fine, since it can be helpful to have a balance between a "heavier," more emotionally draining project, and one that's lighter and fun.

Look back at Step 1's Action (page 29). If necessary, do the brainstorming exercise again to establish your project goals.

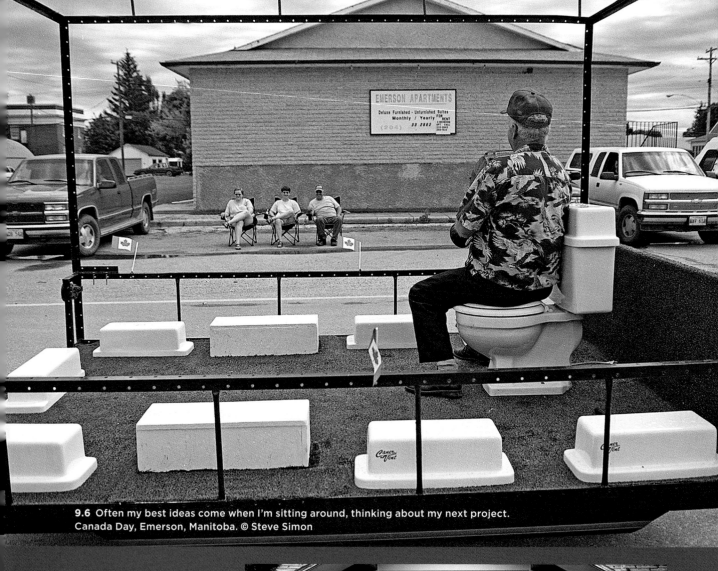

9.6 Often my best ideas come when I'm sitting around, thinking about my next project. Canada Day, Emerson, Manitoba. © Steve Simon

9.7 A couple sits on the porch in Spokane, Washington. © Steve Simon

ARTISTIC GOALS

Artistic goals stretch your visual muscles beyond some of the recommendations in the previous steps. Consider the following goals to develop your skills.

Goal: Take a workshop

Personally, I have always sought out ways to grow and continue the lifelong process of pushing my personal photographic envelope. It's a cumulative thing. As your skills and experience grow, it's harder to find those new ways, but if you seek them out you can identify them. I have had many great experiences at the various workshops I have taken throughout my career. Sometimes, it's just one powerful nugget that you take away that you incorporate in your shooting moving forward. Like shooting a volume of work, the more you expose yourself to learning opportunities, the more your chances increase of picking up something you can use. Find workshops from photographers whose work you admire and do your research. Talk to former students and get the real skinny on what the workshop provides.

There are all kinds of free photography podcasts available from iTunes, along with webinars and videos all over the Web, which can be a great start to finding new information you can use and incorporate into your work.

Goal: Seek out critique

In Step 7, I made it clear that you need help editing your work. Make it a goal to get your work out in front of people who can articulate their opinions and suggestions for your work. Join a camera club or professional organization, or find a mentor. There are also lots of critique forums on the Web that could prove useful. There are more than 2,500 critique sites on Flickr alone.

Goal: Visit museums, galleries, blogs, and websites—and read books

Great work exists out there that you can learn from and be inspired by, so why not make it a goal to seek it out? Start collecting and organizing your browser

9.8 Podcasts are a great way to learn while multi-tasking, and they are plentiful and free. I'm partial to "This Week in Photography."

bookmarks into various sections that make sense for you—Photographers, Galleries, Museums, Blogs—and schedule time to explore them. Your Twitter, Flickr, and Facebook feeds can be great ways to get the message out there (as you'll see in Step 10), but they are also a wonderful resource for following and hearing about new and innovative things photographic. Find 10 smart photography blogs, bookmark them, and subscribe to their RSS feed (**9.8**). Find 10 photographers on Twitter who can point you in interesting photographic directions around the Web. Find the websites of 10 photographers whose work you admire and aspire to. You might also want to start a physical tear-sheet file, ripping images from magazines and printing photographs you find online that you can have around to inspire you. You might even inspire yourself by making it a goal to print and frame some of your best work to have as a reminder of where you've set your photographic bar.

Lessons Learned

IF YOU WANT TO KNOW IT WELL, TEACH IT

My love of photography has always co-existed with a passion to share my knowledge with other passionate photographers. But my motives weren't purely altruistic. I started to teach as a way of learning, writing a photography column as a teenager, which was published in newspapers and helped finance my education. But most importantly, I realized that writing about photography was a great way to learn photography.

Though I was hardly an expert, by the time I finished a particular article, I had a thorough knowledge of that topic. I have also taught photography to thousands of photographers around the world at colleges and workshops. It has always been a two-way learning process for me, having been inspired so often by fellow passionate photography students and colleagues, some of whom are the very best photographers working today.

So if one of your goals is to enhance your knowledge in a certain area, I would encourage you to teach said subject, because the standards of knowledge required to teach something means you'll really know that task when you're ready to share the information with a group of people (9.9). Then you'll learn even more. ∎

9.9 If you want to learn something, teach it. From the book *Heroines and Heroes*, high school students learn about HIV prevention. © Steve Simon

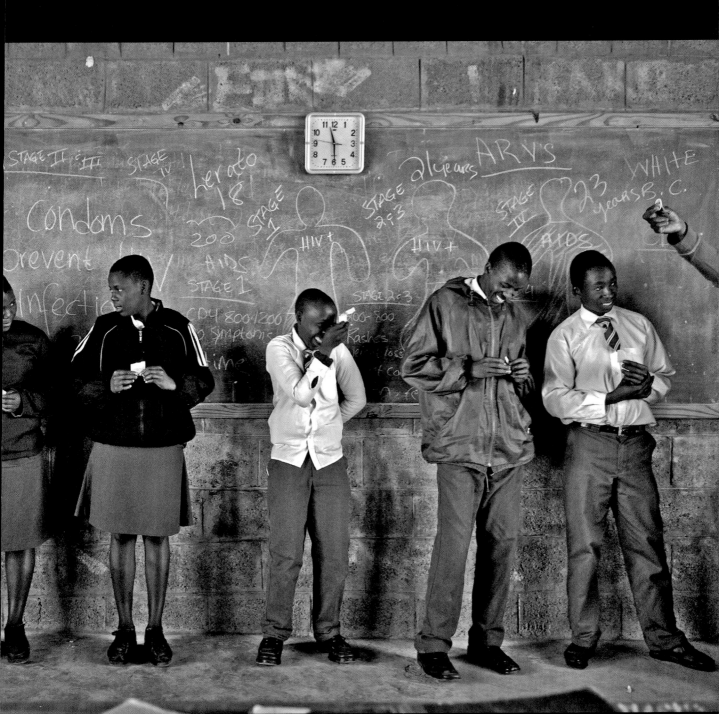

TECHNICAL GOALS AND SHOOTING MORE

"So, keep your eyes open. If you see anything, take it. Remember—you're as good as your last picture. One day you're [a] hero, the next day you're a bum…"
—Weegee

As I've mentioned a few times, technical competence is a given in your journey toward becoming a great photographer.

It's no mystery. If you create technical goals for yourself, you can achieve them by taking a class or learning online, and then practicing what you learn. Go through the volume by scheduling shooting time each week and sticking with it.

Set post-processing goals for yourself. You need to understand your image-processing tools to maximize digital file quality. Maybe you want to figure out a better workflow and backup strategy. Maybe you want to keyword and organize your existing archive. Set up a workable strategy to spend a minimum amount of time per week to achieve this. Schedule it into your calendar and make it a goal.

If it's new techniques you're interested in, pick one and make it a priority. Then learn and practice it. It could be anything, from high dynamic range (HDR) photography to printing your own work, to exploring video and making a multimedia piece that incorporates all the storytelling elements you're interested in.

BUSINESS GOALS

It is true in the business of photography that you "get what you show" when it comes to your portfolio. People who see your work and commission you for a job will often ask that you apply that vision they saw while looking at your work to their particular need. It's a form of typecasting, but when money and reputations are on the line, few art directors and editors are prepared to take chances (**9.10**).

Your goal might be to create new portfolios that move you in new directions reflecting the work you want to do more of.

Whatever your business goals, from selling prints of your work to getting more assignment work, to getting into stock photography or working for non-governmental organizations (NGOs) abroad, you need to mark it down as a first step and then do your research to make it so.

EQUIPMENT GOALS

The Passionate Photographer is not about the equipment; we know that. But there are always items you might think you need—and others you just want. I like the idea of drawing up a dream list, and online vendors like B&H Photo, Adorama, and Amazon are all to eager to help by allowing you to create "wish lists" on their sites to keep track of all the tools you desire.

It's not about the equipment, true, but there are times when new gear can help push you into new ways of seeing and new positive directions. A good first step might be to go through all your existing equipment, from lenses to lens caps, and trim the fat by getting rid of items you don't use. Sell them and allocate the cash to more relevant photographic tools on your wish list or to fund projects. A noble goal.

9.10 Conversation in downtown Fredericton, New Brunswick.
One flash, off camera to the left. © Steve Simon

Step nine

ACTION: Goals and Strategies

When creating your action plan, take some time and find a quiet spot in a library, coffee shop, or anyplace that you like to spend time and just think. Bring a pen and your You Book/iPad. Begin by creating a master list, mapping out a photographic future you can imagine or dream of. Then figure out a master path to take you there. Don't think—just mark it down. Think long-term and big picture. From there you can narrow down your goals. You may want to separate them into short-, medium-, and long-term goals.

When you focus in on your master goals, make them specific and measurable for the best chance of success (**9.11**). Schedule time in your calendar to work on specific actions for each goal. For example, instead of writing "I want to do more street shooting," try "I plan to schedule three hours every week to concentrate on my street shooting portfolio to create a preliminary body of work in six months, then evaluate and decide how to further the project for eventual publication and promotion." A mouthful, for sure, but it's specific and can be scheduled and monitored for progress. Breaking down all your goals in this way will make the action steps more obvious and achievable.

Share your goals with trusted friends who can hold you accountable for their completion. Print your goals and place them where you can see them as a reminder. Think about their order. If one of your goals requires a certain technical competence that you're not confident you have yet, work on the technical competence goal first.

You've got a master list, so don't bite off more than you can chew at one time. Keep your schedule realistic and work hard, but allow for balance. My wife tells me there's more to life than just photography. She's always right.

9.11 One of my goals was to cover Canada Day in all 13 provinces and territories over 13 years. Mission accomplished. © Steve Simon

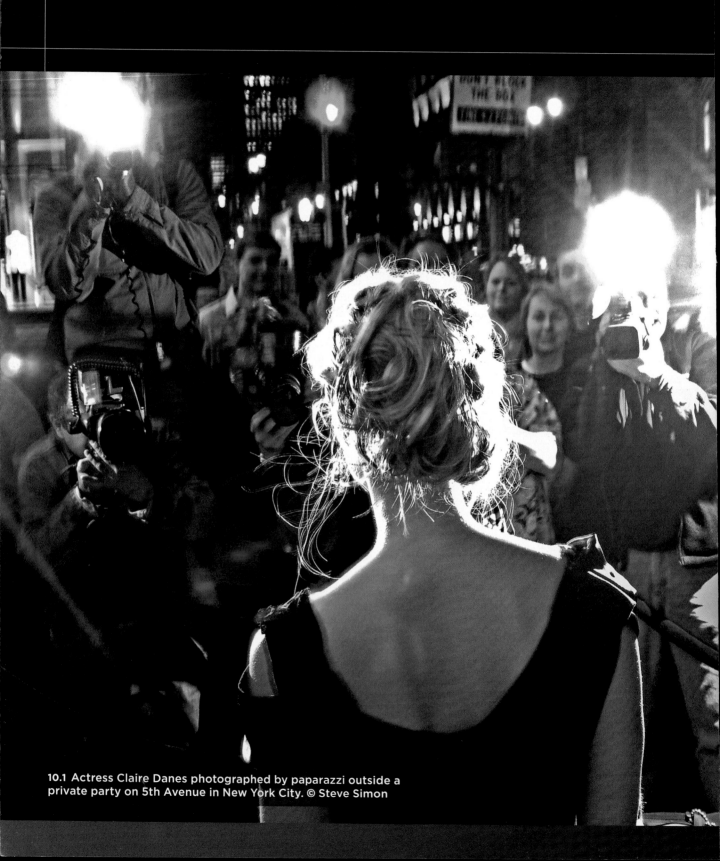

10.1 Actress Claire Danes photographed by paparazzi outside a private party on 5th Avenue in New York City. © Steve Simon

FOLLOW THROUGH: SHARE YOUR VISION WITH THE WORLD

"You can have the best work in the world and if you don't put it in front of people, you'll never get anywhere."
—Ted Grant

In this, the last step toward becoming a great photographer, it's time to finish what you've started and share your vision with the world. Since many of this step's topics are too big to be contained in this chapter, consider them starting points for further investigation into areas most important to you.

I used to joke and say I was absent that day in Mrs. Bores' first-grade class at Gardenview School when we learned about sharing. But good thing I wasn't, because I learned early on in my photographic life that sharing is a great way to learn, and the more I share, the more useful information I acquire and the more opportunities come my way (**10.2** and **10.3**).

10.2 Online photo sites like Flickr can be a great place to get feedback on recent work. © Steve Simon

10.3 Twin brides Roselane Madubedube and Rose Mabale Seqhomoko (right) shared the spotlight at their wedding in Maputsoe, Lesotho. © Steve Simon

Manny Librodo is a former schoolteacher who turned his passion for photography into a successful career, mostly by sharing. He's the first to tell you that he owes much of his success to the Web, with the help and support that has come from the online community of photographers through Facebook and his PBase gallery.

It doesn't hurt that Librodo is extremely talented and a great promoter of his work. His approach to photography is simple. Fueled by passion, he shoots JPEG exclusively (just because he always has) and works using natural light and reflectors to create his spectacular images, which he finesses in Photoshop to get the look he wants.

His gallery of 4,000 images has been viewed an astounding 23 million times (www.pbase.com/manny_librodo) and he gets his name out by entering (and often winning) online photo contests. He's now a full-time photographer and educator living his photographic dream and teaching his techniques at sold-out workshops around the world. Here he comments on how he benefited from sharing his work:

"I first started sharing my travel photos at www.trekearth.com. Glowing and searing comments were thrown here and there. I learned so much from them and I graduated from a point-and-shoot camera to a DSLR camera because of my desire to shoot 'better.' Because of the need to feed my online followers my travel photos, I continued shooting even outside of my travel. I started shooting my students and entered the pictures I took of them in online competitions. I joined more online communities, which honed my skills in both shooting and post-processing. I used to enter daily (www.digitalimagecafe.com), weekly (www.dpchallenge.com), and monthly (www.betterphoto.com) competitions, which luckily reaped me honors and got my name out there. But over and above the victories I've achieved, the critiques I got from people in the community have taught me how to be a better photographer."

THE SOCIAL NETWORK

Much of my photographic life and many of my business relationships have happened without ever meeting face to face. People can learn about me from my website and blog and by following me on Twitter. It's a virtual presence, no body required. Because of that, my photo business has changed. I often get assignments through email, then meet the subject, shoot the job, process the images, email or upload them, and invoice without ever meeting the client face to face or even talking on the phone.

Social media offers unprecedented opportunities to build photographic, personal, and business relationships all at the same time and remarkably quickly, everywhere in the world. I got into Twitter kicking and screaming, then loved it. I quickly realized that my followers were not an anonymous list of names but a passionate crowd of kindred spirits who have similar interests and speak the language of photography that I'm fluent in (**10.4**).

My photographer friend Ben Long equates social networking with fast food. He says if you consume too much of it, you might start to feel sick. It's true that social media can suck you into its vortex and become a powerful engine of procrastination. But it can also provide tremendous opportunities for networking and relationship building. It doesn't cost you money, but it does take up something as valuable—your precious time, which can be used in so many other productive ways. So you want to use social media wisely through smart planning and prioritizing.

With so much business taking place online, it's crucial to make a good virtual first impression. Wherever you have a social media presence, it should be easy to find your other sites. There are many options, but for me, I'm concentrating my efforts on Twitter, Facebook, LinkedIn, and my Passionate Photographer blog. I'm just scratching the surface here with social media, but I understand its power and want to convey to you the importance of breaking into the community, particularly as

you get more serious about your work and want to promote it.

Schedule your time. In Step 9 you established a set of goals. Make taking action a priority, but be realistic about the time you have to work toward your goals. Schedule your email and social media tasks and stick to it, chiming in from time to time with a tweet or picture you want to share. Some great apps are available that let you take back your time and schedule your social media posts for different platforms so you can stay connected in advance. HootSuite, TweetDeck, Seesmic, and CoTweet are a few worth exploring. But part of the organic nature of social media is its immediacy. If you're writing posts for future delivery, write them in the "now" so they don't seem stale or spam-like.

10.4 I love to tweet. Follow me @stevesimon.

10.5 Wedding photographers often like the more personal connection that Facebook brings. © Steve Simon

Briefly...Twitter

I think because of my short attention span, I love Twitter. Of all the social media applications, Twitter is the most fun for me. With Twitter, you can not only quickly and briefly—in 140 characters or less—throw your followers useful tips and photo nuggets while keeping them informed of new work, but you can follow the right people and get little nuggets of inspiration for your business and shooting. I've joked to friends that my followers are like my children; I want to give them the right information and ideas for inspiring them and improving their work.

But I've also learned that all work and no play make Steve a dull tweeter. Some of the most successful photographic Twitterers will bare their soul, photographically and otherwise. Much of their success comes from their honesty, which people respond to. It's amazing how personally connected you can feel with someone half a world away who you've never met. It has made the world feel smaller. Remember the idea that the more personal your photo project/idea, the more universal it becomes? Well, the same holds true with social media.

Some of the most popular photographers I follow are a bit gushy/mushy for my tastes, but I follow them because they provide great tips and links. Some tweet inspirational messages, some are funny, others are all business, and most are a combination of all those qualities. The commonality: They are all authentic and provide worthwhile or entertaining information. When you follow them for a time, you get to know them in what feels like a very personal way.

Think about how you want to come across to others. Do you want to focus in on specific areas? Now's the time to invent or reinvent yourself and your "brand," but let honesty and authenticity be your driving force. People recognize authenticity; you just can't fake it. The Web and social media engines can be powerful marketing tools pointing people to places where you have something to sell, but I suggest you don't make sales the main focus of your social media strategy.

Talk about your stuff, but point your people to photography and other cool people, stories, videos, and tips. Maybe one in 10 tweets can be of a promotional nature, talking about that new print for sale or workshop you're offering. The majority of your communication should be about building relationships in the community. People begin to know you and trust what you have to say as you build that trust with quality information. When that trust is there, they will spread the word to their networks and your reach will grow. Many will want to support your commercial ventures, or pass on your offerings to their followers.

Facebook

The idea that something is too big to be ignored definitely applies to Facebook. Just go to the Facebook statistics page and read about the more than half a billion active users spending more than 700 billion minutes per month on the site, each with an average of 113 friends. That's a huge community with a lot of potential.

Unlike Twitter, there's more room for digging a little deeper on Facebook, but for most people it's primarily a way to keep in touch with friends and family. For photographers, it can be a powerful way to promote your work and business. A friend of mine uses it to get news, help propagate news, rant, riff, and occasionally throw out some creative work to the world. He keeps his longer-form ruminations for his blog.

Technically, you shouldn't be using a standard Facebook profile to advertise or promote yourself or business professionally. There have been a few surprised and bewildered photographers who were removed from Facebook by invisible moderators. But there is a free option for business, where you can create a fan page to promote your brand beyond the 5,000-friend-limit for regular profiles. Whenever you post to your fan page, if you have 2,000 fans

they all get the posting. Some photographers, particularly in the portrait, children, and wedding markets, prefer the more personal connection they get with their standard profile (**10.5**). What's nice about Facebook is you can post and tag photos and videos, which links your post to not only your client's page but to their friends' pages as well, which can drive traffic back to your page.

LinkedIn

LinkedIn is the most "grown up" of the social media I've cited here (**10.6**). Designed as a networking platform for business, it's less visual, yet there are thousands of photographers signed up. Like Facebook, permission is required for you to connect to contacts, but the professional photo community is growing fast, making LinkedIn an important part of your social media community.

10.6 The LinkedIn website.

MY EXPERIENCE

Because I travel so much, I often reach out to my photographic family through the online community (**10.7** and **10.8**). When I'm looking for information on the new place I'm traveling to, I ask my peeps and I've never been disappointed with the responses. I've become "friends" with so many passionate photographers, from South Africa to South Carolina. It's a beautiful and powerful thing to have instant access to the generosity of the photo community for help with photographic questions or problems, 24/7. Whether it's technical info or feedback on photo sharing sites, we've got instant, fingertip access to our support group.

So if you're not doing it yet, join in. Work hard to keep inspiring your followers. Keep your posts interesting and don't overdo it. If you're not in a tweeting mood, don't. You likely will hang on to your followers even if you tweet sparingly; just keep it real and don't feel the pressure to post when you've got nothing to say.

It's good karma to pass forward stuff you find interesting from others. The community helps one another, and getting the word out for others will likely come back to you in a positive way. Since you never know who is online—and when—you might want to schedule a repeat of a clever post to reach those who may have missed the original post.

The power of social media was made apparent to me from my regular appearances on a podcast called This Week in Photography (TWIP). Wherever I travel, I meet fans of the podcast. Once, a fellow photo geek was sitting next to me on a plane and recognized my voice from the podcast. I'm always amazed at its reach and the positive effects that social media has had on my own life and career.

10.7 Florence is a wonderful travel destination for photography. © Steve Simon

10.8 A sign at the airport in Mozambique. © Steve Simon

THE BUSINESS

It's not a big stretch for photographers to want to spend more time being passionate about photography, so the idea of becoming a pro is alluring and worth giving serious consideration. Social media and your website/blog will play an important role in helping to feed that photographic furnace and make money in photography.

Being a professional photographer can be a wonderful way to live, but it's also extremely challenging (**10.9**). The adage that the best way to make a million dollars in photography is to start with $2 million is not far off. It has become increasingly difficult for pros to make ends meet, and the shine of photography is sometimes tarnished by the non-photo-related tasks performed daily to maintain the business.

The reality is this: Be careful what you wish for because the grass is always greener on the other side—meaning that those who don't depend on photography for their living may experience more joy of photography for the love and passion of it than those who do pursue it professionally. Amateurs can pursue their passions, whereas professionals often have to compromise and take certain jobs for the money. That said, all the unpredictable jobs and experiences can inspire a pro, pushing him or her into new and exciting projects and subject matter.

Everything in the photography business presupposes that the work is going to be good or, better yet, great. It's the work that counts most, so efforts must be made on improving your photographic competency and consistency to a level that lets you enter the fray with confidence. You want to be working the Ten Steps: learning, experimenting, taking chances, and moving forward with your vision. That said, let's move on.

When it comes to marketing in photography, the landscape has shifted and changed. It used to be more formulaic; photographers would send out promos, buy space in photographic catalogs, and

10.9 One of my first published photographs. A mother and child on a Toronto bus. © Steve Simon

10.10 A website is your photographic storefront and has become the instant portfolio for photographers seeking new work. Make sure it's inviting and fast loading. © Steve Simon

enter various industry contests to get their name out and find work. Now it's social media.

But true success has always been about building relationships. Be it editors, art directors, or clients, it's through getting to know people that trust is established and breaks are made. Whereas your work was always the springboard to new relationships, there are more opportunities today with the ever-expanding web-based social networking community. There's your work, there's you the photographer, and there's you the human being, and all three seem to be melding into one to become part of the brand you are selling.

THE WEBSITE AND BLOG

I've put these two critical storefronts together because increasingly I'm seeing photographers merge the two. The website is the photographer's digital portfolio; it often represents the work in a more comprehensive way but tends to be static unless you update often (**10.10**). And unlike a blog, it's a one-way conversation.

If you haven't bought your domain name, see if it's available now. Sites like register.com and godaddy.com let you plug in a name and instantly see if it's available. I added "photo" for my website (stevesimonphoto.com) since my name wasn't available. The .com's are most desirable, but don't fret; just establish your online presence and point people to your work.

From a business perspective, your website should reflect the kind of work you do and hope to do more of, and it should also reflect your personality. With literally millions of sites out there, it's a good idea to separate yourself from the others and establish a connection with the viewer right away. It should be consistent with the brand you have created for

yourself, both visually and in its content. Think about creating a logo and color scheme, which can be a consistent design that carries through all your promotional material.

The website will easily link to other work you do, and you should be clear about your site's purpose. Obviously it will showcase your work, but if you want to sell prints or books or develop your workshop or speaking business, this should be apparent.

For clarity, some photographers separate different kinds of work with different sites. I think there is merit in specialization, and if you want to develop a wedding business, for example, a dedicated site gives prospective clients confidence, indicating you're a specialist and expert in that area.

Make it easy for people to get in touch with you by including contact info on every page. It's an instant-gratification world out there with little patience. Make sure your site is easy to navigate, loads quickly, and is updated often to keep it fresh and entice people to come back.

I've only recently gotten my blog up and running. I've wanted to do it for a long time, but until I took my own advice in Step 9 and made it a goal and a priority, it didn't happen. These days, it's the blog—which encourages two-way conversation—that can keep your fans and followers coming back for more. You can post long-form ideas, new photos, and videos to keep the conversation current.

If you choose to do so, you can have a storefront advertising your services and whatever products you have to offer. A blog is the great equalizer. A little guy with a computer and good ideas can compete with well-established websites if they have quality and original content to offer the community. With more than 150 million public blogs in existence, some might say the blogging market is saturated. But if you've got original, thought-provoking and visually compelling content to offer, word will get around fast.

With so many of these social media possibilities, which ones should you have? If marketing is

your goal, probably as many as you can. But do your research and see what makes sense to you. Otherwise, use the platforms you feel most comfortable contributing to. If writing isn't your talent, then the briefness of a tweet or photos with captions or even videos might make sense for you.

THE GOOD BOOK

As I mentioned in Step 1, if you want to see what passion looks like, just look at a photo book. For many photographers, the photo book is the Holy Grail. It can be a great way to encapsulate a project, and it makes a wonderful portfolio piece. It lets you maintain full control of the work—choosing which images show up and where, how big, how they work together, and the accompanying text to give the viewer your vision of a project, uncompromised. Making a bookstore-quality photo book is now well within your grasp, but more on this later.

When we look at a photo book, we're looking the photographer's best vision of the project at the time it was created. An exhibition or web gallery is often fleeting; a book is somewhere, forever.

Getting a book published with traditional publishers of photography books has always been difficult (**10.11** and **10.12**). It's not that rejected work is not worthy of publication; it's just a hard business to make a buck. The offset printing process requires a minimum number of books to be economically viable. It's a niche market and these days, publishers are conservative in their quantities with most print runs between 1,000 and 2,000 copies, sometimes less. Generally, photo books are not big sellers, and when a publisher agrees to do a book they need to figure out how many copies to print. Few books sell out their press run, and the process can be very costly and wasteful since unsold books can be returned and are often "remaindered," banished to discount shelves for a fraction of their cover price. That's a good news/bad news scenario for photographers, since many wonderful books we've come to

know have at one time been remaindered, making them affordable for the photo crowd.

Because making money with photo books is not easily done, many big name trade publishers require photographers or galleries representing photographers to raise money up front to contribute to the cost, even with very well-known artists. A way around this is to self-publish. This is one of the reasons there is a long history of photographers self-publishing books, from Ralph Gibson and Eugene Richards to Lee Friedlander. Even literary, "word" people like Mark Twain, Ernest Hemingway, and Stephen King have self-published.

In the old model, if you could afford the up-front cost of production, you would take home most of the profit, but you also took all the risk. But it tended to be a more collaborative effort, working with a team of designers and editors. The theory was that more heads are better than one, and the book would be better because of the team effort. But when it's your book and you're working with a team, sometimes concessions and compromises are made, which can detract from your original vision.

Compromise no more. Print-on-demand technology has made creating publisher-quality, professionally printed soft- or hard-bound books of your work easy and economical. Now, anyone can become a publisher, and the quality is so good (and always improving) that only experts might tell the difference between the offset printing of traditional books and digital-print books. It's because of this high quality that many traditional photographic publishers are dabbling with on-demand printing for certain limited-edition projects. You make a book one at a time, and some companies let you

10.11 and 10.12 The University of Alberta Press published my first book, *Healing Waters: The Pilgrimage to Lac Ste. Anne*, now out of print. Pages are loaded on palettes before being cut and bound. © Steve Simon

market books on their site, where customers can buy the book and the printer takes care of everything: creating the book, shipping it, and splitting the profit with you.

I use Aperture software to create my books, which lets me easily experiment with different layout and page configurations (**10.13**). When I'm ready, I can choose to save as a PDF, create a book for the iPad, or use one of the great book-printing services from Apple, Blurb, Asuka, Shutterfly, Costco, Lulu, AdoramaPix, or a bookshelf of others (many of the online book publishers offer plug-ins for Aperture and Lightroom, or use similar and free software).

You won't be able to tell the difference between your book (when done properly) and one published commercially. When you've found your project and you work through the Ten Steps, you'll end up with a body of work worth sharing. I suggest you go through the process of putting it together as a book.

It wasn't that long ago when this great technology was not available to us so easily. In the old days, when I had a body of work I wanted to submit to book publishers, I would create a "book dummy" to show my vision of what the book could look like. It would often require making prints, spreading them throughout the house as I struggled with pairings,

10.13 There are a host of book-making sites out there. I prefer Aperture to do all my post-processing, but its book function is particularly powerful. © Steve Simon

10.14–10.19 Places like FotoFest let you bring a body of work to show to a variety of influential people in the world of photography. When you've got a completed body of work, it's a great way to find opportunities to show it. © Steve Simon

sequence, and the all-important cover choice, and then make multiple photocopies to submit to multiple publishers, binding them in some way. It was a lot of manual labor, and while the quality was enough for publishers to see the work, it wasn't great.

In 2005 I had an opportunity to have work from my coverage of HIV/AIDS in Africa published as a book. Instead of doing it the old manual way, I used Aperture to electronically create my vision for the book and print it out for the publisher to base their version on. Printing on demand forces you to do your best job, because you have the ability to add text and choose the size, layout, and design. If you take your time and don't rush the process, you end up with a book whose sum is greater than the individual photographs and other elements that make it up. Once printed, that's it; you're committed. That said, with printing on demand, you'll likely tweak the book in subsequent editions.

From a marketing perspective, the book can also be used as an e-book, which cuts the cost and time of getting it to those you want to show it to, and offers new opportunities—both financial and artistic—for getting it out to your audience.

If you're going to share your vision of the world, use all the many platforms available to you—from web to multimedia to prints. Still, the best way to display the blood, sweat, and tears put into many long-term projects is the photo book. If it makes sense for your work, I advocate making books for different projects and for your portfolio. They are relatively cheap and easy to share, and they can make a great impression on your reviewer.

THE PERSONAL MEET-UP

Despite all the online communication that today's photographer is doing, there comes a point when you have to leave the comfort and safety of your screen and venture out and deal with actual humans. You can never get enough constructive criticism, and one of the best ways to quickly get a lot of it from some of the most knowledgeable and articulate people in the business is to attend a portfolio review.

Several times a year, some of the most influential agents, editors, gallery owners, and museum curators from around the world gather at events like FotoFest (Houston and Paris), Photolucida (Portland), Review Santa Fe, PhotoNOLA (New Orleans), and Contact Photo in Toronto to meet with new, up and coming photographers. It's old school—the opposite of the virtual meeting. It's analog, it's real, and it can have a profound effect on your work and career (**10.14–10.19**).

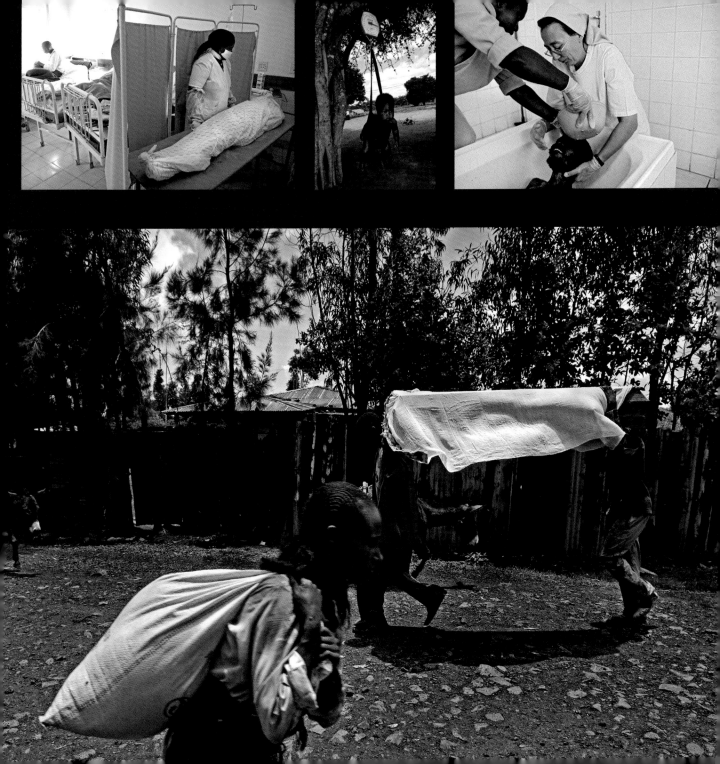

These events are not for incomplete bodies of work, but for passionate projects you've been working on for a long time, ready for exhibition and publication. You pay to attend these events, where you're usually guaranteed a fixed number of 20-minute meetings with some of the most influential "difficult to arrange an audience with" players within the fine art and editorial world.

Here's how they work. You find out who is going to be there, read the description of who they are and the institution they represent, and make your choices about who you should meet with. Obviously you want to match your work to the kind of work they are looking for, which is usually posted in the catalog.

There are many positive reasons for investing in these kinds of events. For one, they force you to get your project into the best possible configuration, like creating a book and print portfolio, crafting a project description and artist statement, and generally thinking things through so you can articulate your feelings about the project. Your project represents

10.20 Even in a digital world, most galleries and museums prefer to see a printed version of your work to see how the quality holds up in print. © Steve Simon

the culmination of all the steps you've incorporated into your work/thought process for photography.

Since many of the attendees represent museums and galleries, the print is still what is most often preferred, but on-demand books can also make a great impression, showing off the work in a more complete way. I prefer having many options, so for me it makes sense to have my work not only in print form but on my iPad or smartphone, website, maybe even a CD slideshow of JPEGs in case someone requests it.

The same thought and quality you used for your book needs to be put into your presentation, making it as perfect as you can and showing a respect for your work and your reviewer. For a printed portfolio, pieces should be crisp, clean, aligned, and the best quality (**10.20**). No compromises. They don't have to be mounted but should be contained in a nice archival box. If you slide prints into a portfolio book, make sure the pages are clean and easy to turn. I like to print verticals in landscape mode, so reviewers don't have to turn their head or the portfolio to see the proper orientation.

In my experience it's best not to try to show too much but to concentrate on your most developed body of work. It's not a bad idea to have other work with you; often, "unofficial" meetings are made, which offer you a chance to see people after hours. This is where having work on an iPad is a great way to show it off in dark restaurants or bars if that's where serendipity takes your review. Always get a business card, and leave your own card as well as other leave-behind material—a postcard or print that has your contact info and an iconic image of yours on it.

Your work will do the talking for you, but obviously you want to make a good impression. Practice the meeting process with a friend or fellow photographer. During your review you will likely get questions, and the more you've articulated your project both orally and in written form, the more comfortable you will be speaking to it.

Of course you're looking for opportunities that the reviewers may be able to provide, but what can be priceless are the insights into your work from smart people at the top of the profession. I've had great nuggets of insight thrown at me during a conversation that impacted my work positively. You might consider taking a recorder with you and asking if it's okay to record the session (they go so fast, and sometimes you miss things). Ask questions. Make sure you understand what is being said.

I've had some great experiences at FotoFest, not just by being immersed in a serious community of talented artists who I learned from, but by constantly seeing new and inspiring work and meeting great people throughout the week.

There's a euphoria that comes from getting a good review, but the key at these events is to follow up and build on the relationship you started. Sometimes promises are made and not kept, so try to temper your excitement until whatever you thought might happen, happens. When the Leica Gallery in New York called me to say they were interested in having an exhibition of my work, it seemed to come from out of nowhere. But the fact is, I had stayed in touch for years, keeping them apprised of new work. It was the relationship I had established, as well as the work, that led to the exhibition.

Bill Hunt is a highly regarded photography dealer, as well as curator and collector in New York. He knows how the game is played. "If you set your mind to it, you can meet anyone...once," he says. "It's that second meeting that proves difficult." When you do meet that person, be prepared.

Bill has allowed me to reprint his "Top Ten" handout on this subject, which I think hits the nail on the head when it comes to building a career in fine art photography.

1. Be talented.
2. Be smart. Think. Don't be a jerk. Be engaging. If you are determined enough, you can meet anyone at least once. Take the situation seriously; don't blow it. Take stock of yourself. Is the work fully realized and are you ready to approach museums or dealers?
3. Be focused. Be single-minded. Be ambitious. Think in terms of the long haul and the full arc of your career.
4. Be clear. Be able to articulate what you are doing, not so much why you are doing it but literally what it is. Rehearse what you are going to say. Keep impeccable records about your work.
5. Be ready. Have prints, have disks, have a resume, have business cards. Don't tell me they're at home or that you are still working on them. Give me something to remember you by. Send a thank-you note.
6. Be full. Have a life. Teach; get commissions, commercial work, stock, whatever. Get money, make love, be happy. It will inform the work positively.
7. Be active. Be your own primary dealer. Take responsibility for museum and magazine drop-offs. Approach collectors yourself. Develop a mailing list. Market yourself. Send postcards. Donate prints to charity auctions. Go to openings. Make friends with your contemporaries. Use them. Always ask to be referred. Publish or get published. Get patrons, mentors, advisors. Use them.
8. Be receptive. Take notes. Bring a pencil and paper to appointments. Do your homework. Know what sort of work galleries show before you approach them. Go look. Say hello, but be sensitive to a dealer's time demands (unless you're buying something). Have a sense of what's out there.
9. Be merciless with yourself. Edit, edit, edit. Edit, edit, edit. Take out anything marginal. Make me hungry to see more of your work.
10. Be patient. Please.

Lessons Learned

KEEPING THE FAITH: EMPTY SKY PROJECT

Faith is an element of my photography that continues to surface in my work, not only in the stories I choose to pursue, but also in my philosophy and approach to shooting.

What happened to me with my project "Empty Sky: The Pilgrimage to Ground Zero" was an exercise in faith and belief in my work and a great example of what can happen when you put your work out there.

The story dates back to just after 9/11. I decided to do a set of pictures documenting the pilgrimage of people who felt compelled to go to Ground Zero, to see with their own eyes the site of such unbelievable destruction. I wanted to do the project, partly to express my own grief and bewilderment after 9/11, but also because of the reactions I witnessed, which were very powerful and told a story about the event that was different from the photographs being made at the site itself (10.21).

After shooting more than 100 rolls of 35mm Tri-X film during a three-month period from late September to Christmas 2001, I felt I had a series of photographs that would work well as a book. I created multiple copies of a book dummy and had done my research looking for publishers of photography books, to whom I then submitted the work.

Though the project was well received—judging by the positive comments in some of the rejection letters—they were rejection letters nonetheless (10.22). Many rejection letters. Photography is a great way for us to communicate what we think is important or beautiful or scary in life, or for us to call attention to a problem that needs attention; in other words, it is a very personal way to communicate. So when you are rejected, it can hit you pretty hard. But it's important not to take it personally, and to learn from it.

10.21 A man looks through binoculars to where the Twin Towers used to be. From the "Empty Sky" project. © Steve Simon

W.W. NORTON & COMPANY, INC.
500 FIFTH AVENUE NEW YORK NY 10110-0017

April 29, 2002

Steve Simon
▮▮▮▮▮▮▮▮▮
New York, NY 10011

Dear Steve Simon,

Since September 11ᵗʰ I have received well over a dozen photography proposals on different aspects of the WTC and its aftermath. And I'm just one of many editors of photography books in this city. Yours is at the top of the heap of what I've seen: the photos are very good, often moving and with high artistic quality as well as sincere emotional content. Nevertheless, I'm passing on it for much the same reason as the others, which is to say that I and my colleagues here feel that there is a serious glut of books on this topic coming in the next six months. The professional photography groups such as Magnum will make their own books, and many more projects are in the works already. We're reluctant to enter that market.

Nonetheless, I thank you for the look and wish you luck. You do have a good group of photos here.

Sincerely yours,

Vice President
Senior Editor

JLM/cro

CALLAWAY

Dear Writer,

Thank you for sending us your manuscript. Due to the high volume of unsolicited submissions we receive, we are unable to respond to each one personally.

The editorial board has reviewed your manuscript and we do not feel that your project is appropriate for our publishing program.

We wish you the best in finding a home for your work.

Sincerely yours,

Editorial Department
Callaway Editions

umbrageeditions
publications
traveling exhibitions
multi-media

Steve Simon
▮▮▮▮▮▮▮
New York, NY 10011
▮▮▮▮▮▮▮

May 3, 2002

Dear Steve Simon:

Umbrage Editions appreciates your interest in working with us. The work submitted consists of lovely images and it is evident that you have a real affinity for New York and her people, and a true understanding of the events surrounding September 11. However, we regret to inform you that after careful review of the description and the enclosed images, we cannot take on this project. We have concluded that it does not fit our current publication plans. We wish you the best of luck in finding an appropriate publisher for this project.

We suggest that you contact Magnum, Life Magazine, Regan Books, and Berkeley Publishing Group. They have recently released publications dealing with the attack on, and aftermath of, the World Trade Center, and might be able to help find an arena for your work.

Sincerely,

▮▮▮▮▮▮▮▮

515 canal street #4 • new york, new york 10013
telephone: 212.965.0197 • fax: 212.965.0276
info@umbragebooks.com • www.umbragebooks.com

10.22 Rejection letters.

If you're planning a book, expect rejection and keep the faith. Persevere. Despite the many rejection letters, I believed in this work and did not give up on my dream of getting it published in book form. I learned from the constructive criticism the letters would often contain and finessed the book dummy to improve it.

After the flurry of rejection letters, I tried a different way of approaching my publishing problem. The late Susan Sontag lived in my building. She was connected to photography through her seminal book *On Photography*. She was also an opinionated and well-known New Yorker. I thought that if she would agree to write a foreword for this project, then maybe book publishers would take more notice of the work.

So I got the doorman, Ralph Garcia, to get my book dummy to her, which he did (**10.23**). The very next day I got a call from her assistant telling me how busy she was and it might take a few months for her to even look at it. (He said she would get about 150 similar requests in a year.) I mentioned that I had extra copies and no expectations; I really just wanted her to see the work, and by the end of our conversation I was convinced that he would keep his promise and show Ms. Sontag the book dummy. That was that.

Months passed and I continued to seek a publishing deal but kept getting rejection letters. I never heard back from Susan Sontag or her assistant. But one day I did get a call out of the blue from a photographer named Andy Levin, who told me he was looking at my work from Ground Zero and that he liked it very much. He told me that he had purchased a book dummy of my work from a guy who sold it to him on Seventh Avenue for four dollars (**10.24**).

10.23 Ralph Garcia. © Steve Simon

10.24 A book dummy of the "Empty Sky" project. © Steve Simon

10.25 *The American Spirit.*

"What? Who are you?" I asked.

He went on to tell me that the guy who sold him the book dummy said he had plucked it from Susan Sontag's garbage! "Hmmm," I thought. This was a lot to take in. But Andy Levin continued our conversation and told me about his friend at *Life* magazine (Barbara Burrows) who was publishing a commemorative volume of images post-9/11 that would be published on the one-year anniversary and asked if he could show her the work.

To make a long story shorter, the *Life* book, *The American Spirit*, with an introduction by George W. Bush, published eight pages of my work from Ground Zero (**10.25**). I got my biggest paycheck since moving to New York in 2000 ($8,000), and with the credibility of the *Life* book I was able to find a small publisher in Montreal who published *Empty Sky: The Pilgrimage to Ground Zero* (**10.26**).

I went back to Ralph and told him my amazing luck, and he said, "Sure, that's Steve." Steve is an enterprising gentleman who takes advantage of good things discarded by New Yorkers and often would set up a stand on Seventh Avenue to sell stuff that people throw away. (Today, he uses Craigslist.) I don't know if Susan Sontag ever actually saw the book dummy, but that's okay. In my acknowledgments, I thanked all the players in this story, from Ralph to Steve to Andy to Susan Sontag. I had done all the right things in trying to find a publisher, but it was a recycling bin in my building that led to my biggest success in publishing at the time (**10.27**). For me, the moral of the story is that if you truly believe in what you are doing, things will work out. Persist and persevere. You never know where your next success will come from, so don't give up. Get the word out, and keep the faith. ■

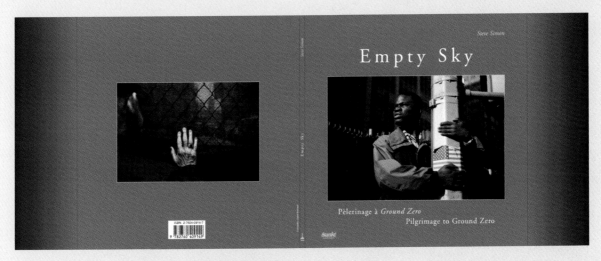

10.26 The *Empty Sky* book gets published. © Steve Simon

10.27 Susan Sontag's recycling bin. © Steve Simon

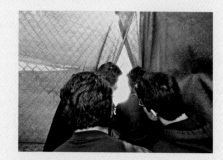

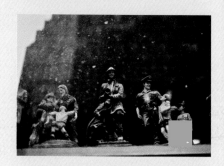

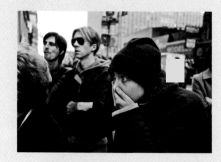

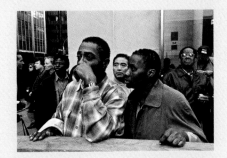

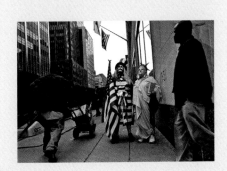

Step ten

ACTION: Review and Follow-Through

We've covered a lot of ground in these Ten Steps, so I wanted to provide a brief summary of some of the major concepts I've talked about before I turn you loose to practice and shoot your way toward becoming a great photographer. I have no doubt that with your action plan, passion, practice, and persistence, you will get there.

Step 1: Passion: An Inch Wide, a Mile Deep

The most rewarding part of the photographic process often comes when you find a project or theme you feel passionate about. By finding meaning and purpose in your picture-taking process, you will learn about yourself while elevating your personal photographic vision. Liberate yourself from photographic routine. Ask yourself, "What is it I am trying to say through my photography?" Be original, authentic, and true to who you are as a person and photographer when looking for your passion project. Think big. Find that story or theme that inspires you to commit and drives you to work hard, moves you past frustrations and through obstacles, pushes you toward a photographic place of competence and excitement you cannot even imagine at the beginning. Many of the best ideas come from your own life. Personal experience and exploring your own connections often yield some of the best, most rewarding stories. Look at photo books for inspiration. It's all been done before; do it better; do it your way. Like music, photography is a universal language we can all understand. The more personal you make it, the more universal it becomes. When working on one story over time, challenge yourself to see new details, notice nuances, never stop looking. The idea is everything. If you can't decide on a grand project, try a short-term one first: a person, an event, a business, a "day in the life" or portrait series. It can be still lives, landscapes, or other groups of images with a common thread that ties them together. Keep it simple; less is more. A project can be presented chronologically or thematically, but the images need to work together. Look for subjects and environments that you're going to enjoy and have fun with. Access really is everything, to maximize shooting possibilities and strengthen the work. Choose subjects that allow unfettered access. Having a mission or artist statement can help clarify and focus your vision for a consistent point of view, as well as form a framework for future shooting.

Step 2: Volume, Volume, Volume: 10,000 Hours: Practice and Persistence

The more you shoot, the better you get, period. The more you shoot, the faster you react, the more experience will teach you what works and what doesn't. The more you shoot, the more your eye is on the viewfinder and you find yourself in the right place at the right moment in the right light without having to consciously think about it. You need to go through a volume of work to get to the other side of great images. If you shoot it, in volume, your unique style will reveal itself; there will be no need to force it. Master your gear and your creativity will soar as technique fades to the unconscious and becomes intuitive as you explore your subjects with abandon. The gap between what you thought you got in the field and what you get will close. You won't have to think, just do. Just shoot it.

Step 3: Work It: Don't Give Up on the Magic

The compositional dance: Move around the floor, eye to the viewfinder, sometimes thinking, sometimes feeling your way through but constantly exploring, trying new angles to see what they look like to arrive at the best possible place to take the picture.

Your first shot is your starting point. Give yourself a variety of options. It's a game of inches. Slight movements have dramatic effects on your final image, altering the juxtaposition of foreground subjects with background elements and the horizon. Boldly find your best shooting position, keeping a low profile, always moving, getting closer and working quickly and quietly.

Step 4: The Lonely Adventurer: Concentration and Never Lingering in Your Comfort Zone

To shoot at your highest level, you need to be a lone wolf and find your way to that photographic zone of high concentration where you're in the moment and all distractions fade away. The ability to maintain your cool, calm, and concentration amid the sights and sounds and smells of a new and vibrant location is key to coming away with strong images, but it's also challenging, particularly in highly charged and difficult situations. Your time is often limited; when possible, take a walk through the entire periphery of where you're shooting, noting areas with the best visual potential to maximize results. More time spent in these areas allows you to peel the onion, scratching below the surface for images you might otherwise not see. Trust your instinct for safety and intuition to guide you to the right places, past obstacles toward new and interesting places. Be patient. Maintain your concentration.

Step 5: The Evocative Portrait: Photographing People Gets Easier

Depending on your shyness level, it can take varying amounts of practice to figure out your own strategies for getting close with strangers in order to make the images you want. Don't ask if you can take their picture; ask if you can speak with them for a moment, because even if they agreed to let you take a shot, their expectation would be just one or two frames. But you want to take more than a few because you know the best pictures often come as the shoot evolves, as you and your subject get more comfortable together—many, many frames down the photographic road. Once you have the okay, you can put Steps 2 and 3 to work. It's not always easy to engage a potential subject, but it does get easier and I have found the experience to be incredibly rewarding on so many levels.

Step 6: Follow the Light… and Learn to Master It

Following the light increases your chances of getting great images because where there is great light, there are great images to be made. Light helps tell the story of the photograph. Light is constantly changing and there is never really a bad time to shoot; light can always be interesting. Walk around the scene and observe how camera position affects the light. Side and back lighting are two powerful ways to use natural light. Bad weather often equals great light, and great light is worth waiting for. As you follow the light, pay close attention to the quality of low light. With today's amazing high ISO capability cameras, success is no longer determined by quantity but by quality, even in low dim light. Every shooting situation

continues on next page

continued from previous page

requires a strategy; strategize following light. Where is the sun? Where does the light look most interesting? Go to it. At dusk and dawn, when the sun is low in the sky, shadows and textures are most pronounced for a three-dimensional look to the landscape. The light is often a golden color, immersing the scene in warm, even light, toning down potentially distracting colors by bathing all colors in a warm glow. Use white balance creatively to interpret the color of a scene with RAW files. A custom white balance is a good idea when photographing people under available artificial or mixed lighting. Monitoring the histogram—and specifically the red channel histogram—is a great way to find potential white balance/skin tone problems and correct them. Keep a log in your "You Book" of great light, dates, and times for future reference.

Step 7: The Art of the Edit: Choose Well and Be the Best You Can Be

Editing is crucial to get your best work to rise to the top of your portfolio. You want to have a tough time editing; it means you're producing a lot of good work. It's a skill that develops with time, but it has its limits. Seeking out respected, objective second opinions is crucial since sometimes you're too close to the work to see it clearly. Getting good-quality feedback is so important but not always easy to find. Finding people who can articulate their critique of your images in a way that you can understand and use to learn, grow, and improve your work is essential to your development as a photographer. Make your editing workflow thorough so you can trust your choices without having to re-edit. Edit on instinct. Remember that image content can often trump technical perfection.

Step 8: Assessing Strengths and Weaknesses: Never Stop Learning and Growing

Assess your work and take a critical look back. I look at the work and ask myself questions. Did I work the image enough? Did I vary my coverage enough or was I shooting from similar angles? How about lens-to-subject distances? Ultimately, the big question is: How can I make things better? On the plus side, I see what is working with my latest images and polish the strengths I possess as a photographer. Once you identify areas for improvement, target a remedy. It's not a mysterious process. Technical problems have solutions that often can be Googled in a few keystrokes. But that's just part of the answer. Go out with your camera and address weaknesses head-on. It requires smart practice and truly learning from your mistakes by going back and correcting them. Mistakes are an inevitable part of the learning process. Don't beat yourself up over them; learn from them. Re-shoot when possible.

Step 9: Action Plan: Setting Goals and Creating Strategies

From my experience, getting your photographic life organized is a great first goal to set. Take a look at your photographic life by thinking about where you are now and where you might want to go. Assigning goals is a good way to start a path to future photographic success and happiness, defined by you. Free your mind of clutter by consolidating thoughts and ideas in one place. Create a "You Book" to contain all your goals, notes, sketches, inspirations, ideas, doodles, storyboards, and anything that pops into your brain that you can use

later. Start out with the creation of a master list, mapping out a photographic future you can imagine or dream of. Think long term and big picture. You can then boil general goals down into more specific ones that are measurable when assessed for best chance of success. Schedule time in your calendar to work on specific actions for each goal.

Step 10: Follow Through: Share Your Vision with the World

Shoot, share, learn; and shoot some more. Repeat. Enjoy. Become the great and passionate photographer you dream of being.

© Steve Simon

INDEX

10,000-Hour Rule, 34, 244

A

Abell, Sam, 72, 84, 130
access considerations, 122–126
action in photos, 28
action plan, 207–219
 artistic goals, 213
 business goals, 216
 equipment goals, 216
 ideas related to, 210–211, 212
 master goal list for, 208, 218
 organizational goals, 209–210
 project goals, 211
 summary of, 246–247
 technical goals, 216
Adams, Ansel, 163
AF/AF-ON button, 81
"aging" your images, 169, 170
Allard, William Albert, 132
ambient light, 142–143
"America at the Edge" project
 (Simon), 7, 181–182
 images from, 5, 6, 8–9, 10, 118,
 129, 182
American Spirit, The (*Life* magazine),
 240
Americans, The (Frank), 36, 183
Aperture Priority mode, 46–49
Aperture software, 171, 185, 231
apps, iPad, 210, 211
Arbus, Diane, 15, 63, 73
artist statement, 27–28
artistic goals, 213
Aryan Nations World Congress,
 102–103
assessing your work, 189–199, 204,
 246
assigned portraits, 138–140
assistants, 113–114
Atwood, Margaret, 4, 7
Auto ISO option, 52
Auto white balance setting, 158
autofocus system, 78, 79–81
Avedon, Richard, 38, 120–121

B

backgrounds, portrait, 138, 139
backing up images, 176
backlighting, 151–152
Badger, Gerry, 13
balance, compositional, 85
Balog, James, 23
Beatles, The, 34
Beckett, Samuel, 193
being in the moment, 104–105
*Being Wrong: Adventures in the
 Margin of Error* (Schulz), 192
Bicycles Locked to Poles (Glassie), 22
Biden, Joe, 196
black-and-white images, 163, 198,
 199
blinkies, 60, 162
blogging, 229
blue hour, 156–157
blurry photos, 52
*Book of 101 Books: Seminal
 Photographic Books of the Twentieth
 Century, The* (Roth), 13
books, photo, 13, 229–232
Bourne, Scott, 38
Brady, Matthew, 207
brain, left vs. right, 40
brainstorming exercise, 29
Brandenburg, Jim, 23–24, 25
Brassai, 13, 15
Buissink, Joe, 116
Burrows, Barbara, 240
Bush, George W., 83, 240
business of photography, 227–228
 career guidelines, 235
 goals related to, 216

C

Callis, Chris, 35
cameras
 hand-holding, 46, 53–54
 image review screen on, 48, 61,
 112–113, 135
 instant-picture, 114
 minimalist, 43

 resetting each day, 61
 shift from film to digital, 33
 shooting position for, 198
 See also equipment
Canada Day photos, 218–219
candid portraits, 121, 122–123
Capa, Robert, 27
capital punishment, 10
career guidelines, 235
Cartier-Bresson, Henri, 27, 31, 32,
 68, 69, 84, 98, 120
causes, 22–23
challenges, 23
Chapnick, Howard, 14
"Chased by the Light" project
 (Brandenburg), 23–24, 25
Churchill, Winston, 132
Clinton, Bill, 162, 174, 175
clipped highlights/shadows, 57–58,
 59, 60, 162
Close, Chuck, 12, 34
Cloudy setting, 159
color
 black and white vs., 163, 198,
 199
 composition and, 77–78
 of light, 156–162
color cast, 158, 162
color temperature, 158
comfort zone, 68, 72, 101, 120, 245
commercial portraits, 120
community members, 113–114
composition, 66–95
 autofocus and, 78, 79–81
 basics of, 66–69
 choices/decisions in, 74–76
 design principles for, 85–91
 lens selection and, 73–74, 198
 lesson learned about, 92–94
 manual focus and, 78–79
 patience in process of, 82–84
 shutter speed and, 69–70
 vantage point changes and,
 72–73
 visual elements in, 76–78

working the scene, 70–72,
92–94
concentration, 98–101, 106, 245
Coney Island, 13, 94
confinement, 196
Confucius, 82
constructive criticism, 196,
198–199, 213
contact sheets, 169, 178
continuous light, 144
Continuous Servo mode, 80, 81
contrast in images, 198
contributions, monetary, 114, 115
creative block, 109
critical thinking, 196, 198–199
critique, seeking out, 213, 232
cropping images, 179, 198
cross-type sensors, 80
custom white balance, 158, 160–161

D

Danes, Claire, 220
Danson, Andrew, 22
Daylight setting, 159
*Day-to-Day Life of Albert Hastings,
The* (Deveney), 20–21
Dean, Jimmy, 35
decisive moment, 69
deleting vs. saving images, 174–175
design, compositional, 85–91
details in photos, 28
Deveney, KayLynn, 20–21
digital cameras. *See* cameras
diopter setting, 46
direction, finding, 109–112
documentary photos, 22, 104
Dragon Dictation, 210
Durrence, Bill, 72

E

Eastman, George, 147
Edgerton, Harold, 69–70
editing images, 166–186
backing up and, 176
cropping and, 179
deleting vs. saving and,
174–175

determining goals for, 182
developing skill at, 168–171
exercise on reviewing and, 186
initial process of, 171–173
learning from, 177–179, 180
making connections via,
184–186
post-processing and, 168, 179
purpose related to, 180–182
rating system for, 172–173
ruthlessness in, 176–177
second opinions on, 182
sequencing and, 183
summary of, 246
Edmonton Journal, The, 2, 106
Edmonton Tornado, 106–108
Einstein, Albert, 21, 98, 109
Eisenstaedt, Alfred, 106, 138, 174
*Empty Sky: The Pilgrimage to Ground
Zero* (Simon), 38–39, 236–243
environment for portraits, 138, 139
equipment
goals for, 216
mastery of, 40–41, 43
See also cameras; lenses
Ericsson, Anders, 34
essays, photo, 14
Evans, Walker, 163
events for personal meet-ups, 232,
234–235
*Everything I Ate: A Year in the Life of
My Mouth* (Shaw), 21
evocative portraits, 120, 130, 131,
145, 245
exercises
on assessing your work, 204
on choosing shots, 117
on composing images, 95
on editing images, 186
on evocative portraits, 145
on finding your passion, 29
on following light, 164–165
on goals and strategies, 218
on shooting in volume, 61
EXIF data search, 197
exposure compensation (EC)
dial, 48

exposure information, 48, 57–60
exposure modes, 46
"Extreme Ice Survey" project
(Balog), 23
eye contact, 132, 133

F

Facebook, 213, 224–225
Fairey, Shepard, 130
faith, 236
Falwell, Jerry, 110
Family of Man exhibit, 15
family photographs, 15
Farlow, Melissa, 94
feedback, 182, 196, 198–199, 213,
232
Ferrato, Donna, 22
fill flash, 143
film-to-digital shift, 33
finding direction, 109–112
first impressions, 171–173
fixers, 113–114
flash
ambient light and, 142–143
continuous light vs., 144
high-speed sync for, 143–144
off-camera placement of, 141,
144
in portrait photography,
141–144
through-the-lens, 143
See also lighting
Flash white balance setting, 159
Flickr website, 213, 222
Fluorescent setting, 159
focusing your camera, 78–81
autofocus system for, 78, 79–81
hyperfocal distance for, 78–79
interpreting shots through, 198
following light, 152–153, 164–165,
245–246
food photography, 21–22
foreground, out-of-focus, 87, 89
form of objects, 77
FotoFest event, 232, 235
frames within frames, 87, 88
framework for photo stories, 28

framing images, 66, 87, 88
Frank, Robert, 36, 183
Freeberg, Andy, 171
Friedlander, Lee, 230

G
Garcia, Ralph, 239
gear. *See* cameras; equipment
Gibson, Ralph, 230
Gilden, Bruce, 121
Gladwell, Malcolm, 34
Glass, Ira, 35, 176
Glassie, John, 22
goals
 artistic, 213
 business, 216
 equipment, 216
 ideas and, 210–211, 212
 master list of, 208, 218
 organizational, 209–210
 project, 211
 technical, 216
golden hour, 77, 78, 156
Grant, Ted, 221

H
"Hail Mary" shot, 74
Halstead, Dirck, 174–175
hand-holding your camera, 46,
 53–54
Hastings, Albert, 20–21
HDR photography, 59
*Healing Waters: The Pilgrimage to Lac
 Ste. Anne* (Simon), 180, 230
Heisler, Gregory, 40, 43
Hemingway, Ernest, 230
highlight clipping, 57–58, 59, 60,
 162
highlight warning option, 60, 162
high-speed sync, 143–144
high-volume shooting, 36–37, 61
Hine, Lewis Wickes, 27
histograms
 exposure, 57–60
 RGB, 161–162
HIV/AIDS project, 180–181, 232,
 233

Holmes, Joe, 135
horizon line, 90–91
Hoza, Rita, 113
Hunt, Bill, 235
hyperfocal distance, 78–79

I
ideas, 21–22, 29, 210, 212
image review screen, 48, 61,
 112–113, 135
image stabilization (IS) technology,
 53–54
Incandescent setting, 159
inclement weather, 161
inspiration, 11, 33–34
instant-picture cameras, 114
instinct, 102
intuition, 102, 104
iPad apps, 210, 211
iPhone photos, 45
ISO setting, 50–52

J
Jackson, Michael, 208
Jempe, Beene, 131
JPEG file format, 55, 195

K
Karsh, Yousuf, 34, 119, 132, 198
Kennedy, Tom, 77
Kigali, Rwanda memorial, 18, 19,
 101, 104
King, Stephen, 230
"Kissing" album, 184–185
*Knife and Gun Club: Scenes from an
 Emergency Room, The* (Richards),
 22
Kolobe, Flory, 173
Koudelka, Josef, 27, 191

L
landmark/icon photos, 95
landscapes
 capturing light in, 148
 converting to black and white,
 163

 sense of scale in, 88
Lange, Dorothea, 18, 29, 92
leading lines, 87, 88
learning from mistakes, 192–195
left-brain/right-brain dilemma, 40
Lehane, Dennis, 144
lenses
 composition and, 73–74, 198
 vibration reduction, 53–54
 wide-angle, 74, 75
 zoom, 73
 See also equipment
Lessing, Janine, 44
Levin, Andy, 239–240
Lewinsky, Monica, 174, 175
Librodo, Manny, 222
Life magazine, 22, 28, 102, 240
Life of a Photograph, The (Abell),
 72, 84
light, 77, 147–165
 ambient, 142–143
 appropriate use of, 148–152
 blue hour for, 156–157
 capturing in a moment, 148
 characteristics of, 140
 color of, 156–162
 direction of, 141
 following, 152–153, 164–165,
 245–246
 golden hour of, 77, 78, 156
 natural, 146, 149, 150
 quality of, 140, 150
 waiting for, 154
lighting
 landscape, 148
 portrait, 140–144
 silhouette, 151–152
 See also flash
Lightroom software, 168, 185
lightstalkers.org website, 114
Lincoln impersonator, 126–127
LinkedIn website, 225
Live View feature, 74, 161
Living with the Enemy (Ferrato), 22
locals as assistants, 113–114
Lomography movement, 43, 196
Long, Ben, 44, 117, 223

low-light photography, 41, 50–51, 149–150
lucky accidents, 192, 194

M
Madubedube, Roselane, 222
Magnum cooperative, 27
Maisel, Jay, 35, 191
Mamotete, Miriam, 84
Mangelsen, Thomas, 112–113, 169, 170
Mann, Sally, 15
manual exposure mode, 46
manual focus, 78–79
marketing issues, 227–228
master goal list, 208, 218
mastery, 34
Mate family, 150
Matrix Metering, 46–47
McCain, Cindy, 195
McCain, John, 53
"Meetings" (Shambroom), 25–26
Meir, Golda, 189
metadata search, 196, 197
metering systems, 46–48
"Migrant Mother" (Lange), 18
minimalist film cameras, 43
mistakes, learning from, 192–195
Mokholokoe, Mamello, 178
moments, capturing, 32–33
monetary contributions, 114, 115
Moriti, Mapuste, 78
Morley, Alison, 210
Moyers, Bill, 36

N
Nakabonye, Euphrasie, 32–33
naked vulnerability, 202
National Geographic, 23, 72, 77, 130
natural light, 146, 149, 150
 See also light
nature photography, 23
New York Times Magazine, 11
newspaper photography, 4
nighttime photography, 15
Nikon Matrix Metering, 46–47

noise in photos, 50
normal lenses, 73
nude photography, 200–202
Nyirabukara, Suzane, 71

O
Obama, Barack, 130, 152
observing light, 152–153
off-camera flash, 141, 144
On Photography (Sontag), 239
On This Site (Sternfeld), 21
on-demand printing, 230–232
opinions, soliciting, 182, 196, 198–199, 213
Orbinski, James, 102, 104
ordering images, 183
organizational goals, 209–210
Outliers (Gladwell), 34
out-of-focus foreground, 87, 89
overexposing images, 59–60
Owens, Bill, 15, 16–17

P
Palin, Sarah, 53
Paris By Night (Brassaï), 13
Park, Trent, 27
Parkinson, Norman, 43
Parr, Martin, 13
passion, 11–12, 29, 244
Passionate Photographer app, 210
patience, 82–84
Patterson, Freeman, 196
paying for pictures, 114
PBase gallery, 222
Pellegrin, Paolo, 27
people photos. *See* portraits
permission to shoot, 122–126
personal meet-ups, 232, 234–235
personal projects, 20–21
personal style, 38, 40
photo-a-day blogs, 23
photo books, 13, 229–232
Photobook: A History, The (Parr and Badger), 13
photo essays, 14

photographers
 creative block in, 109
 warm-up process for, 114, 116–117
photographic zone, 98, 99, 117
photography
 business of, 216, 227–228
 career guidelines, 235
 joy of, 203
 power of, 18–19
 teaching, 214–215
"pixel" art, 12
podcasts, 213, 226
politicians, 22
portfolio review, 232
portraits, 28, 119–145
 access to, 122–126
 assigned, 138–140
 candid, 121, 122–123
 environment for, 138, 139
 evocative, 120, 130, 131, 145, 245
 eye contact in, 132, 133
 lesson learned about, 136–137
 lighting used for, 140–144
 permission to shoot, 122–126
 revealing subjects through, 120–121
 self-conscious, 130
 smiling faces in, 130
 spontaneity in, 132–135
 talking to strangers about, 126, 128–129, 145
 working with subjects of, 135
post-processing images, 156, 168, 179, 216
practice, 34–35, 244
printed portfolios, 234
print-on-demand technology, 230–232
problem solving, 109
project goals, 211
project ideas, 21–22, 29
purpose
 editing with, 180–182
 maintaining a sense of, 104

R

Rauschenberg, Robert, 97
RAW files, 55–56
 highlight recovery in, 162
 white balance corrections in,
 158, 161
RAW + JPEG setting, 55
reference books, 13
reflectors, 142
rejection letters, 236, 238, 239
Republican Convention (2004), 30,
 109–111, 126, 163
Resnick, Mason, 36
reviewing images, 112–113
RGB histograms, 161–162
rhythm, compositional, 85
Richards, Eugene, 11, 22, 34, 191,
 200, 202, 230
Rodger, George, 27
Roth, Andrew, 13
rule of thirds, 87, 90
Rwanda genocide memorial, 18, 19,
 101, 104
Ryan, Kathy, 11

S

Salem Sue photos, 62–63, 64–65, 95
Saudek, Jan, 191
saving vs. deleting images, 174–175
scale, sense of, 87, 88
scheduling tasks, 210–211
Schulberg, Budd, 140
Schulz, Kathryn, 192
Schweitzer, Albert, 14
second opinions, 182
self-conscious portraits, 130
self-published books, 230
Seqhibolla, Alina, 136–137
Seqhomoko, Rose Mabale, 222
sequencing images, 183
Seymour, David "Chim," 27
Shade setting, 159
shadows
 clipping of, 57–58, 59
 portrait lighting and, 140–141
Shambroom, Paul, 25–26
shape of objects, 77

sharing your work, 221–222
 events for, 232, 234–235
 lesson about, 236–240
 marketing related to, 227–228
 photo books for, 229–232
 social media for, 223–226
 website and blog for, 228–229
Shaw, George Bernard, 166
Shaw, Tucker, 21–22
shooting posture, 46
Shutter Priority mode, 48
shutter speed, 52–55
 composition and, 69–70
 freezing/blurring using, 198
side light, 151, 152
signature image, 28
silhouettes, 59, 151–152
simplicity rule, 43
Single focus mode, 79–80, 81
small projects, 26–27
smiling faces, 130
Smith, Ronald, 10, 82
Smith, W. Eugene, 2, 15, 22
social networks, 223–226
soft light, 140–141
Sontag, Susan, 239, 240, 241
spontaneity in portraits, 132–135
sports photography, 36, 43, 78
Steichen, Edward, 15
Sternfeld, Joel, 21
story ideas, 21–22, 29
street photography, 36
strengths/weaknesses, 191–192,
 204, 246
style, personal, 38, 40
Subotzky, Mikhael, 27
Suburbia (Owens), 15
sunlight. *See* light
sunrise/sunset, 154, 156
*Survivors: A New Vision of
 Endangered Wildlife* (Balog), 23

T

tablet computers, 210
talking to strangers, 126, 128–129
teaching photography, 214–215
technical goals, 216

technical mastery, 40–41, 43
technique vs. style, 38
telephoto lenses, 74
Ten Steps summary, 244–247
texture of objects, 77
This American Life radio show, 35
This Week in Photography (TWIP)
 podcast, 213, 226
through-the-lens (TTL) flash, 143
time considerations, 69
"Tomoko Uemura in Her Bath"
 (Smith), 22
tonal composition, 77
tornado photography, 106–108
tourist areas, 114
Towell, Larry, 15, 27
*Tree: A New Vision of the American
 Forest* (Balog), 23
Triage (documentary), 102
tripods, 54–55
Truth Needs No Ally (Chapnick), 14
Twain, Mark, 230
Twitter, 213, 223, 224

U

UBook diary, 210
Umuhoza, Vanessa, 32–33
underexposing images, 59
Unofficial Portraits (Danson), 22

V

Van Riper, Frank, 168
Vancouver Winter Olympics, 42, 43,
 47, 52
vantage points, 72–73
vibration reduction (VR)
 technology, 53–54
visual weight, 85
volume shooting, 36–37, 61, 244
vulnerability, 202

W

"Walk to Paradise Garden, A"
 (Smith), 15
warm-up process, 114, 116–117
weaknesses/strengths, 191–192,
 204, 246

weather, inclement, 161
websites
 creating your own, 228–229
 photography resources on, 213
 social networking, 223–226
wedding photography, 52, 224
Weegee, 216
Weston, Edward, 85
White, Minor, 48
white balance, 158–162
 custom setting for, 158,
 160–161
 histogram for monitoring,
 161–162
 preset options for, 158, 159
Whitman, Walt, 200
wide view, 28
wide-angle lenses, 74, 75
wildlife photography, 23
Winogrand, Garry, 36, 168–169, 170
wireless flash, 144
working the photo/scene, 66, 68,
 70–72, 92–94, 245
workshops, 213
World from My Front Porch, The
 (Towell), 15
written statements, 27–28
wrongness, 192

Y
Young, Al, 117

Z
zoom lenses, 73–74

ACKNOWLEDGMENTS

I'm extremely grateful to my wife, Tanja, and to my parents, Mac and Frances, and sister, Teresa, for their love and encouragement and for letting me commandeer the second bathroom in our small Montreal apartment where I developed film and made contact prints while other kids played in the light. I'm sure my family loved the smell of fixer as much as I did. My buddies Roger Rossano, Andre Chitayat, Tom Mayenknecht, Marc Rochette, Ben Long and Jules Richer, who helped spark the photographic flame that burns out of control today.

I'm also grateful to all the people I've met and photographed over the years, and to my fellow passionate photographers who I've learned from personally and who have inspired me with their work.

To all the wonderful artists and photographers who have generously shared their wisdom and quotes here, thank you. Gregory Heisler, Chuck Close, Sam Abell, Bill Frakes, W.M. Hunt, Dirck Halstead, KayLynn Deveney, Bill Owens, Jim Brandenburg, Paul Shambroom, Eugene Richards, Janine Lessing, Larry Towell, Scott Bourne, James Balog, Thomas Mangelsen, Andy Freeberg, Ted Grant, Manuel Librodo, Kathy Ryan, Andrew Danson, Andy Levin, Freeman Patterson, Tucker Shaw, Albert Hastings, Jay Maisel, Chris Callis, Howard Chapnick, Mason Resnick, Ira Glass, Henri Cartier-Bresson.

To *the* editor, the ever-talented, eternally patient, and always professional Ted Waitt and the *Passionate* team at New Riders: Charlene Charles-Will and Kim Scott for their design vision, Lisa Brazieal, and Sara Todd.

To the great corporate support I've enjoyed because, in the business of photography, you can always use a helping hand: Apple's Martin Gisborne, Don Henderson, Kirk Paulsen, Joseph Schorr, Keith Rauenbuehler, Patrick Pendergast, and the entire Aperture team and Advisory Board.

Nikon has been my partner from the beginning and has never let me down. Andrew Rubenstein, Bill Pekala, Debbie McQuade, Melissa DiBartolo, Lindsay Silverman, Mark Suban, Michael Corrado, Kristine Bosworth, Paul Lee, Steve Heiner, Paul Van Allen, Christopher Knapp, Nikon NPS Canada, Soichi Hayashi in Japan and MWW Groups' Althea Haigh, Geoff Coulter, Brittany Pass and Carson Kressley, for making me look fashionably good in those Nikon webisodes.

I trust SanDisk and the SanDisk Extreme Team, especially Peter Liebmann. B&H and David Brommer, Adorama and Martino Corto, Anne Cahill, and Bob Todrick at McBains' have all inspired me with their passions. I always enjoy speaking at PhotoPlus Expo in New York thanks to Moneer Masih-Tehrani and Lauren Wendle.

It's true, you learn much by teaching, and I've taught in a lot of places. At the School of Visual Arts (SVA) and the Digital Master's Program where the bones of this book were created; thanks to Katrin Eismann, Tom Ashe, and Laura Sterling. To the staff and colleagues at The International Center of Photography: Alison Morley, Suzanne Nicholas, Bob Sacha, Nina Berman, Coco Lee Thurman, Kathryn Kuczynski, Karen Furth, and Donna Ruskin. The Mentor Series Treks are always amazing thanks to Michelle Cast, Erica Johnson, and my fellow mentors Bill Durrence, David Tejada, Mark Alberhasky, Layne Kennedy, Reed Hoffman, and the participants.

You will not find a more passionate group of photographers than at Gulf Photo Plus in Dubai. You should go. Mohamed Somji, Hala Salhi, Phillippa Johnson, Myraa Ahuja, Bobbi Lane, Joe McNally, Drew Gurian, David Hobby, Vince Laforet, Matt Kloskowski, Chase Jarvis, Melissa Rodwell, Claire Rosen, Robin Nichols, David Nightingale, Zack Arias, Dan Depew, Joey Lawrence, Farah Nosh, Chris Hurtt, Miriam Walsh.

I always have fun and learn stuff on the "This Week in Photography" podcast. Thank you Frederick Van Johnson, Ron Brinkmann, Aaron Mahler and Alex Lindsay. Nikonians Mike Hagen and J. Ramon Palacios.

The Olympics Assignment: Rick Collins, Brian Howell, Julie Morgan, Ben Hulse, Greg Durrell, Ali Gardiner, The Rohweder Family and Cheryl Claibourne, who took me with them on a photographic ride I will always treasure.

Of course to the students everywhere whom I have taught and who have taught me back.

If I missed you—and I'm sure I have—I apologize and promise to remedy the oversight in the second edition. Shout-outs to:

Judy and Larry Anderson, Richard Arless, Russell Armstrong, Mark Astmann, Margaret Atwood, Mitch and Trina Baum, Spencer Baum, David Bergman, Shaun Best, Lisa Bettany, Karen Biever, Elizabeth Biondi, Sue Bird, Bernard Brault, Peter Bregg, Joel Breslof, Sue Brisk, Morgan Broman, Barbara Baker Burrows, Dave Buston, Shaughn Butts, Dominique Charlet, Jennifer Childs, Darren Ching, Ted Church, Tedd Church, Andy Clark, Jim Cochrane, Mike Colon, George Cree, Lindsay Crysler, Stewart Curry, Dennis Darling, Barbara Davidson, Jay Defoore, Bill Dekay, Jill Delaney, Antonio DeLuca, Don Denton, Jay and Rose Deutsch, Nick Didlick, Chris Diemert, Yuri Dojc, Dennis Dubinsky, Ray Van Dusen, David duChemin, Bruce Edwards, Conrad Eek, Terrie Eiker, Ethan Eisenberg, Erin Elder, Jason Eskenazi, Mirjam Evers, Melissa Farlow, Laurel Fischtein, Sharon Fischtein, Larry Frank, David Friend, Rob Galbraith, Brian Gavriloff, Bernard Gladstone, Rachel Gorman, Patti Gower, The Grandmothers, Ted Grant, Ed Greenberg, Dan Habib, David Handschuh, Tom Hanson, Elda Harrington, V. Tony Hauser, Katja Heinemann, Eamon Hickey, Joe Holmes, Alicia Homer, John Hryniuk, Mike Jorgensen, Dan Jurak, Ed Kaiser, Yousuf Karsh, Ed Kashi, Thomas Kennedy, Barry Kirsh, Heidi Kirsh, Ted Kirsh, Ken Kobre, Charles Kolb, Flore Kolobe, Goldie Konopny, Chuck Kuehn, James Lahti, Louise Lariviere, Rita Leistner, Mathabisang Leputla, Jean Francois Leroy, Jennifer Lewis, Stephen Lewis, Joseph Linaschke, Elaine Ling, Giuseppe Liverani, Dick Loek, Ao Loo, Avery Lozada, Larry Macdougal, Rick MacWilliam, Beau Madden, Frank Madden, John Mahoney, Steve Makris, Seema and Dick Marcus, Dick Marjan, Randy Mark, Mary Ellen Mark, Jean Jacques Maudet, Peter McCabe, Kerry McCarthy, Paul McCarthy, Jerry Mcintosh, Susan Meiselas, Irv Mintz, Ben Mokholokoe, Mamello Mokholokoe, Lorraine Monk, Eva Moore, Jesse Moore, Alan Morantz, Amy Morse, Barb Musey, Prudent Nsengiyumva, Amy O'Hara, Mike O'Hara, Laura Oldanie, James Orbinski, Ken Orr, Clive Oshry, Jean Margaritis Otto, Horacio Panone, Bruce Parker, John Peterson, Mirko Petricevic, Mike Petro, Leah Pilon, Mike Pinder, Violet Quigley, Roth and Ramberg, Trey Ratcliff, Sue Rauenbuehler, Oscar Reed, Patrick Reed, Michael Regnier, Dan Rennick, Liz Roberts, Peter Robertson, Ben Rondel, Roger Rossano, Felix Rrusso, Liz Rubincam, Christine Ryan, Kathy Ryan, Marti Saltzman, Tina Scheinhorn, David Schloss, Budd Schulberg, Jean Eudes Schurr, Chris and Lynn Schwarz, Ian Scott, Bree Seeley, Seraanye Selialia, Doug Shanks, Colin Shaw, Joan Sherwood, Cheryl Shoji, Joanne Silber, Neil Smalien, Dave Smith, Jeffrey Smith, Susan Sontag, Francesca Sorace, Greg Southam, Lesley Sparks, Kim Stalknecht, Bayne Stanley, Andrew Stawicki, JoAnne Stober, Derrick Story, Mike Sturk, Liz Sullivan, Mary Swanson, Gabor Szilasi, Sara Terry, Andrew Tolson, Juan Travnik, John Trotter, Van Tsicles, Anne Tucker, Pierre Vachon, Kevin Vanpassen, Ami Vitali, Don Walker, Jill Waterman, Rhona Waxman, Tammy Waxman, Don Weber, Bernie Weil, John Westheuser, Jamie White, Margaret Willimason, Larry Wong, Mr. Yashuda.